STOCK PHOTOGRAPHY

STOCK PHOTOGRAPHY

ELLIS HERWIG

AMPHOTO
American Photographic Book Publishing
An Imprint of Watson-Guptill Publications
New York, New York

Photographs of the author are by Lincoln Russell.
All other photographs are by the author.

First published in New York, New York, by American Photographic
Book Publishing: an imprint of Watson-Guptill Publications,
a division of Billboard Publications, Inc.,
1515 Broadway, New York, NY 10036.

Library of Congress Cataloging in Publication Data:

Herwig, Ellis.
 Stock Photography
 1. Photography, Freelance. 2. Photography, Commercial.
 I. Title
TR690.2.H47 770'.68 81-10861
 AACR2

ISBN: 0-8174-5900-6 (hardbound)
 0-8174-5901-4 (softbound)

Manufactured in the United States of America

1 2 3 4 5 6 7 8 9/86 85 84 83 82 81

Edited by Liz Burpee
Designed by Robert Fillie
Graphic Production by Hector Campbell
Text set in 10-point Century Expanded

Acknowledgments

Without Mike Mazzaschi, Martha Bates, and the rest of the gang at Stock Boston, Inc., I would never have become a stock photographer or written this book. The past decade with this up-from-the-roots agency made me learn most of what I know about the field.

Without the help of Sheri Blaney, Barbara and Don Abood, and the rest of the stock photo agency people who pitched in with ideas and critiques, the book would have been much harder to write.

Without Lincoln Russell's pictures of me, the book would have been less enjoyable to produce.

Without the the encouragement of my wife, Mara Casey, this book would have been insufferable.

Without my *Photomethods* colleague Dave Sagarin, who introduced me to Liz Burpee and Diane Lyon of Amphoto, this book would not have ever existed.

Thanks to you all.

CONTENTS

Chapter One
THE BIGGEST PICTURE MARKET 11

Assignments vs. Stock 11
Where Has the Glamour Gone? 12
Professionals Do It for the Money 12
A Look at the Stock Photography Market 12
Stock Photographs Are Indispensable 14
The Best Sellers 14
Quality Is a Must 19
No Fortunes Here 19
Stock Shooting Shows Commitment 21

Chapter Two
RESEARCHING THE STOCK
PHOTOGRAPHY MARKET 23

Research Yourself 23
Shoot Your Favorites 23
What Are You Really Selling? 24
Customers for Stock Photography 24
Learn From Potential Clients 25
Analyze Results, Compare With Your Interests 26
The Big Book Market 26
Want-Lists 26
The Textbook Market Is Specialized 27
The Textbook Market Is Knowledgeable 28
Make Your Own Want-List 28
Don't Shoot A Whole Textbook List 30
Magazines 30
Researching the Special-Interest Market 31
Approaching Your Target 31
Computerized Picture Research 33
Pick Customers You Want to Work for 33

Chapter Three
LOOKING FOR STOCK PHOTOGRAPHS

Pretend to Be a Stranger 35
The Art of Looking 36
Bring Along a Want-List 36
Stock Photography Don'ts 47

Chapter Four
FAMILY STOCK PHOTOGRAPHS 49

Research Your Market 49
Photogenic Families 53
Photograph Several Families 53
Photogenic Situations 57
Special Occasions 57
Important Subjects 57
View From Your Clients' Perspective 61
Where Do You Start? 61

Chapter Five
STOCK PHOTOGRAPHS ON VACATION 63

What's Your Market? 63
Textbook Pictures Look Alike 63
Check With a Travel Agent 65
Look at Travel Magazines 65
More Planning—Better Results 69
Standard Foreign Subjects 69
Plan Not to Shoot 73
The Payoff Is More Than Money 77

Chapter Six
FILMS, CAMERAS, AND QUALITY 79

Professional Standards Are Standard 79
 First of All: Sharpness 79
 Slides: Sharpness Plus Correct Color 79
Color vs. Black and White 80
 Making the Choice 81
 The Favorite Color Film 81
 The Best Black-and-White Film: Fast 82
 Standardize on Standards 82
First Choice in Cameras 82
 Convenient Size Is Vital 82
 Next Quality Is Versatility 83
Lenses 83
 Get the Right Zoom 83
 Add One Lens at a Time 85
 Check the Wide Angles 85
Accessories 86
 Automatic Winders 86
 Meters 87
 Filters 87
 Tripods 88
Bring Your Own Light 88
 Flash Isn't the Answer 88
 Incandescent Is Easier, Surer 90
 Keep Lighting Simple 91
Comfortable Shooting Means Better Pictures 92
 Keep Your Camera Accessible 92
 Keep Your Thinking Positive 92
 Master Your Equipment 93
 Say You're a Nut 93

Chapter Seven
PICTURE PROFESSIONALISM 95

Pick Out the Best 95
 The World of Magnifiers 95
 The Right Viewing Light 96
 Slide Protection 96
 Plan for Captions 105
 Extra Prints 105
Catalog Your Work 105
 Codes for Color 105
 Photocopies 106
Captions Are Vital 106
 Identification 106
 Information 106
 Point of View 107
 Easy Retrieval 107
 Stick-With-It Captions 107
Photocopying Has Many Uses 108
 Submit Copies 108
How to Submit 108
 The Query Letter 109
 Personal Contact 109
What's a Copyright? 109
 Division of Rights 109
 What You're Selling 109
 Work for Hire 110
 One-Time Rights 110
 Copyright Stamps 110
 Unauthorized Use 111
 Reuse Sales 111

Permissions 111
 Invasion of Privacy 113
 "Ridicule?" 113
 Libel 113
 Protective Captions 114
 Model Releases 114
 Your Audience 117
 Good Habit No. 1: Get a Release 117
 Good Habit No. 2: Classify It 117
 Making the Request 117
 Releases Are Worth the Trouble 118
 Houses, Pets, and Land 118
 Make It Clear 120
Your Shipments Are Valuable 120
 The Consignment Memo 121
 Importance of Letterhead 122
 Records 122
 Proof of Delivery 122
 Returns 123
Submitting Is Work 123

Chapter Eight
STOCK MARKETING:
YOURSELF OR AN AGENCY? 125

Can an Agent Help? 125
 Advantages of Selling Stock Yourself 126
 Disadvantages of Selling Stock Yourself 126
 Advantages of Using an Agent 128
 Disadvantages of Using an Agent 128
 Making Up Your Mind 130
 Summary 130
Finding the Right Agency 131
 Big Stock Houses 131
 And Small Ones 131
 How Do You Start Looking? 133
 Query and Follow-Up 133
 What They Want to Know 133
 What You Want to Know 134
 New vs. Old Agencies 136
How Do You Feel About It? 136
 Distance From Your Market 139
 Be Cynical About Agencies 139

Chapter Nine
THE STOCK PHOTOGRAPHY
SUCCESS LIST 141

SPECIAL INTERESTS OF
STOCK PHOTO AGENCIES 150

MARKETING DIRECTORIES
AND SOURCES 151

STOCK PHOTOGRAPHY

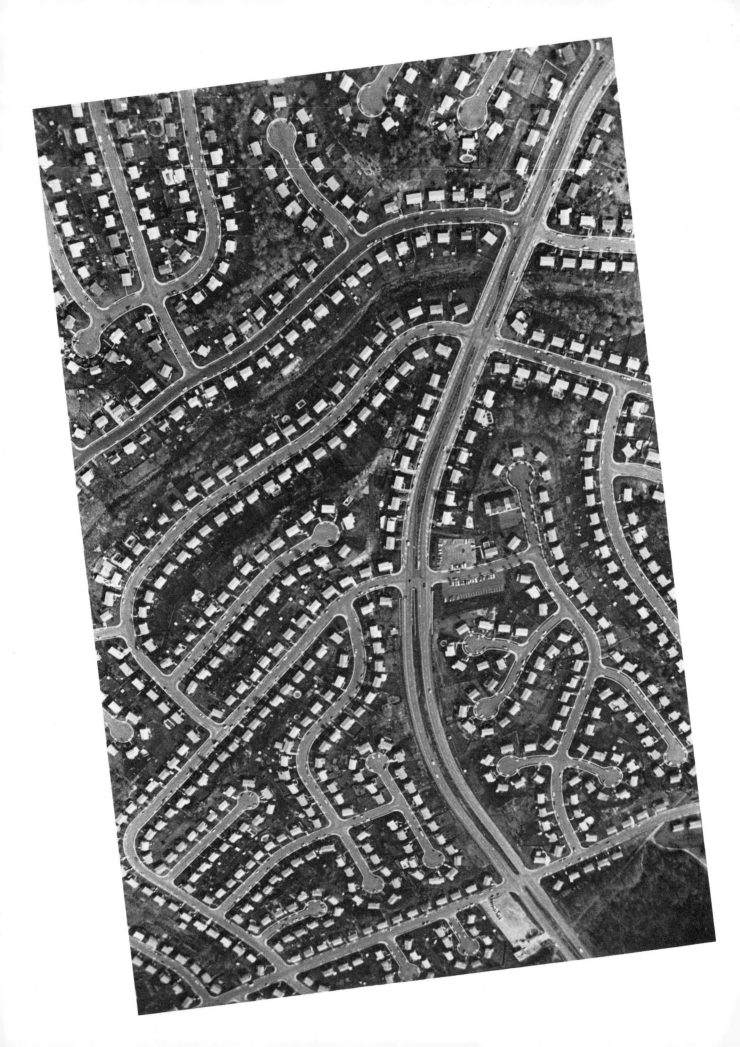

THE BIGGEST PICTURE MARKET

THE MULTIMILLION-DOLLAR picture market is a deceptive thing. People seem to think that the hundreds of thousands of photographs published every year are all produced by full-time professional photographers who collect fat fees and travel to romantic places. It's a thing for insiders, right?

Wrong. The biggest picture market is for stock photographs—existing pictures leased for one-time use only to publishers and advertisers and the rest of the communications industry. Most of these photographs are not produced by full-time professionals. Many of them are of subjects most people see daily.

Assignments vs. Stock

It may come as a surprise that the last thing a magazine, advertising agency, or textbook publisher wants to do is give assignments to photographers. An assignment is always a gamble. There is no guarantee that it won't rain when a sunny day is needed, that a camera won't malfunction, that a roll of film won't be ruined in a processing lab, that a photographer won't miss a plane. Such things happen every day, and the result is money spent for nothing. Photographers on assignment charge for their time, not for their results.

No potential picture user will hire a photographer when a stock photograph can be found to do the job. There's no gamble; the picture already exists. If it's what the user wants, he pays for its use; if it isn't, it costs nothing. What he sees is what he gets, and without delay.

The art director of a major travel magazine says that whenever he needs a particular picture he looks for it first in the files of the local stock-photo agencies, resorting to assigning the job only when other means fail. He adds that he usually gets what he wants from stock. If this attitude is typical, it means that many more stock photographers are making sales and that many more professional photographers are not getting assignments. The implication is clear: Stock photography is where the action is.

Everyone has driven through huge planned suburban communities like this one, but it took an aerial photograph to make a meaningful illustration of such a housing sprawl. The $35 it cost to hire an airplane and pilot was paid back by the stock sale—and this picture should sell for years to come.

Where Has the Glamour Gone?

The widening use of stock photographs has consumed most of the glamorous assignments professional photographers used to be envied for. When a magazine editor or art director can get pictures of London, Paris, or Rio from a stock-photo file, a professional photographer isn't about to get an expenses-paid trip to those places. What photography assignments are being given out are for increasingly specific picture needs, such as product shots and industrial scenes or factories. Ask the average pro how he or she feels after a week of photographing cement plants, and the odds are the answer won't include much about art or romance. This kind of photography is just plain hard labor.

Not all professional assignments are this rough, and there are still thousands given out every year involving persons or products not to be found in stock files. The full-time professional assignment photographer will always be needed. Yet that is scant comfort to the thousands of would-be professionals entering a field that has been overcrowded for decades. There is an increasingly acute lack of work for them to do—and only partly because of the mushrooming of stock-photo enterprises. Competition is fierce. Coupled with the demands of frequently unreasonable or unsympathetic clients who "always want the picture yesterday," the skyrocketing costs of maintaining studios (a prominent professional in Boston—not even New York—figures his studio overhead at $4000 per *week*!), and the price-cutting caused by hordes of newcomers on the make, the widely touted glamour of the professional photographer's lot is beginning to look questionable in the 1980s.

Professionals Do It for the Money

A professional is in photography first and foremost to make a living. Esthetic considerations are secondary to what the client asks for. Given the competition in the assignment market, it's understandable that many professionals turn bitter and cynical. Some even talk wistfully of their amateur days, when they took pictures because they wanted to, not because they had to. Such attitudes are rarely met with in the stock-photography marketplace. While producers of stock photos are just as important to picture users as are competent assignment photographers, the market itself, like an iceberg that shows only its tip, is largely unnoticed. In spite of near invisibility, though, it consumes the work of countless amateurs.

It's easy to make a case that the amateur photographers are the more fortunate. Even the term, stemming from the Latin *amator*, "lover," is complimentary.

Can a person do anything really well if it is boring? Many professional photographers say "Yes," and that they're paid to be bored. Amateurs don't have any such stimulus; but then, they are working for love.

A Look at the Stock Photography Market

Once you try looking for the uses of stock photography you'll be amazed at how many there are. Even a little casual research will open your eyes to the vastness of this market.

☐ Step into the public library and look over the magazines on display. With the exception of news and fashion publications, most of them depend heavily on stock photographs. Look over the advertisements, too. Notice how many of the pictures are of people doing everyday things. They are pictures you could have taken yourself.

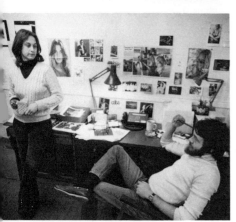

Agencies for stock photography— whether the New York style with millions of pictures on file or the small husband-and-wife operation—are enjoying a boom. As more stock photos become available, more picture users find they can fill their needs from stock files rather than hiring photographers (and at a much lower price). The result is that photography assignments are declining in number as stock sales increase. Stock is where the action is.

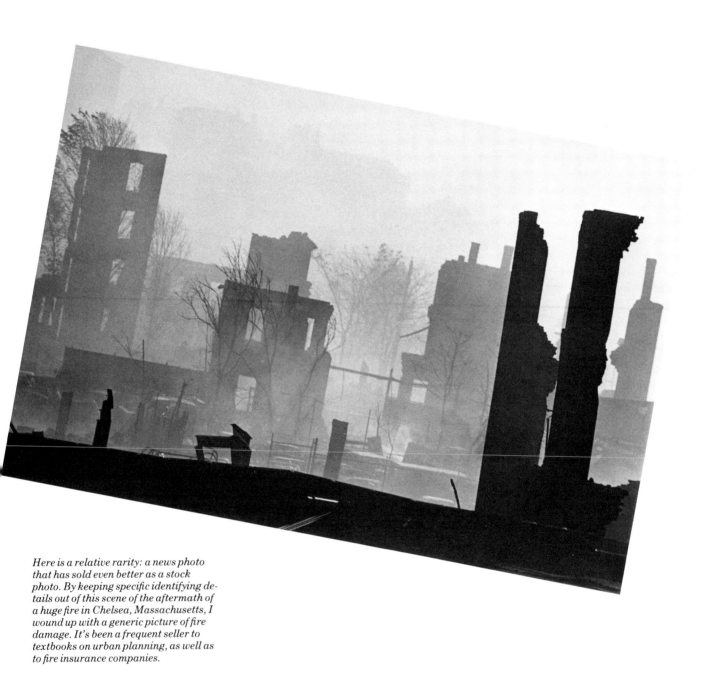

Here is a relative rarity: a news photo that has sold even better as a stock photo. By keeping specific identifying details out of this scene of the aftermath of a huge fire in Chelsea, Massachusetts, I wound up with a generic picture of fire damage. It's been a frequent seller to textbooks on urban planning, as well as to fire insurance companies.

□ Drop by your local school library and examine the textbooks. These are probably the biggest users of stock photographs in the whole picture market. Notice how many of them deal with humanistic themes—family life, work, human interaction. How many of these pictures could you have taken? Probably someone just like you did take most of the ones you see: not a famous professional, but someone who loves photography and can see picture possibilities in the everyday world.

□ Take a look at the greeting cards at a stationery store. The producers of these cards buy thousands of stock photographs every year. Because the cards are meant to be sold by the millions to people just like you, they show subjects everyone is familiar with: lovely flowers, charming landscapes, happy couples, children, families. How many times have you thought the people in those photographs look like people you know?

Stock Photographs Are Indispensable

The picture market's thousands of magazines, books, greeting cards, and advertisers couldn't survive without stock photographs. How could the picture editors of a psychology textbook find likenesses of American Indian children in Arizona, a college student protest, and a father taking care of his children if a photographer had to be assigned to each? It couldn't be done, any more than a greeting-card printer could find Christmas snow scenes when cards go to press in October.

To fill such needs, thousands of picture buyers spend millions of dollars every year. If you're willing to spend the time and energy necessary to produce the high-quality photographs these people need, there's no reason some of that money shouldn't go to you.

Unlike most professional assignment photography, stock photography is open equally to amateurs and professionals. In fact, the amateur is often in a better position to produce quality work: The professional is selling himself or herself, whereas the stock photographer is only selling photographs.

Every professional assignment photographer must spend a long period of time seeking the trust of potential clients. Doors must be knocked on, portfolios shown, disappointments overcome. Only when a client believes a photographer can be absolutely trusted to bring back the desired photograph will an assignment be given. This long, often disheartening period of paying dues can occupy years, during which time the would-be professional makes little or no money. But the amateur who takes stock photographs doesn't depend on this for a living. While the professional is taking a portfolio from one office to the next, the amateur is out taking pictures—pictures that can be sold immediately if the right buyer is found. The amateur doesn't have to accept dull assignments to pay the rent. He takes pictures that interest or challenge him, and such pictures are likely to be good because of this enthusiasm.

Attitudes can't be hidden behind a camera. A photographer's most precious asset is enthusiasm, and the amateur has an easier time maintaining it than the professional does.

The Best Sellers

Although any subject is a potential seller from stock, some subjects are surer than others. Human activities are Number One. If you think this generalization covers a wide area, you're right. It covers subject matter accessible to anyone. Most publications are not looking for originality, but rather for professional-quality pictures. The canny stock photographer knows that the same

I doubted that this photo of a transvestite nightclub entertainer would ever sell as a stock photo. To my surprise, it began making sales in the mid-1970s and is still selling today. Psychology textbooks are getting more and more innovative, and sensitive subjects like this are becoming acceptable. Stock photos don't necessarily have to be of ordinary subjects.

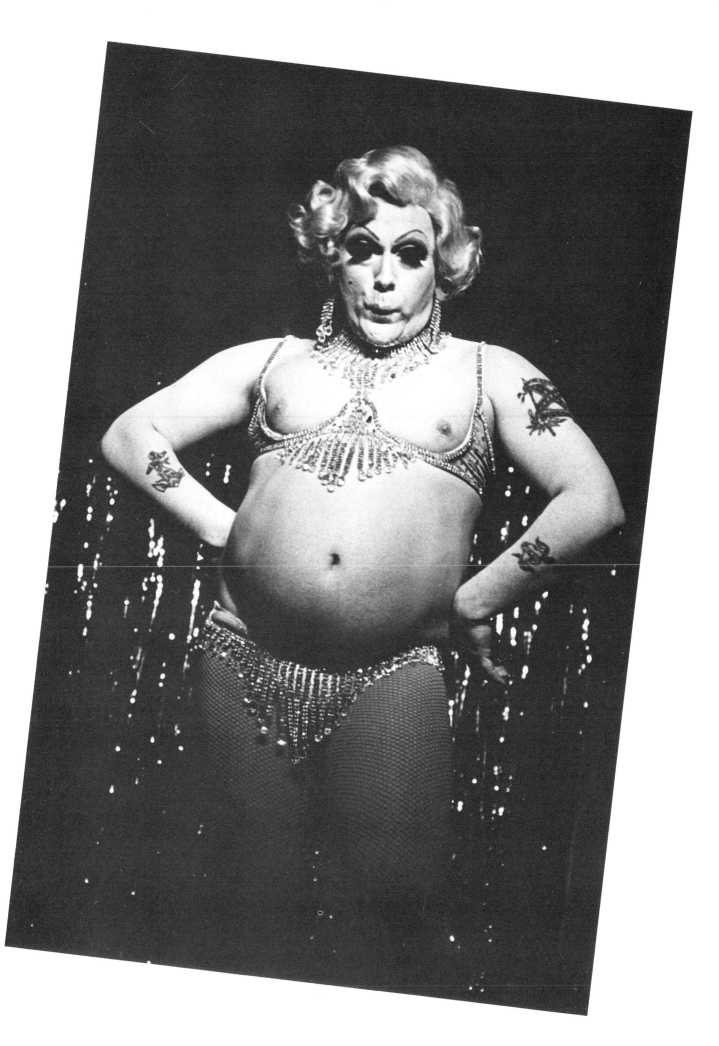

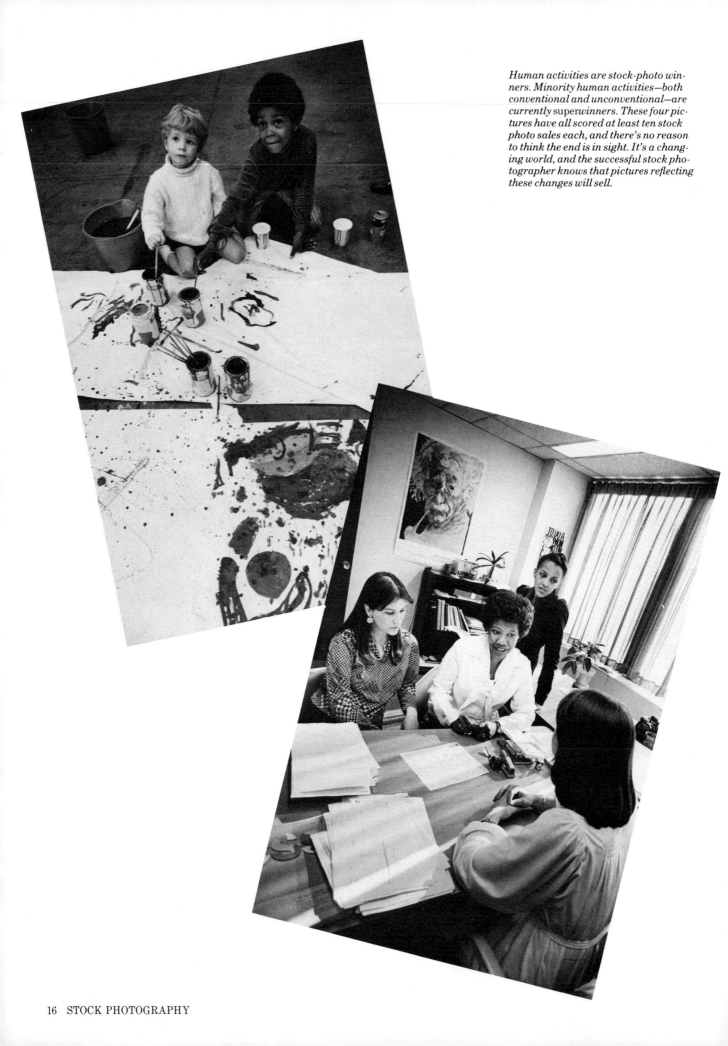

Human activities are stock-photo winners. Minority human activities—both conventional and unconventional—are currently superwinners. These four pictures have all scored at least ten stock photo sales each, and there's no reason to think the end is in sight. It's a changing world, and the successful stock photographer knows that pictures reflecting these changes will sell.

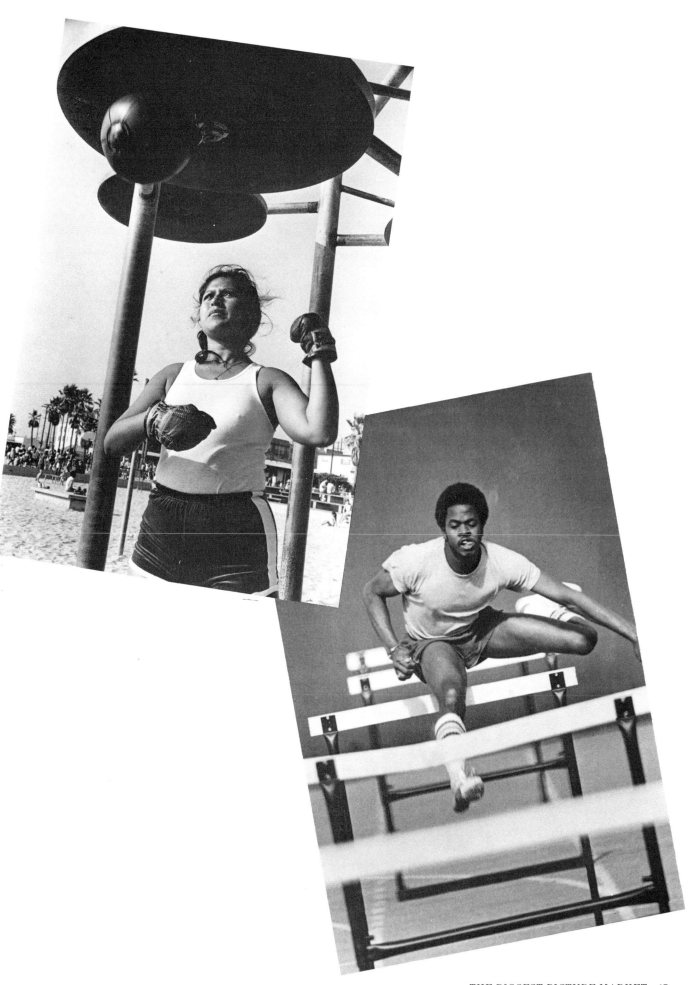

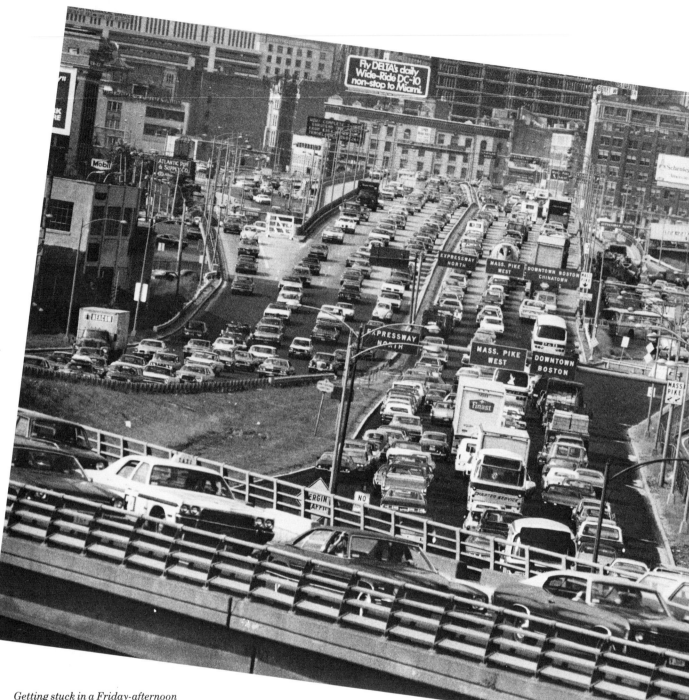

*Getting stuck in a Friday-afternoon
traffic jam is a familiar experience to
many people. As a result, such situations
are often used in books and magazines
to illustrate such subjects as urban life
or automobile pollution. This telephoto
"stack-up" of a Boston traffic jam seems
to be just what a lot of picture buyers
want—it has scored more than three
dozen stock sales.*

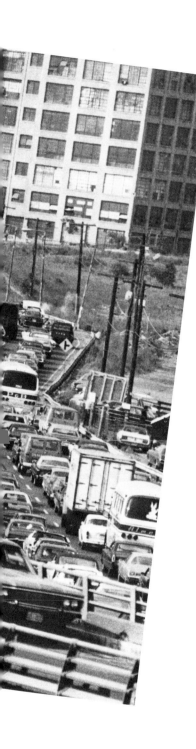

picture can be sold to thousands of buyers; conversely, one buyer may need countless variations on the same theme.

Indeed, most potential stock photography subjects are so much a part of everyday life that they're often overlooked. A spectacular color shot of a sunset over the Rocky Mountains might be enjoyable to look at, but a picture of a little girl taking her first step in a living room would be a more likely seller. Such a picture would have a spectrum of potential buyers, from greeting cards to posters to textbooks.

The result is that countless saleable stock photographs never get taken. Not only do few photographers cultivate the ability to see significant images in everyday life, but also the current "me generation" philosophy militates against the idea that pictures you don't particularly like yourself may well be useful to someone else.

The need for stock photography subjects has yet to produce a glut of stock photographs. An executive of a major New York stock-photo agency, which handles the work of some 4000 photographers (some specialized enough to supply only electron-microscope photographs of influenza viruses!) observes, "Every day, I'm amazed at what we *don't* have."

Quality Is a Must

Stock photography is simple—but that is not the same as being easy. For one thing, top quality is important. So what does the term *top-quality photography* mean?

Quality is meaningless until it is defined in relation to a given need. In stock photography, *quality* means those technical and visual characteristics the majority of picture buyers expect to see in work submitted to them. This means photographs free of amateurish goofs. The whole point of using stock photographs is that they are cheaper or more convenient than assigned photography, or both. They must be of comparable quality.

☐ Color slides must be needle-sharp and perfectly exposed.

☐ Black-and-white prints must be properly focused and of the correct density for reproduction in printer's ink.

Even more important than technical quality are strong images that make useful points. In commercial use, photography is not a subtle medium. The photograph of that little girl taking her first step had better be a clear, tight close-up in which the action is visible, logical, and understandable. It should have a well-organized caption to convey additional useful information.

Technique should not be noticeable to the viewer. The stock photographer isn't taking pictures to show off technical virtuosity, and stock photos are seldom knockout contest winners. The ideal response to a well-done stock photograph is a positive reaction to the subject matter, not to the technique or to the photographer.

No Fortunes Here

The market for stock photography is full of opportunity, but that doesn't mean it's going to pay you before you have paid your dues. It's up to you to seek out the parts of this huge field that fit your interests and abilities. You will have to learn to accept your share of rejections and disappointments before you get the hang of stock selling.

You also won't get rich selling photographs from stock. Steady sales call for a large inventory of work that is being continuously increased and updated.

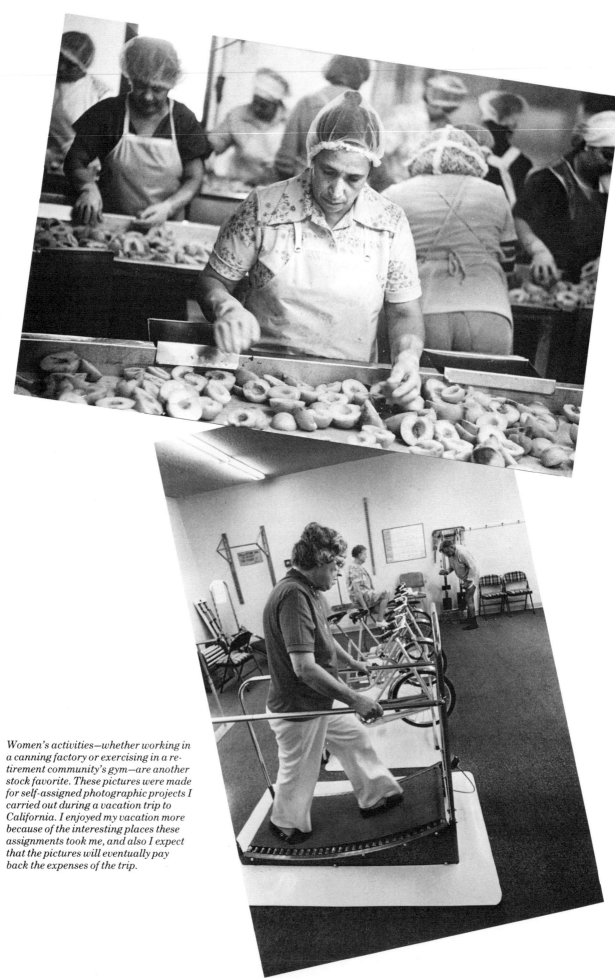

Women's activities—whether working in a canning factory or exercising in a retirement community's gym—are another stock favorite. These pictures were made for self-assigned photographic projects I carried out during a vacation trip to California. I enjoyed my vacation more because of the interesting places these assignments took me, and also I expect that the pictures will eventually pay back the expenses of the trip.

Even among professional photographers such a stock is regarded as a part-time source of income. For the amateur, more important than wealth (which is seldom found in any photographic enterprise) is the fact that the stock-photography market is a field where subjects are accessible to everyone and where amateur enthusiasm, coupled with professional discipline, results in publication alongside the work of the pros.

It may be unlikely that a major magazine will give you an assignment, but there's no reason you can't give yourself one that's just as challenging. The pictures you produce as a result are prime stock merchandise, just as saleable as the pictures the professionals take. Furthermore, you can pick the good assignments when you make them up yourself. The professionals have to take what they can get.

Many established professional photojournalists look upon stock photography as the most interesting work they do; they say it keeps them from getting stale. Because of this, many professionals work at lower rates for clients whose assignments offer enough flexibility to allow personal stock photography to be fitted in along with the assigned work. They have found that the money they lose on the assignment fee is more than made up by the money they make in later years from the sale of the photographs they shot for stock in combination with their assignments. In fact, professionals have sometimes done assignment work just for expenses if the stock photography potential was big enough. The photographers who get paid for assignments are finding out that stock is an ever richer field when it's utilized effectively. You have the same chance at these opportunities.

With advance planning, vacation trips can turn into moneymaking trips if you shoot for stock as you travel. Countless local activities offer picture opportunities, making it in your best interests to meet new people doing interesting things that you can photograph. Stock photography possibilities are everywhere, and you'll find that taking advantage of them is an exciting way to expand your friendships and experiences.

Stock Shooting Shows Commitment
Most important of all, stock photographs test your commitment to photography. They show how good a photographer and how astute a businessperson you can be. The name of the game is fine photography. If that's what you want to do, stock photography is a game you can play.

This book will help you understand who buys stock photographs, what the best subjects are, how to shoot stock pictures, how to handle them, and some of the basic legal and business principles involved. After that, it's up to you. Thousands of photographers depend on their backlog of stock pictures to earn for them some of the millions of dollars spent every year on photography. One of them might as well be you.

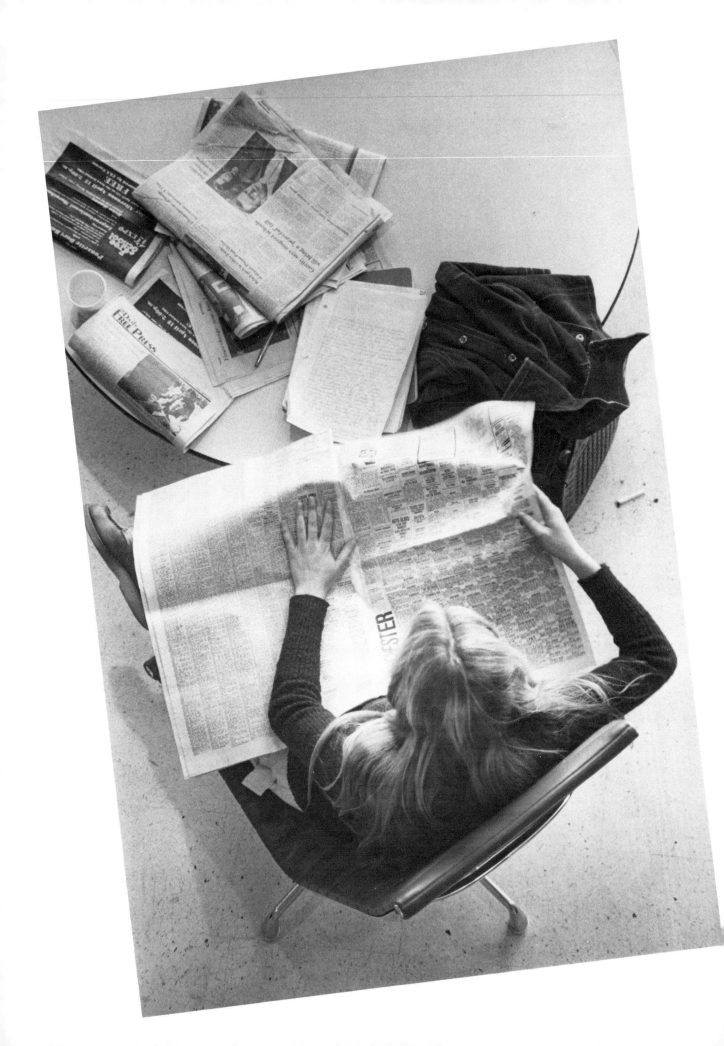

Chapter Two

RESEARCHING THE STOCK PHOTOGRAPHY MARKET

THE STOCK-PHOTOGRAPHY market is large but subtle. To find a buyer for your pictures, you must begin with some systematic research into what you want to photograph and what potential customers need. The process is a sort of collaboration, in the long run.

Research Yourself

Start by asking yourself some questions:

□ Are there specific subjects you have access to?

□ Of all the subjects you have photographed, which ones have you most enjoyed photographing?

□ Evaluate your technical qualifications: Can you handle low-light shooting? Aerial shots? Do you do better with outdoor or indoor subjects? How much equipment do you have? What results can you expect from it?

□ Are you sure your work is up to professional quality? Have you ever showed it to some professional for a critique?

□ Are you willing to put up with hard work and rejections in the pursuit of markets? No seller of photographs ever escapes these.

Since setbacks are inevitable, it's important to be motivated. That's the reason for asking yourself all these questions. You're more likely to keep trying with subjects you care about.

Shoot Your Favorites

Once you've settled on some favorite subjects, learn all you can about them. If you like to photograph children, make a list of all the things a child could be doing. Try taking as many photographs as you can of the activities on that list. Did you like taking those pictures? Are they good? Have them evaluated. The more justified confidence you have in your work, the more you'll sell.

Stock photography is no place for the passive attitude often found among

When I took this overhead shot of a woman reading the morning paper's "want" ads, I had no idea it would turn out to be a dozen-sale stock-photo success. In those days, I thought only the unusual sold. Now I know better; everyday activities like this, which can be photographed anywhere, are the real "meat" of stock photography. Keep looking for them and photographing them—you'll make sales.

professional photographers who expect their clients to do their thinking for them. Your client is *you*. There's no excuse not to be enthusiastic about shooting stock photographs—in fact, there's no other reason for shooting them. You're doing it on faith. No one can buy a stock photograph that doesn't exist. You've got to take the pictures first. Enjoy taking them. It may be the only pleasure you get, for not every stock photograph is a winner. Enjoyment is the most important part of the whole enterprise, and it's all that separates the enthusiastic stock photographer from the photographer who merely supplies a technical service.

What Are You Really Selling?

Before you look for customers, give some thought to what you're selling: convenience. You're selling existing pictures that no one has to make any promises on. It's not the same as an assignment, when you're asking a client to gamble on your ability to take a picture. Yours are already taken. A stock photographer with a good selection of work is more welcome to a picture editor or art director than a would-be assignment photographer. The stock photographer is there to make that person's job easier. Since it's always easier to pay for the use of a stock photograph than to risk hiring (and trusting) a photographer, figure that you're selling something a picture user would prefer to buy.

Your request of a potential customer is reasonable. You're not asking for his trust—just a chance to show your work.

Don't be embarrassed that you're not a full-time professional photographer. Almost no full-time professionals make their whole livelihood from stock photography. In fact, income from stock for professionals averages about twenty percent. So figure that stock photography is a part-time occupation even among full-time photographers. You're in the same class they are.

Customers for Stock Photography

Photography magazines seem to believe that New York City is not only the photographic capital of the world but the only photographic market of consequence. The truth is that there are at least 23,000 users of stock photographs scattered all over the United States. The closer to home you start looking, the easier the search for clients will be.

Get out your classified phone book. Give some thought to the kinds of people who might be expected to be interested in using stock photographs.

Local publishers. If publishers use photographic illustrations in their books, they're almost sure to be interested in stock photographs. If they publish material of local significance, you've got a particularly good chance of making sales. Call and ask who handles picture research. Make an appointment to go over and discuss their needs. Have a look at what kinds of pictures they've been getting.

Advertising agencies. Some stock photographers do lots of business with ad agencies, but they can do it only if the agency's accounts lend themselves to the kind of illustrations a stock-photo file could be expected to supply. An agency whose needs are mostly studio-shot product photographs probably won't have much use for stock photography, whereas an agency that handles travel accounts often needs them. Investigate an ad agency's business. Call the agency and ask to speak to the head of the art department. Explain the kinds of pictures you like to take and that you have available, and ask whether there is any need for such work among the agency's current accounts.

Stock-photograph sales start with research at the local library. Check through magazines and textbooks for picture markets that interest you, and use the library's reference services to obtain the directories listed in this book to find other buyers. The more you know about who's buying what, the more stock photos you'll sell.

Remember that ad agencies are constantly losing accounts and taking on new ones. An agency that isn't interested in what you have now may well be interested in the future. It's worth a trip to show your work to as many of the art directors as possible. Even if they don't need it, they might know someone who does, and their opinions of your work might prove useful to you. (Remember that pictures used for advertising purposes *must* have model releases for all recognizable people. This is discussed further in Chapter Seven.)

Graphic designers. These people do piecework design of publications for a wide variety of clients. Their need for stock, like that of ad agencies, varies depending on what clients they currently handle, but whenever they do need pictures, they generally prefer already existing stock pictures over assigned photography.

Audio-visual houses. Slide shows are big business, and a growing industry is devoted to producing them. The main ingredient in these shows is color slides, and such businesses often need a lot of stock photographs quickly. As with ad agencies and graphic designers, their needs change frequently, requiring return calls.

Local newspapers. Topical news pictures are shot to order, but newspapers often use stock photographs, too, especially if they put out feature supplements or Sunday magazines. If your photographic interests run to local scenes and activities, you may find editors who are interested in buying from stock. Remember that newspapers often work on tight schedules and need pictures fast.

Chambers of commerce. As with newspapers, if you have many pictures of local scenes you'll find your local chamber of commerce interested. Most of these organizations depend on handout pictures from local merchants and news media. If your work is superior, you can expect not only sales but also a useful entrée into local activities, many of which can produce additional stock subjects.

The list could go on forever. At one time or another it seems that almost every business has some need for stock photographs. Whether you can fill such needs is another matter; but the market is there, right in your hometown. Before you being looking for sales farther afield, be sure you've done justice to your local customers.

Learn From Potential Clients

What kinds of questions do you ask these local stock photograph users? If you're just starting out, the odds are good that you'll need information and advice more than sales, so try to find out all you can about *their* picture needs. Here are some of the questions you can ask.

☐ *What kind of pictures are the hardest to obtain?* You may be surprised at the answers to this question. Most photography editors and picture researchers say that their biggest headaches are pictures of the most ordinary subjects: local landmarks, children at the beach, notable buildings. Most photographers overlook these everyday pictures on their way to "gee whiz" pictures that are more exciting to look at but of little stock value. Ask for as many specific examples as you can. It can be your handy picture list.

☐ *What does a client pay for the use of a stock photograph?* Although some sales of stock color pictures to national advertisers can run into four figures, local

Art directors and graphic designers are steady buyers of stock photographs, by necessity: Their budgets often discourage them from assigning photographers and, too, the range of their picture needs—coupled with short deadlines—makes stock their best source for illustrations.

and limited-use fees can run as low as ten dollars. Is it worth the trouble? That's up to you to decide; but, assuming you want to take the picture anyway, even that fee is worth having. Also, since you are selling the photograph for one-time use only, there's no reason another sale of the same pictures can't bring more money at another time.

Remember that one of the attractions of a stock photograph is that it's easier and cheaper to obtain than an assigned photograph. You might be paid $200 to take a photograph, but remember that assignments are based on time. The odds are that a stock photograph fee is lower than an assignment fee. Certain photographers say the difference between stock and assigned photograph is convenience and reliability, not money. and therefore the stock fee should be the same as the assignment fee. It's food for thought, but in current stock-photo thinking it's the exception rather than the rule.

□ *How do potential customers go about finding stock photographs?* Do they deal exclusively with agencies or do they do business with individual photographers? Is there an established procedure for handling stock photographs in the office? For their safekeeping? Some stock users are careless with your pictures; they're customers to avoid. Your photographs are valuable.

□ *Are users interested in being informed about your future interests and inventory?* Stock photography needs change. It's important to keep your dealings current. Some photographers send out lists and/or newsletters.

Analyze Results, Compare With Your Interests
When you've finished quizzing potential customers, sit down and make a list of what you've learned. How do their needs, fees, and procedures match your own photographic interests and capabilities? Where those needs and your interests overlap is the place you should start thinking of pictures to take.

Local sales can make money for you, but there are bigger markets for your stock and you can reach them with telephone calls and the U.S. mail. Probably the biggest one is educational publishing.

The Big Book Market
This is such a huge market that it should be considered by itself. Thousands of textbooks are published every year. Many of them use stock photographs, sometimes hundreds in a single volume. Textbook publishers are organized to get the most out of the stock photography market. They have well-organized picture research and editing staffs with established procedures and prices.

Want-Lists
The basic tool of the textbook picture researcher is the want-list, or list of photographic subjects needed to illustrate a particular manuscript. It's important to understand the hierarchy of communications media illustrated by this procedure: The words come first, the illustrations second. The want-list is extrapolated from the text. Successful textbook stock photographs are pictures that reflect themes common in current textbook publishing. For example, here are some excerpts from a want-list for three college-level textbooks, one on business procedures, one on retailing, and one on marketing:

museums
art galleries
building projects
international harbors (e.g., Long Beach, CA, and New York)
crowds

This multi-image audio-visual producer has to feed slides to the six projectors in the background for just one presentation. Such large-volume picture markets can be filled only by stock photographs, and A/V houses purchase thousands every year.

single-parent families
energy conservation
child care
home delivery (milkmen, bakery trucks, laundry)
delivery men/women (e.g., U.P.S.)
gift-wrapping service
suburban housing
children with computers
computer stores
home computers
beauty shops
dress shops
neighborhood grocery stores
couples shopping (young and middle-aged)
crowded shopping-center parking lot
families watching TV
bricklayers
management personnel
roller-skating
shoplifting signs
store demonstrations (person handing out free samples of food)

The list goes on for five single-spaced pages. Most of the requests are for everyday subjects, reflecting the humanistic-photojournalistic approach common to the textbooks for this age level.

The Textbook Market Is Specialized

It is important to understand some of the more subtle ramifications of the textbook picture market. The preceding list is for college-level readers. Although the subjects are everyday ones, they are relatively sophisticated in content, logical for a book at a late-adolescent or adult level. Notice that most of the subjects are people doing things that the reader can understand from previous experience. Most of these pictures would be sought in black and white rather than color. This is often the case with textbooks for older readers, except for covers and chapter-opening illustrations.

Color versus black and white in textbook illustration isn't just a matter of esthetics but of comprehension. Young children don't have the sophistication to understand black-and-white illustration. To them, black-and-white photographs are just gray blurs. Books for this group use color photography almost exclusively. Books for kindergarten to third-grade children rely on fanciful artwork rather than photography. Photographic comprehension appears to be an acquired ability. Here are some selections from the want-list of a social-studies textbook for third- to sixth-graders, all in color:

aerial of beach in summer, especially with people and a good shoreline
some people who live by the shore (*e.g.*, Cape Hatteras people)
houses by the shore, especially those on stilts
Chinatown, New York City (not just restaurants, but Chinese signs
 visible and identifiable)
parks that have paths
old-style bowl fountains
desert anywhere in the Middle East, with oil fields
citrus groves with irrigation
holy places in the Middle East (all three major religions)

any oasis in the Middle East
photo denoting the importance of oil in the Middle East
Washington, DC, sights; Mount Vernon, White House
police officer directing traffic
Jewish, Moslem, and Quaker services in the United States
rural and urban grammar schools
downtown view of shopping and business district
passenger and freight trains
freight being loaded on truck, bus, ship, train, plane
high-rise and duplex buildings
single-family suburban homes
blue-collar and white-collar working situations
mother working, father working
people at a museum, at the beach, on trips ("How Do We Have Fun?")

Compared with the college-level picture requests, these are more generic, keyed to the fact that younger readers need to be educated in basic ideas. The selections are more along the postcard than the photojournalist style of college-level textbook photograph requests.

The contrast between the two lists points up the diversity of requests from textbook publishers and the precision with which they break down picture needs. Textbook picture researchers are among the most knowledgeable and sophisticated professionals in the business. Though textbook stock sales aren't the highest-paying ones, there are a lot of them.

The Textbook Market Is Knowledgeable

Because the textbook market is so well organized, the stock-photograph researchers know where to go for their material. They know the agents and photographers who can supply their needs, and they know what the going prices are. Textbook publishers buy a lot of stock photographs, but you have to take them very seriously and understand their needs if you want to make sales.

Sales of stock photographs depend considerably on playing the odds in a large-volume business, and so the more understanding you have of the needs of particular buyers, the better your own chances will be. In spite of the volume of photographs taken every day, few picture editors and researchers complain about getting too many good pictures (though they *always* complain about getting too many bad ones!). That's why research is so essential. Successful stock photography is less the production of remarkable images than the production of useful ones.

Seeing the usefulness of pictures is a learnable skill. Before you pick up a camera, do your homework.

Make Your Own Want-List

Probably the best way to learn about textbook picture needs is to visit a school library and go through a collection of these books. Group them first by age, then by subject. Make a list of the pictures they contain, complete with a brief description of the subject matter and treatment. Soon a pattern will emerge of how each subject is depicted for readers of different ages. Once you've done this, write a general description of the picture requirements of each book. Try to work backward and come up with the want-list that was probably compiled to obtain the illustrations you've seen. The more you understand the needs of textbook picture researchers, the more likely you are to start seeing the kinds of pictures they want.

Were there any textbooks that particularly caught your eye? Any selections

Women in atypical roles have become a media cliché. Does that mean that illustrations of this idea won't sell? Quite the opposite. Most media repeat themselves frequently, and this has made this photographically ordinary picture of male and female police officers a steady stock seller for five years. Once again, don't be too proud to photograph the obvious.

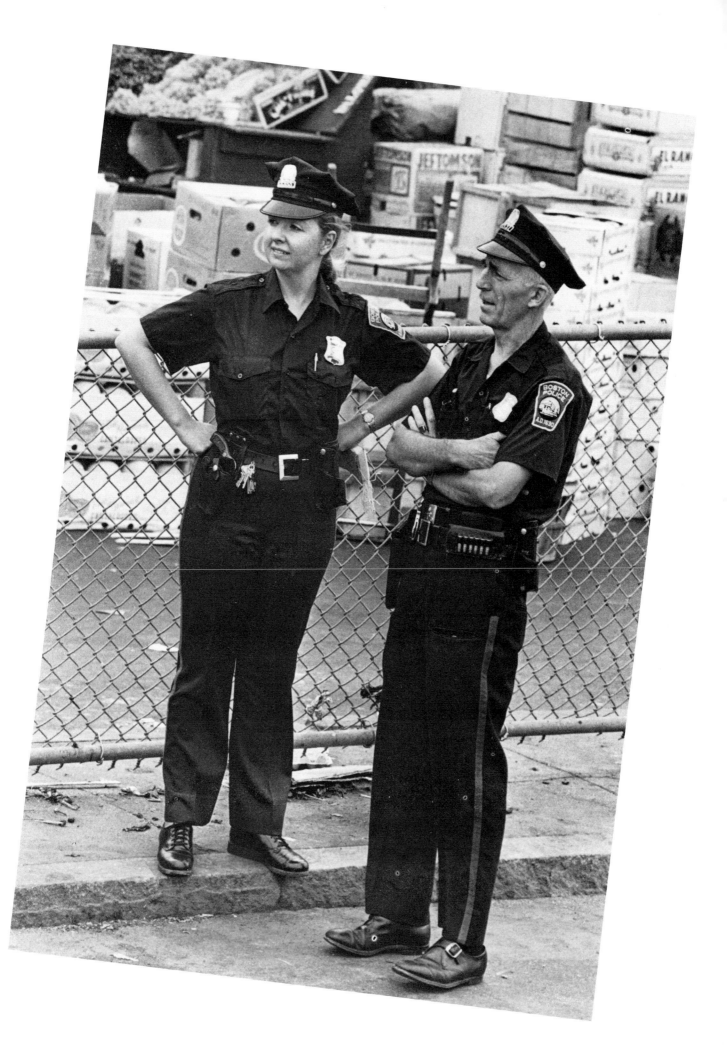

that looked better than others? If so, it might be worth finding out who did the picture research for that book. Look up the name and address of the publisher (it should be on the title page), telephone and ask for the researcher's name. Say you were impressed with his or her editing job and ask what projects are currently under way. You might find that there are some subjects you're interested in. Ask for a copy of the next want-list; it's a reasonable request.

Don't Shoot a Whole Textbook List

The temptation when you receive a want-list is to rush out and shoot every subject on it. In some cases you could. As we've seen, many textbook picture needs are easy to find. The trouble with this attitude is that it sets you up for a lot of disappointment. You're not the only photographer who has that want-list. It went out to dozens of other photographers, plus stock photograph agencies with big inventories and well-organized research procedures. Just because you *can* shoot three quarters of the pictures on the list doesn't mean you should. The odds are that most of your work will be rejected, and you'll feel betrayed by that unseen list writer. All that work for nothing!

Herein lies one of the important lessons for reading want-lists: You can't expect to score just because you can fill that list's requests. Lots of other photographers and agencies can too. What's important is to read the list and pick out the subjects you would enjoy photographing whether you sell the picture or not. *Those* are the subjects to concentrate on, for not only will you do the best job of photographing them, but you'll also enjoy doing it. If the picture sells, fine. If it doesn't sell, you've still enjoyed yourself. A successful New England stock-photo agency estimates that at the most it sells *five percent* of the pictures it submits to clients.

Magazines

Another area where homework really pays off is among the specialized magazines. Next to textbooks, this is one of the biggest stock-photography markets. Just about every human activity is catered to by at least one magazine, and most of these publications aren't found on your average newsstand. Many are distributed to subscribers by mail or, in corporate publications, in-house. How to find them? There are a number of directories, some of which are listed in the back of this book. Probably *Photographer's Market* (which can be ordered for around thirteen dollars from Writer's Digest Books, 9933 Alliance Road, Cincinnati, OH 45242) is the best single investment you can make in market research. A new edition appears every year. The 1981 version had more than 250 pages of descriptions of specialized publications. The list is subdivided into associational publications; company magazines; consumer magazines; newspapers, tabloids, and newsletters; trade journals and business publications, and there is even a section on nonpaying publications. The *Photoletter*, a newsletter that comes out twenty-two times a year, is another good source of information for stock photographers. It supplies information about rates, whom to contact and where, deadlines, and technical considerations where applicable. It's well worth the $60 a year (write to Photosearch International, Osceola, WI 54020).

Here are some recent needs of special-interest magazines, as reported in the *Photoletter:*

☐ A Colorado leisure magazine is looking for photographs of teenage or college people canoeing on lakes or rivers, a color shot of a butterfly in the wild, a young person applying for a job, and scenes of life in a college dormitory.

☐ A family magazine in Minnesota is looking for shots of teenagers inter-

acting with each other, seventh-graders involved in sports, a family meal or celebration involving seventh-graders, and groups of teenagers walking down a path (vertical format).

□ A magazine in Ohio is looking for pictures of people in accounting-related positions, such as bookkeepers and accounting clerks, at work at these tasks or performing other job-related tasks such as conferring with co-workers, filing, typing, or working at computer terminal. Minorities should be included whenever possible.

□ A magazine with a southwestern circulation is looking for pictures of Native Americans doing clerical and secretarial duties.

□ A police magazine is looking for photographs of law-enforcement officers in "dramatic, humorous, and unusual situations."

These magazines cover a wide range of activities, but they share basic characteristics that make them good possibilities as customers for stock:

□ Most of these magazines aren't rich. They can't afford the picture rates common in national-circulation publications. Thus, they aren't able to afford the services of big-time photographers and picture agencies.

□ Many of these magazines have specialized audiences and subjects that are hard to illustrate. Since the magazines can't afford to hire photographers, they must deal with stock photographers who are interested enough in the magazine's subjects to want to photograph them. Here again, enthusiasm pays off.

□ These magazines are found all over the country. Once again, you can cultivate a local client with whom you can deal personally.

Skim through the listings in *Photographer's Market* and the other directories; you'll see special-interest and company magazines scattered in the most surprising places. These magazines don't deal with the New York crowd of photographers and agencies; they deal with people like you.

Researching the Special-Interest Market
How do you research this market? Start by going through one or more of the marketing guides and list all the magazines dealing with subjects you're interested in. Many listings mention that the magazine will send you a sample copy for a price and often that a list of guidelines for submitting material is available, too. This is money well spent, for you'll find yourself looking over magazines you never thought existed, magazines willing to consider your photographs for use—if they're top quality. Then you can target the ones you want to sell to.

Approaching Your Target
If you like what you see in a sample copy, make a list of the photographs you have and include some information about your photographic interests. Enclose some logical samples of your work as well. Send this query letter to the magazine's editor, asking if your work and the subjects you like photographing would be of any use. You aren't trying to make sales at this point; you're gathering information, getting a feel for the market. Follow up with a phone call. Ask the editor what's planned for the next few issues and what subjects are the most difficult to obtain. Did you get any ideas about potential stories or pictures from reading the sample copy? See if the editor is interested. You'll quickly find that editors are always interested in ideas because ideas turn into stories.

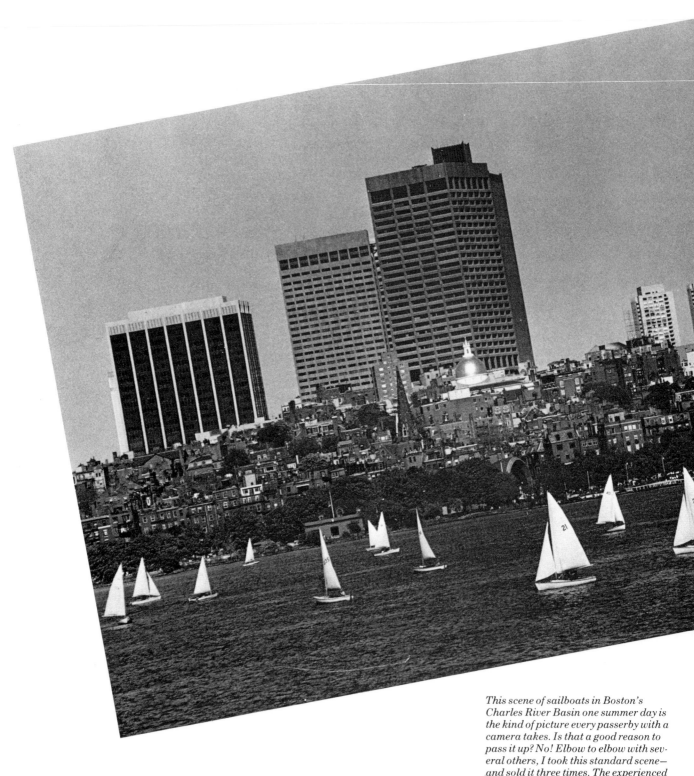

This scene of sailboats in Boston's Charles River Basin one summer day is the kind of picture every passerby with a camera takes. Is that a good reason to pass it up? No! Elbow to elbow with several others, I took this standard scene—and sold it three times. The experienced stock photographer knows that an everyday scene can still be a saleable one. This is just the kind of picture the conventionally trained photographer with an eye for the unusual overlooks. Be humble and join the ranks of the conventional photographers. Unusual doesn't necessarily mean better.

Magazine editors are willing to talk with potential contributors who they believe can produce acceptable material, but you have to do your part by investigating a publication's quality and making sure that your pictures and ideas are up to the expected standard. Editors are willing to talk, but they don't take kindly to having their time wasted. Pick your samples with care. Make sure your picture list is appropriate to the publication.

Computerized Picture Research

An interesting approach to the traditional problem of putting the right picture users in touch with the right picture suppliers has been started by Compu/Pix/Rental (C/P/R) (21822 Sherman Way, Canoga Park, CA 91303). This is a computerized reference service that matches current picture requests from a variety of publications with inventory information on member photographers. Once the publication has this information, it contacts the photographer directly to make final arrangements. If the described pictures seem to match the publication's needs, a price is agreed on.

For a $40 membership fee ($30 for members of C/P/R's parent organization, Associated Photographers International), new members are expected to fill out an informational survey sheet and submit a work sample (usually twenty color slides), which is evaluated and returned. The relevant information and subject matter are filed on the computer and suitably cross-referenced, to be matched with picture requests from member publications.

The president of C/P/R, Bert Eifer, explains that, unlike a stock-photograph agency, which routinely takes a fifty-percent commission on all work handled, C/P/R levies only a ten-percent fee on sales of members' photographs. He says his new company's targets are the estimated 23,000 small publications that can't afford the big-time picture rates, a group he wants to match with the 1,000 photographers who are currently on the computer list.

This service isn't for full-time professionals, although some do belong. Bert Eifer regards his members as the advanced amateurs who can benefit from an occasional stock sale to a publication they wouldn't otherwise know about, including those in foreign countries. Having just begun as this book was being written, Compu/Pix/Rental's coumputer-dating approach to selling stock photographs has yet to prove itself. If the idea appeals to you, write for further information.

Pick Customers You Want to Work For

Paging through *Photographer's Market*, you'll find a host of other potential stock users: poster companies, greeting-card publishers, advertising and public-relations agencies, and audio-visual firms. The selection is gigantic and at first glance intimidating. The first question you'll think of is, "How can I cover all this ground?" The answer is that you don't have to cover more than a little bit of it to make stock-photograph sales. Remember that liking what you do and enjoying doing business with your customers are more important than how much money you make. Most stock-photo sales are for less than $50, according to a successful Boston agent. Since you can't expect to get rich in this business, try enjoying it instead. In the long run that pays off, too.

Whether you deal with textbooks, magazines, or audio-visual firms, the same rules apply:

☐ Find out what's needed.
☐ Determine whether you can supply it.
☐ See if you enjoy doing business with that client (and vice versa).

Chapter Three

LOOKING FOR STOCK PHOTOGRAPHS

NOW THAT YOU have some understanding of the subjects stock-photo users want, it's time to develop the skill of seeing photographs in everyday life. This is a learnable skill, and practice makes perfect. Don't even bring a camera along. The biggest burden a photographer can be saddled with is a camera. It gets in the way of your eyes, which are the real tools of photography; if you don't *see* pictures, you won't take them. All you'll see is that mechanical contraption called a camera.

To cultivate stock-photo "seeing," start with the world around you, the world you see every day and probably don't give a second thought to. Your surroundings are full of opportunities.

Pretend to Be a Stranger

Start small. Take the street where you live and pretend you're a visitor who's seeing it for the first time. Make a list of all the things people do—the things you never noticed before. Everyday activity is raw material for an infinite number of stock photographs.

The street is the richest supply of people pictures there is. Think of Henri Cartier-Bresson, the great French photographer who has spent fifty years photographing street scenes and never seems to run out of subjects. You don't have to intrude on a street scene; just look with an educated eye.

The greatest barrier to seeing pictures in everyday life is that everything is so familiar. If you were visiting a foreign country, the everyday comings and goings of the locals would be unfamiliar to you—and interesting. Try to bring an equally fresh eye to your local world. Shake off your lifelong familiarity with it; look with a new perception.

Are all possible stock photographs to be found on the street where you live? Of course not, but there are enough to keep you photographing indefinitely. The more you sharpen your vision on your everyday world, the better photographer you'll be in more exotic surroundings. People are the Number One stock-photo subject, and people all over the world have a lot in common. The closer you look, the more you'll see the bits of human nature that will produce stock photographs in Peoria or Peking.

Boylston Street, Boston—but this could be a street anywhere. What's important to realize is that the goings-on of the average street can supply an infinite number of stock photographs. The biggest sellers are selected scenes of the everyday life that goes on all around us.

The Art of Looking

You're not looking for fine or graphic art. Some photographers have the idea that every time they click a shutter they're supposed to produce art. Not only is this impossible; it's unnecessary. Stock photographers aren't in the art business but in the communication business. Art reflects the feelings of the artist. A good stock photograph expresses something about the subject; it's a useful image for someone who needs to make a point. Forget about Art. Think about people—stock subjects and stock clients. The artistry is in your powers of observation.

Even forget about being a photographer. Think of all that research you've done. Try walking down the street as if you were a picture researcher, grabbing useful subjects with your eyes and pruning away the excess imagery.

Bring Along a Want-List

Bring a stock photograph want-list with you, either one you've gotten from a publisher or one you've extrapolated from textbooks or magazines you've examined. See how many of the entries on the list you can fill from the activities you see. Try reversing this approach: Make notes about the scenes you observe and compare them with that want-list.

Let's think how some typical street scenes might produce useful stock photographs.

Children are ideal stock subjects. They're more open about their feelings than adults, and as a result they act them out more. Their activities are high on many want-lists.

Look at the average group of children playing outdoors. Is it just a crowd? Look closely. What kinds of games are they playing? Are the girls playing with the boys, or are the two sexes playing separately? Are the young mixing with older children? Are any children not mixing at all? Do they appear sad or rejected? How about minority children? Are they accepted or rejected by the group? Who's leading the group? Do some children appear to be falling into leader or follower status? Are any children crying or fighting?

These questions open up endless possibilities for stock photographs of the human dynamics that are the subjects of many sociology, psychology, and child-development textbooks and magazines. In that crowd of playing children there are pictures to keep you busy all day. Try scribbling down a list of all the ideas being illustrated by this interaction, then compare the list with published stock photographs. You'll see a lot of similarities.

Look with a sociological eye. Watch for everyday municipal services. How about the letter carrier? Is it a man or a woman? Garbage collection is something you might overlook, but you'll see lots of requests for pictures of it to illustrate urban-planning textbooks and magazines. How about police directing traffic? That's a want-list classic. There are variations on this: a woman crossing guard near a school, a policeman handling traffic at a major intersection. A woman at a major intersection is yet a third picture. You'll probably find all three on someone's want-list.

Keep looking for details. Stock photographs are clear and direct. They are usually used to express *one* thought, *one* idea. They're not expected to be subtle. Therefore, the more carefully you concentrate on specific details, the better your stock photographs will be. Think of all the ideas on the want-lists you've seen. What details do you see that will express them visually? What's the simplest way to make those points in a picture?

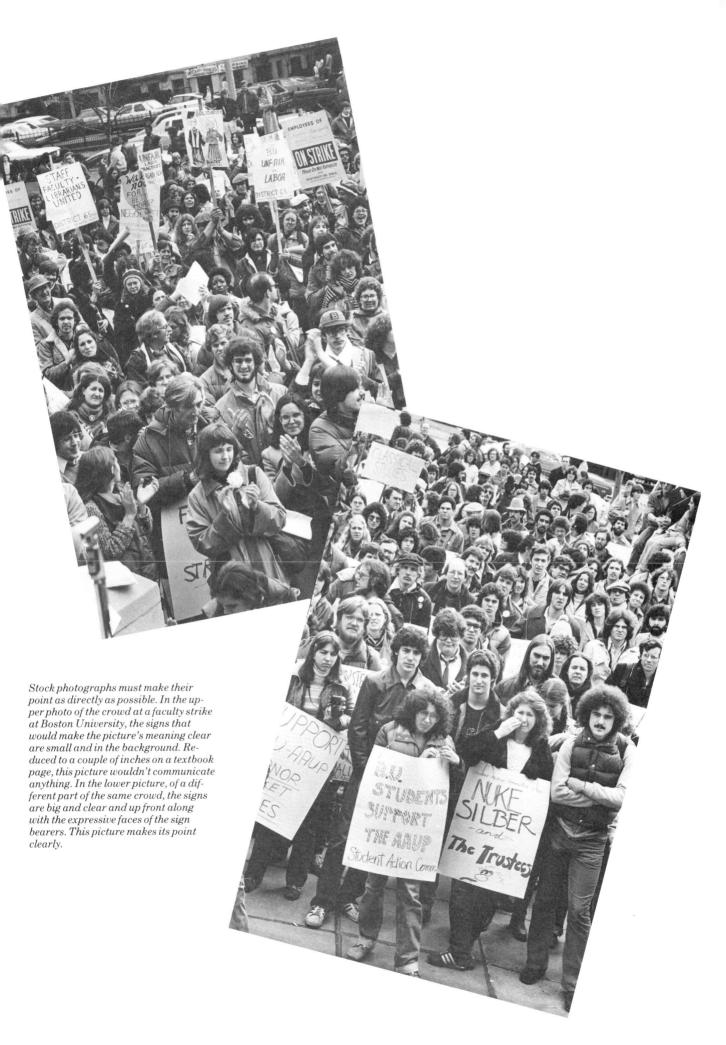

Stock photographs must make their point as directly as possible. In the upper photo of the crowd at a faculty strike at Boston University, the signs that would make the picture's meaning clear are small and in the background. Reduced to a couple of inches on a textbook page, this picture wouldn't communicate anything. In the lower picture, of a different part of the same crowd, the signs are big and clear and up front along with the expressive faces of the sign bearers. This picture makes its point clearly.

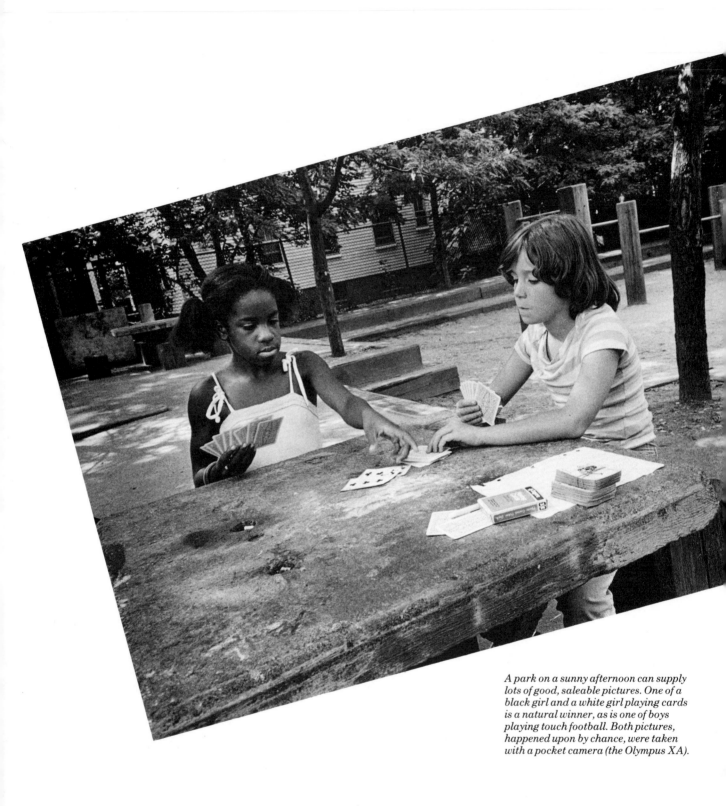

A park on a sunny afternoon can supply lots of good, saleable pictures. One of a black girl and a white girl playing cards is a natural winner, as is one of boys playing touch football. Both pictures, happened upon by chance, were taken with a pocket camera (the Olympus XA).

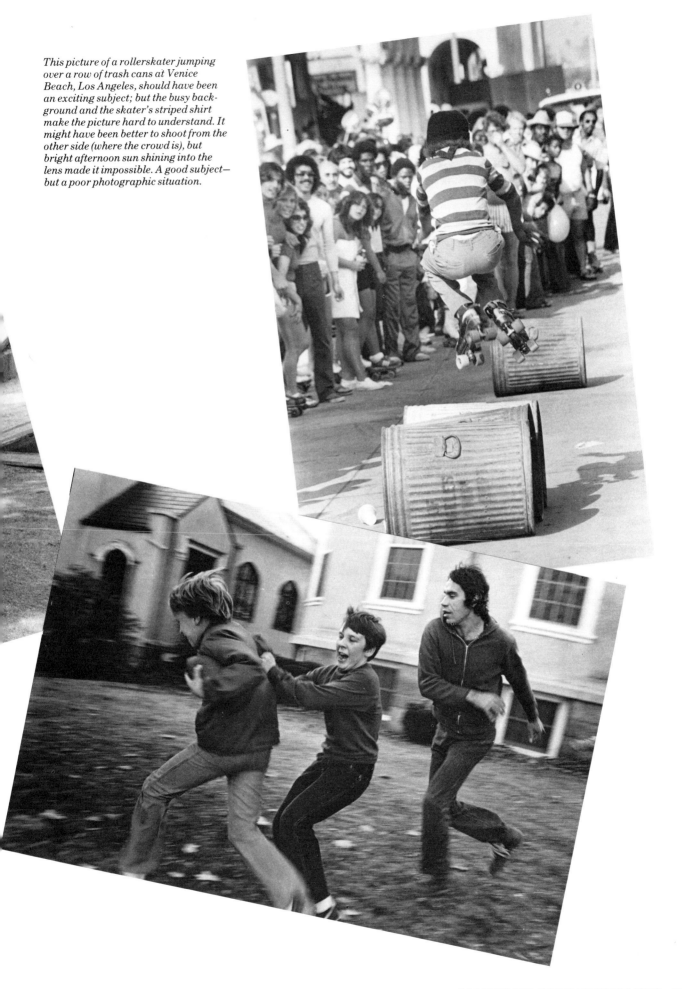

This picture of a rollerskater jumping over a row of trash cans at Venice Beach, Los Angeles, should have been an exciting subject; but the busy background and the skater's striped shirt make the picture hard to understand. It might have been better to shoot from the other side (where the crowd is), but bright afternoon sun shining into the lens made it impossible. A good subject— but a poor photographic situation.

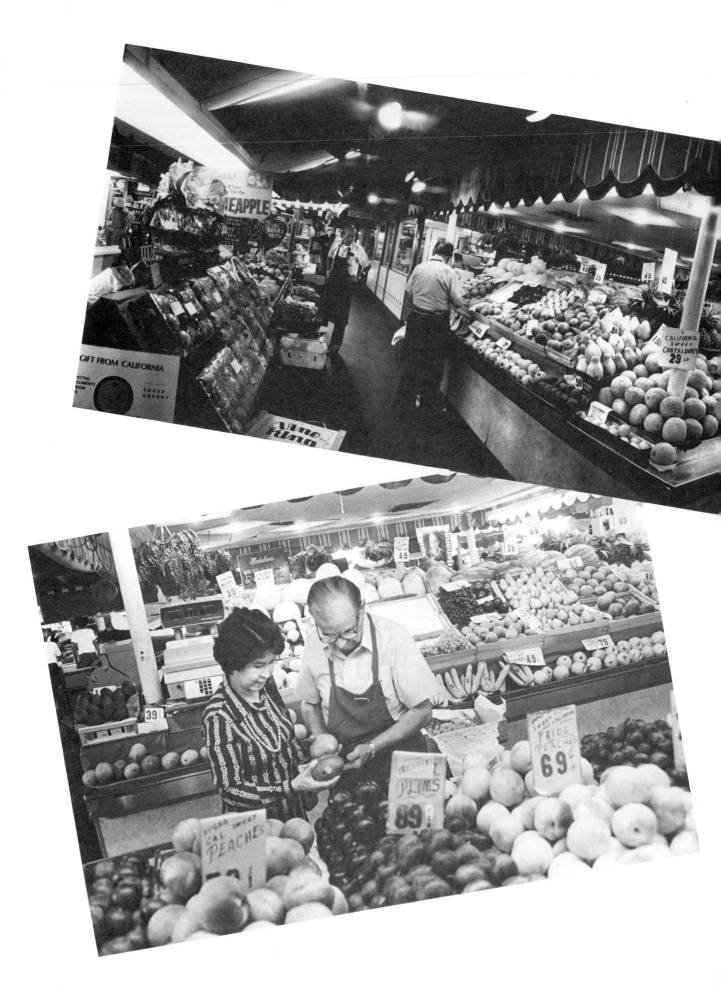

Useful details are everywhere. A broken parking meter or a car with a dented fender would be useful in a book on traffic control. Houses in good (or bad) repair could sell to urban-planning or sociological publications. Try looking at something as simple as a cracked sidewalk and thinking of all the ideas it could illustrate: bad urban planning, sidewalk safety, frost heaves, the decline of a neighborhood, or perhaps even an abstract close-up for a psychology textbook.

Picture-seeing is like a treasure hunt. Think of all the ideas any single subject might express. Turn this around and think of as many ways as you can to express the same idea. Loneliness or alienation, a common subject in books and magazines, could be expressed by a child standing apart from a crowd, a lone house in an empty street, a series of dilapidated mailboxes with only one name showing, or even a wide-angle shot of a single figure in gray, barren surroundings. Look for images that express a common idea: These are the pictures that sell.

Don't overlook the obvious. You've probably walked past the local city hall a hundred times without taking a picture of it. Lots of chambers of commerce would ask for just such a scene. What are the notable scenes in your town? The parks? The shopping streets? There are picture researchers who say that these easily overlooked scenes are the hardest to find. Yet they are the easiest to shoot. Don't say you will "take a picture of it someday." The photographer who does not put off taking photographs is the photographer who builds stock and makes sales.

Sidewalk activities offer good stock subjects. How about window displays and window shoppers? Lots of books and magazines on merchandising need such pictures. What are passersby doing? Conversations always make for pictures, especially when they're between people of different ages or races. A mother with an impatient child makes a good picture, and a father in the same situation makes another. Shoppers loaded with packages are subjects for a dozen potential stock sales, illustrating themes from merchandising to physical safety. Are there any handicapped people? If they're going about everyday life along with unhandicapped people, you've got a real winner of a stock photograph.

How about signs? Communication is a subject covered by hundreds of publications. Signs in a foreign language juxtaposed with English-language signs can sell to language texts as well as sociology books. Signs of sales in supermarket windows would interest picture researchers for both grocery retailing and home-economics publications. Signs advertising special services for any particular group support ideas that are often expressed in print.

Think about current trends in everyday activities. How about a restaurant catering to vegetarians, natural-foods buffs, or dieters? How about signs expressing increased energy costs—a perennial topic in books and magazines?

Signs can also express abstract ideas. A complicated signpost with arrows pointing off in many different directions could illustrate confusion in a psychology textbook as easily as it could be used by the local chamber of commerce to describe the different attractions of the town. A car covered with political bumper stickers could illustrate the diversity of American political parties. A grammatically incorrect sign could express the concept of poor education.

There's more than one way to photograph most subjects. The enormous Farmer's Market in Los Angeles seemed a natural for the super-wide-angle panoramic lens, but a close-up of a housewife buying vegetables looked to be an equally valid approach. It was only necessary to move a few feet and use a different camera and lens.

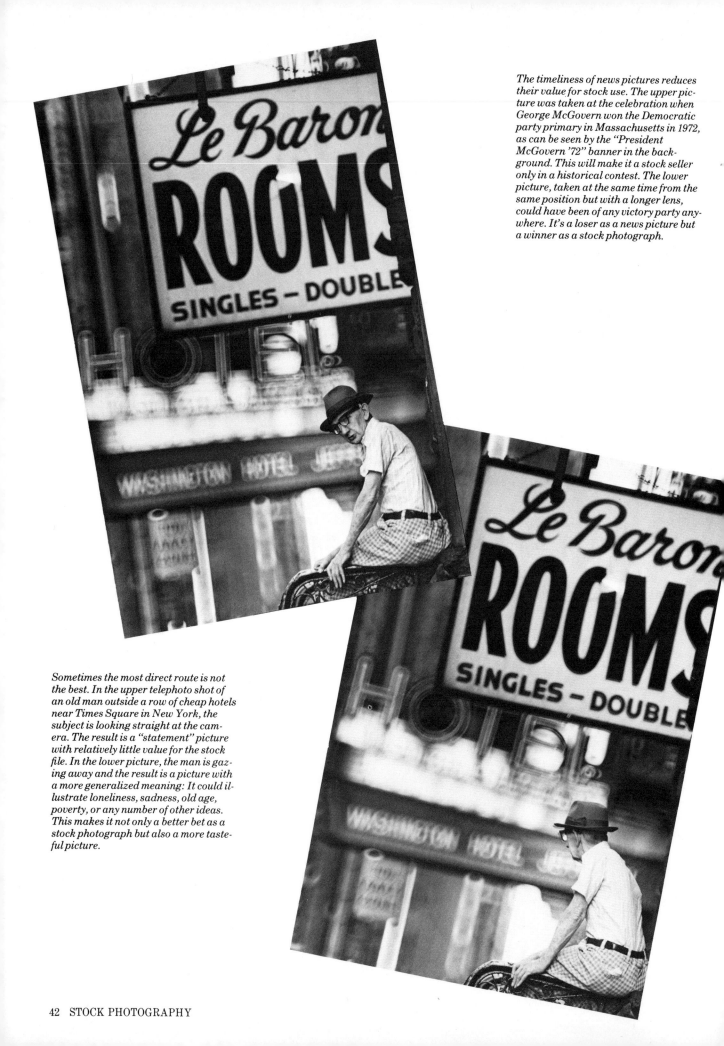

The timeliness of news pictures reduces their value for stock use. The upper picture was taken at the celebration when George McGovern won the Democratic party primary in Massachusetts in 1972, as can be seen by the "President McGovern '72" banner in the background. This will make it a stock seller only in a historical contest. The lower picture, taken at the same time from the same position but with a longer lens, could have been of any victory party anywhere. It's a loser as a news picture but a winner as a stock photograph.

Sometimes the most direct route is not the best. In the upper telephoto shot of an old man outside a row of cheap hotels near Times Square in New York, the subject is looking straight at the camera. The result is a "statement" picture with relatively little value for the stock file. In the lower picture, the man is gazing away and the result is a picture with a more generalized meaning: It could illustrate loneliness, sadness, old age, poverty, or any number of other ideas. This makes it not only a better bet as a stock photograph but also a more tasteful picture.

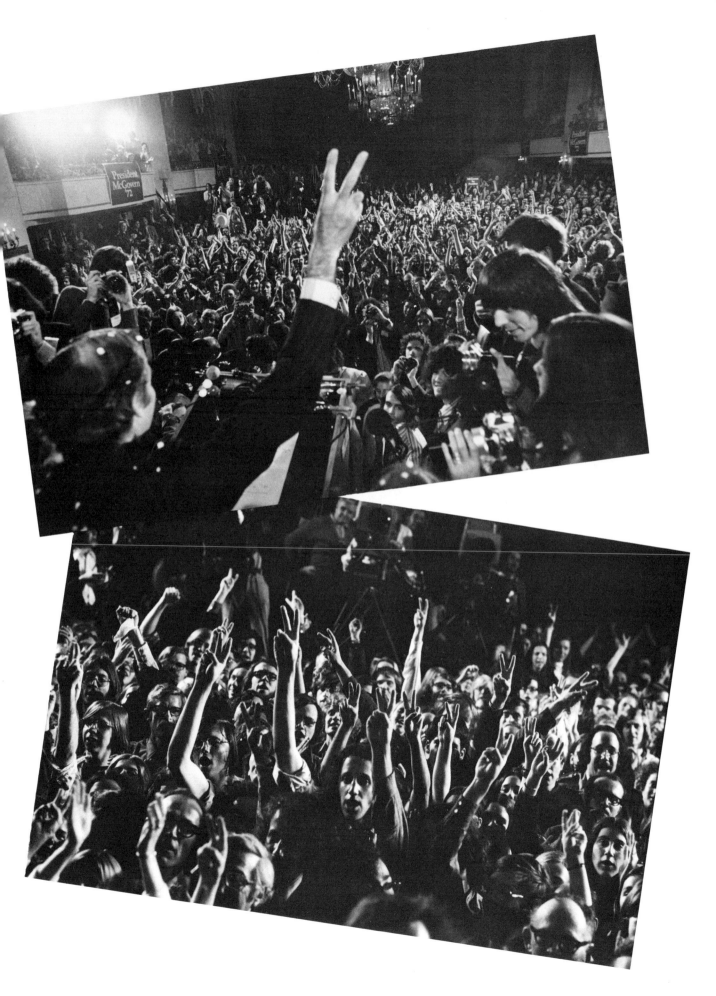

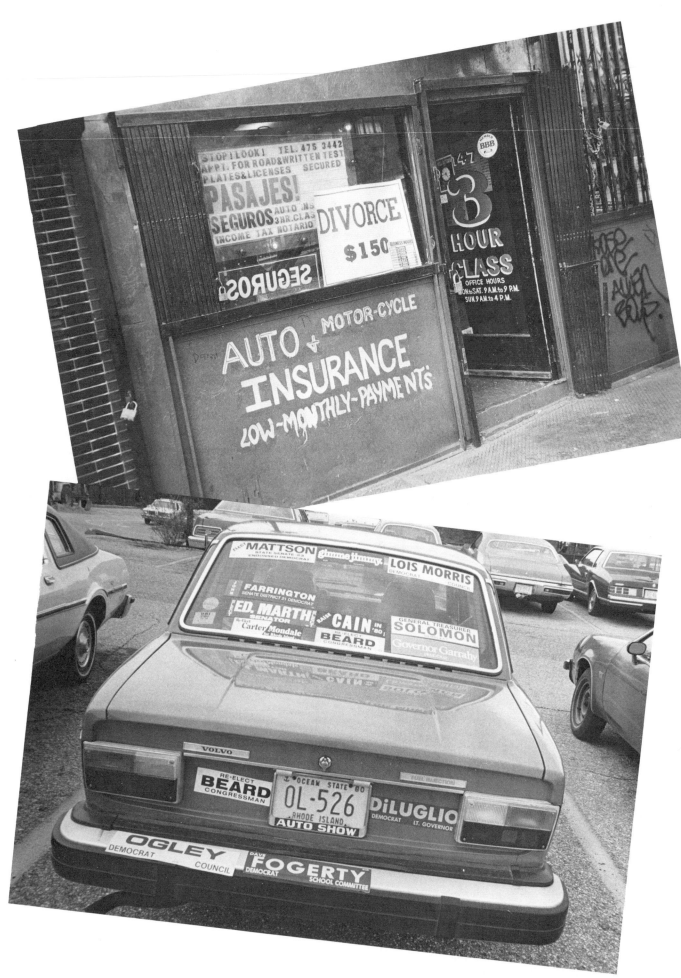

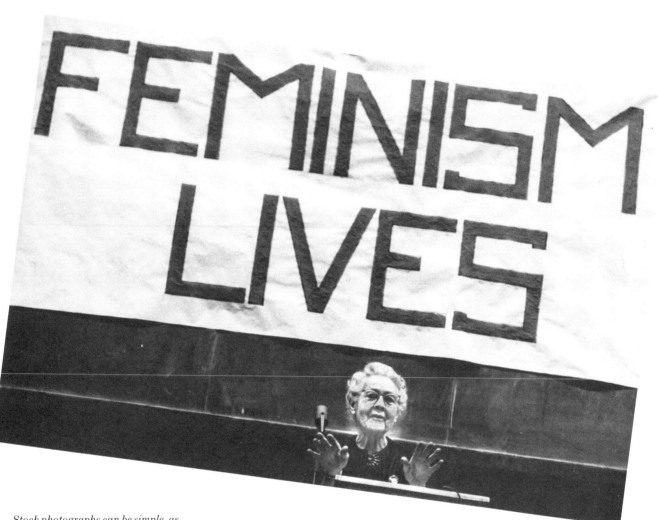

Stock photographs can be simple, as long as that simplicity makes the meaning clearer.

On the opposite page, *two pictures of signs—one on Houston Street in New York City, the other in a parking lot in North Kingston, Rhode Island—both make the point of many ideas and many occupations without the need for more elaborate visual treatment. Although as photography they are routine, as stock they are effective examples of visual perception.*

Above, *the message of the single sign is even clearer. Taken at a feminist meeting in the early 1970s, this picture was a big seller for a while. It is very topical, though, and hasn't sold once in the last few years. The tastes of stock-photo buyers reflect the times, and trendy subjects can't be expected to keep selling indefinitely.*

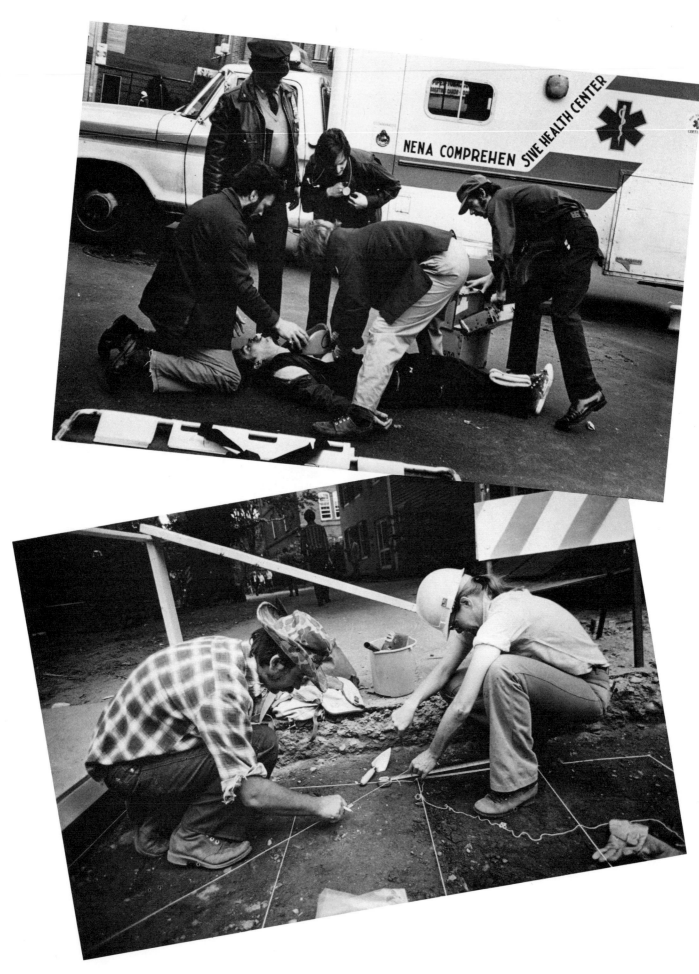

Stock Photography Don'ts

In all these picture ideas, some thoughts remain central to the successful stock-photography approach. Remember some of the things a stock photograph is usually *not* expected to do.

☐ *Stock photographs aren't supposed to take sides.* You're selling an abstract idea, not a personal statement. If you spend your time looking for illustrations of strong opinions, you'll miss a lot of saleable photographs. Stock photographs are visual properties, not support for partisan points.

☐ *Stock photographs don't usually go over well when they take a strongly negative point of view.* Most textbooks and magazines tend to take a *positive* stance in those areas where stock photographs will be used. Even where the subject is an unhappy one, the approach should be constructive. Therefore, stay away from the ugly, the abused, and the extremely unhappy. Whether or not you feel that photographing people in such situations is justified, you can be sure that stock-photo researchers won't be interested in them. Those are subjects for professionals on specific assignments. Keep your strong opinions to yourself when you look for *stock* photographs. (This does *not* include everyday tears, stress, or problems, as we shall see in the next chapter.)

☐ *A stock photograph must be complete in itself.* Stock photographs are seldom sold as a series, and you can't expect one picture to depend on another to complete its point, as it would in a photographic essay. Always work on the assumption that each picture will stand alone.

Stock photographs can be found almost everywhere, but the street is where most successful stock photographers go when they want to be surrounded by an endless supply of subjects. The more you sharpen your perception, the more you will find to photograph on any street in the world.

Opposite, above: *Strolling on an errand in New York one day, I happened on this car-accident scene. Using my pocket camera, I made a lot of pictures of the paramedical team in action; later these were sold for use in a textbook on public health. If I had been looking for this picture, I'd never have found it; having a camera handy routinely seems to make me lucky. Notice how clearly you can see what each person is doing. It's important to show what the picture is about.*

Opposite, below: *Happening on this pair of hard-hats laying out a sidewalk in Harvard Square, Cambridge, Massachusetts, I took a few quick pictures with my pocket camera. Once again, it's not great photography; but the man and the woman in similar poses make for an effective statement on the new presence of women in the construction trades.*

This page: *While this sow in the wallow might be of interest to a farmer, it's too gross a subject for worthwhile stock-photo shooting. Avoid truly ugly subjects; you'll find choices of subject matter for stock files tend toward neutral to mildly positive.*

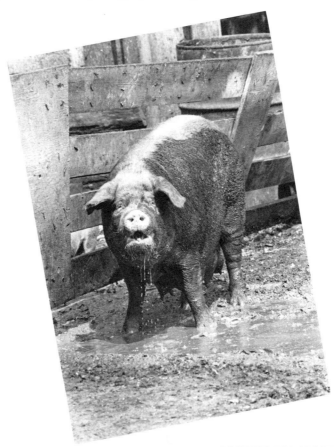

Chapter Four

FAMILY STOCK PHOTOGRAPHS

THE FAMILY REPRESENTS a cross section of life, and family life is one of the biggest stock photograph sellers. It's a subject everyone has access to, one that you can never take enough pictures of.

Should you photograph your own family or someone elese's? There's no reason you can't do both, but you'll find that photographing a family other than your own has certain advantages.

☐ As an outsider, you'll see pictures an insider would overlook.

☐ The family you photograph won't have one member missing—you, behind the camera.

☐ You'll be less likely to be drawn into family interactions that you would do better to photograph than to participate in.

On the other hand, lots of pictures develop at a moment's notice in your own home. They're stock-photography winners, too. The best approach is a compromise: Keep a camera handy around the house but make it your business to scout out other families in your neighborhood.

Research Your Market

What's the ideal photographic family?

Young children having a good time are always worth photographing, however conventional the picture may seem. This little boy in a playground in Dorchester, Massachusetts, was no exception. If you look at the figures in this picture, though, you'll see a problem photographers often encounter when working with children: Everyone is looking straight at the camera. Fortunately, the foreground figure is too happy to stare. When you photograph children, you have to shoot fast—they'll perceive any hesitation on your part, and their stares will ruin your pictures, more often than not.

There isn't one, because the market for family photographs is so big. At one extreme are religious publications and greeting-card companies looking for idealized scenes of family life—happy couples, smiling babies, and Christmas-tree scenes. At the other end are psychology textbooks whose picture research staffs complain that they can't get a selection of family scenes that look "really real," showing tension and anger along with the happier aspects.

Do some research on the family stock photography market, giving some thought to the approaches you'd enjoy taking. If you're interested in idealized family scenes, you'll need a family that looks the part. The better behaved everyone is, the more pictures you'll get. If you're inclined to the photojournalistic approach favored for psychology textbooks, you'll want a family that is not

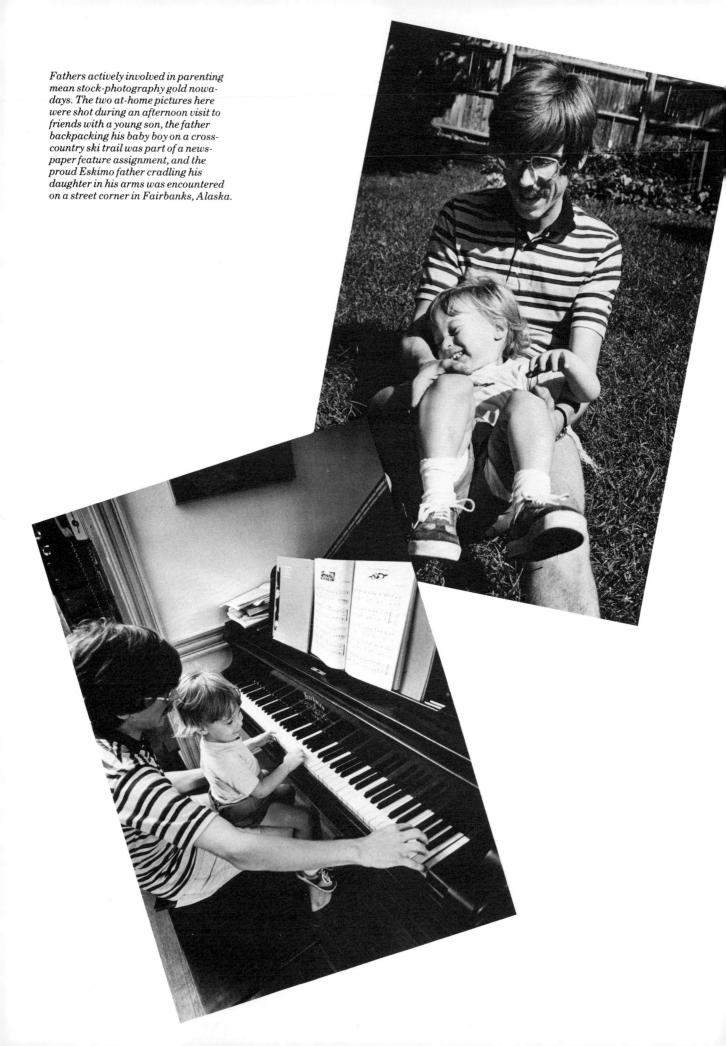

Fathers actively involved in parenting mean stock-photography gold nowadays. The two at-home pictures here were shot during an afternoon visit to friends with a young son, the father backpacking his baby boy on a cross-country ski trail was part of a newspaper feature assignment, and the proud Eskimo father cradling his daughter in his arms was encountered on a street corner in Fairbanks, Alaska.

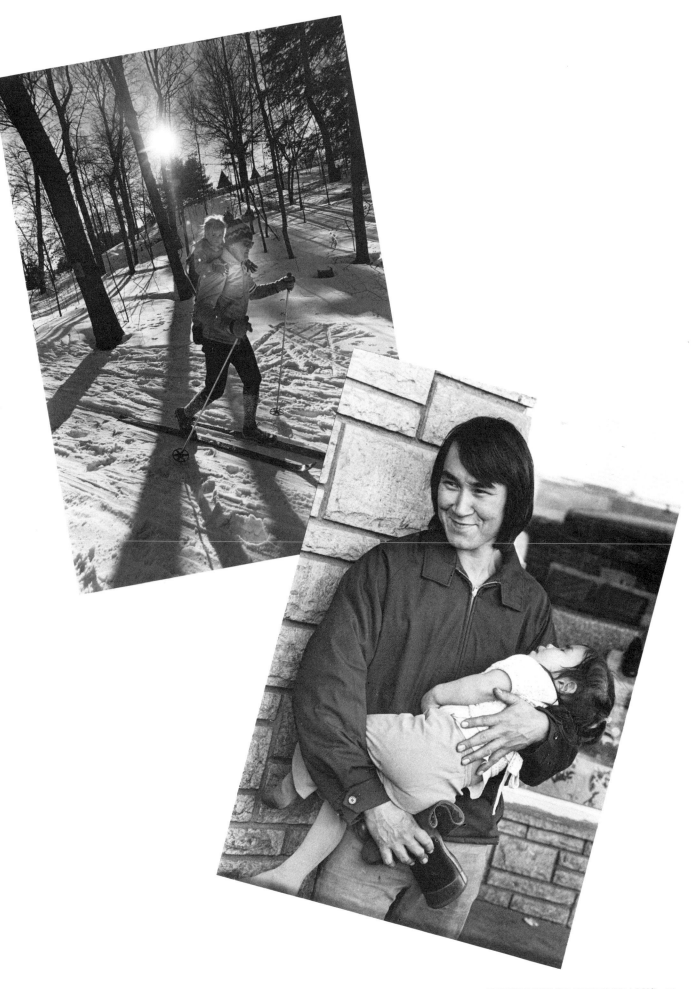

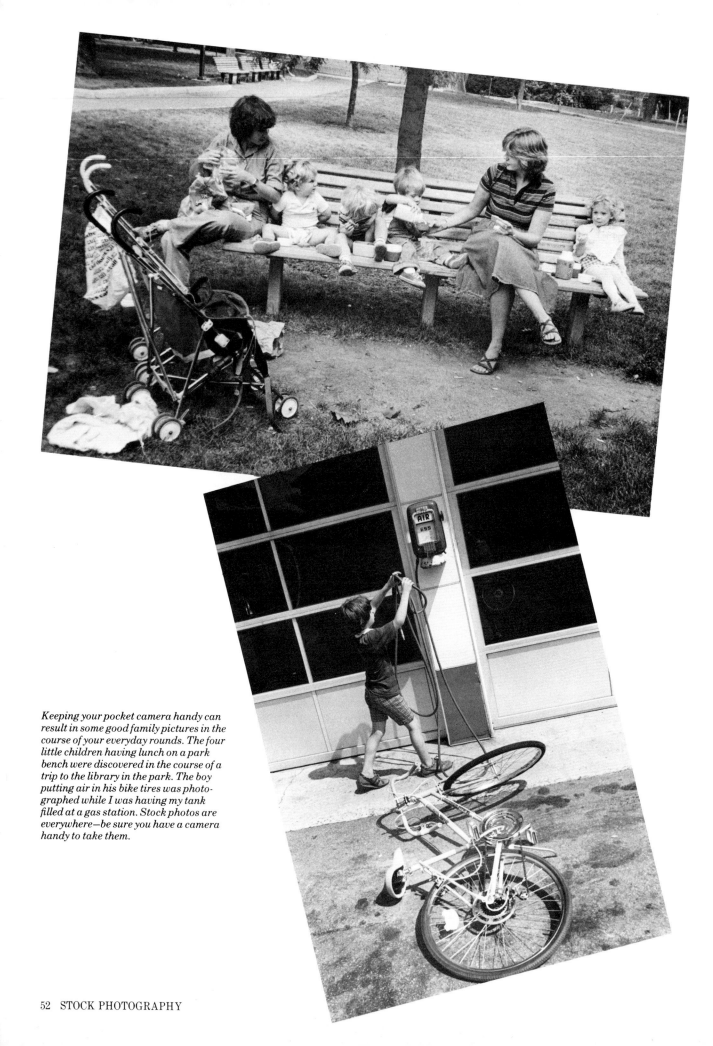

Keeping your pocket camera handy can result in some good family pictures in the course of your everyday rounds. The four little children having lunch on a park bench were discovered in the course of a trip to the library in the park. The boy putting air in his bike tires was photographed while I was having my tank filled at a gas station. Stock photos are everywhere—be sure you have a camera handy to take them.

only expressive but also willing to have you around when things get unpleasant—a family you know well and whose members trust you.

Photogenic Families

What are some desirable characteristics for a "stock-photo family"?

Cooperation: Family members must be willing to have you around. If you expect to force yourself on any family and get good pictures, you're mistaken. The ideal situation is when your presence isn't even noticed. Be assured of a warm welcome before picking up a camera.

The house: The home must lend itself to quality photography. A tiny house where you can't back up enough to shoot good pictures is a waste of time—unless you're looking specifically for unpleasant pictures (which usually don't sell anyway, as was pointed out in the previous chapter). A messy house is just as undesirable. People may not notice a pile of laundry or an uncleared table in the home they live in every day; but freeze that scene in a picture, and that's all a viewer will notice—to the detriment of whatever activity is being shown. If you have to, do some straightening up before you start to shoot. It'll pay off in better pictures. (You'll make a lot of friends doing this, too!)

Limited action area. Look for a home where a good deal of action can be expected to take place in one or two locations. When you're working indoors, you'll probably be working with aritifcial light. If you have to arrange lighting in more than one or two areas, you'll be spending too much time fussing with lights and that much less time taking pictures.

Variety of ages. A family with a wide range of ages can be expected to produce that many more good pictures of family life. If a grandparent lives with the family, so much the better. If the children are of different ages and sexes, you'll have more to photograph.

Good looks. The family should be attractive and expressive. Such people will be more amenable to letting you take pictures of them, and they'll produce better pictures as a result.

It makes good sense to offer all the prints the family wants in return for being allowed to photograph them. Few families would turn down the chance to get professional-quality pictures of themselves for nothing. It also makes sense to offer to take the photographs at times of their choosing, such as on holidays when visitors are expected (although you should plan to attend such stock-photograph-rich occasions, anyway—we'll come to that in a moment). It's also elementary courtesy not to overstay your welcome. No matter how inconspicuous you try to be, your presence will be noticeable.

Photograph Several Families

Seek out several families to photograph. Not only will this give you more choice of subject matter, but it will also give you a choice of family types. The nuclear family is only one subject. Lots of textbooks and magazines are interested in single-parent families, families with one child, adopted children (especially when they're of a different race), and noticeably old or young parents. The stock photograph market doesn't deal just with norms: It's the uncommon variation on a common theme that is the hardest for a picture researcher to find. If you want to make textbook sales, look for such anomalies.

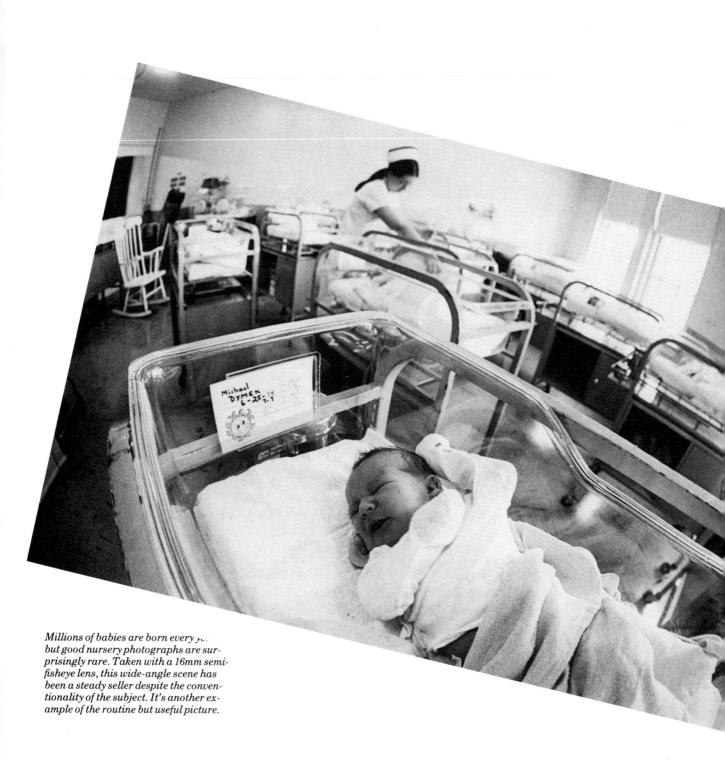

*Millions of babies are born every year
but good nursery photographs are sur-
prisingly rare. Taken with a 16mm semi-
fisheye lens, this wide-angle scene has
been a steady seller despite the conven-
tionality of the subject. It's another ex-
ample of the routine but useful picture.*

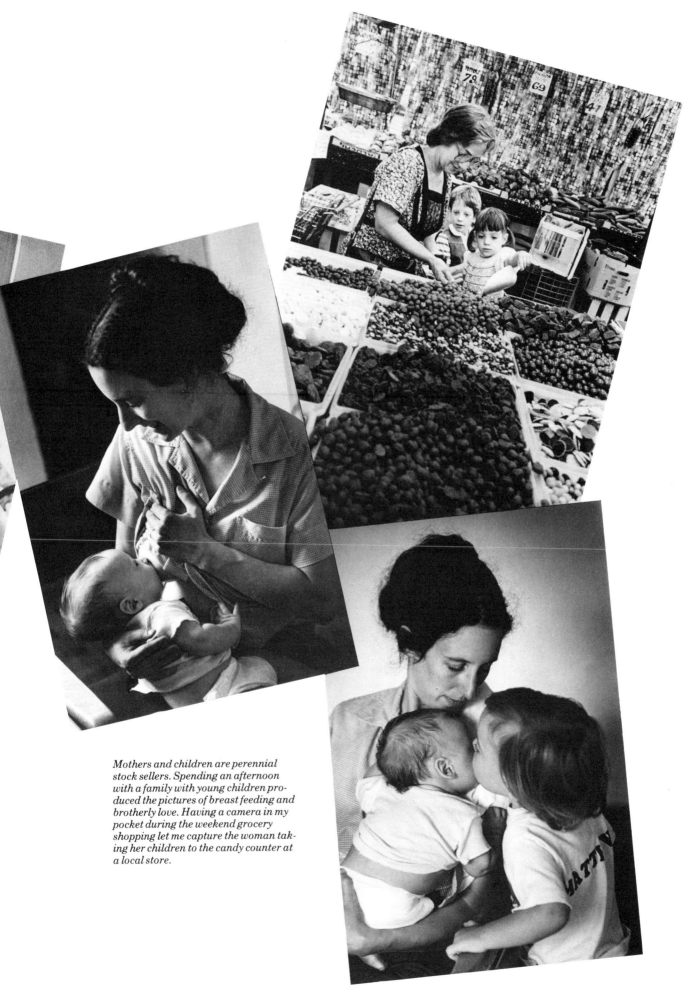

Mothers and children are perennial stock sellers. Spending an afternoon with a family with young children produced the pictures of breast feeding and brotherly love. Having a camera in my pocket during the weekend grocery shopping let me capture the woman taking her children to the candy counter at a local store.

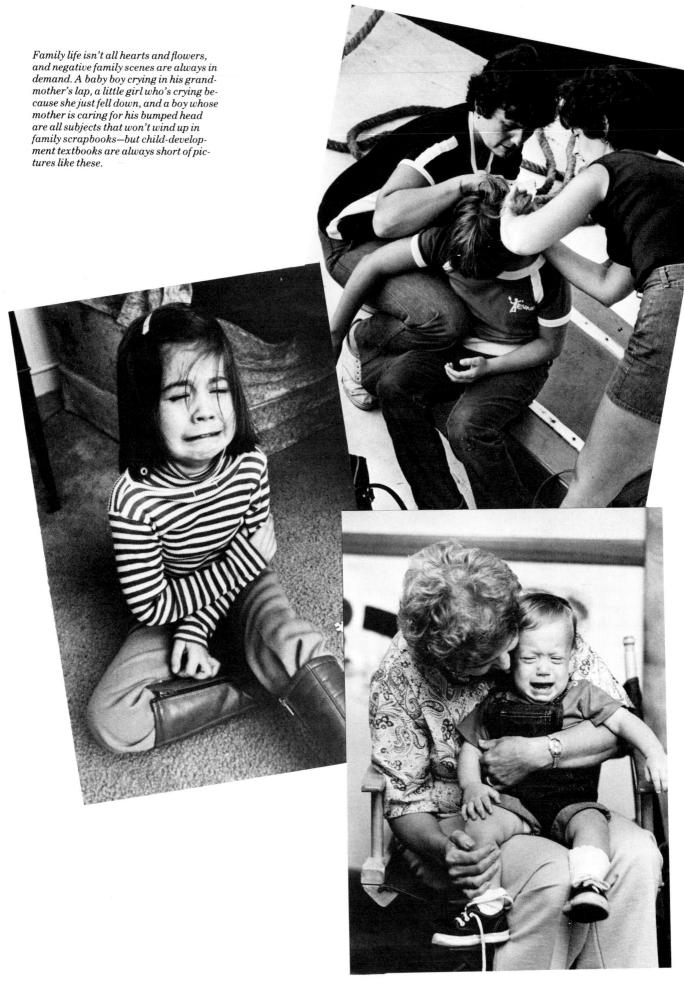

Family life isn't all hearts and flowers, and negative family scenes are always in demand. A baby boy crying in his grandmother's lap, a little girl who's crying because she just fell down, and a boy whose mother is caring for his bumped head are all subjects that won't wind up in family scrapbooks—but child-development textbooks are always short of pictures like these.

Photogenic Situations

Although you could probably spend every day photographing a family and continue to get useful pictures, it's a better idea to plan to be present when a family is most likely to produce good stock photographs.

Special Occasions

Holidays. Holidays are often productive of good stock photographs. If you're looking for idealized family pictures, such standbys as the family gathered for Thanksgiving dinner or opening presents around the Christmas tree are always worth shooting again. Family holiday gatherings usually produce some friction and unhappiness as well; photographs showing these emotions can be sold in the textbook market.

Homecomings or departures. Any out-of-the-ordinary situation is likely to produce useful stock photographs. Normal life is disrupted, producing sadness or happiness—usually both. The occasion might be a child packing up to go away—to camp or to college—or a youth graduating from high school or college, or coming home from military service.

Times of family significance. Weddings, birthdays, and anniversaries come under this heading. These are occasions when the family ranks are drawn together. The results, both good and bad, make good stock situations.

These recommendations are for what are traditionally regarded as special occasions, but this doesn't mean that just an ordinary day or two in the life of a family isn't also good subject matter. Everyday family life is a big textbook seller. What are some objects to look for?

Important Subjects

Emotions expressed openly. Whether positive or negative, these feelings are traditional subjects, and therefore appropriate for stock photography. Bear in mind that *negative* emotions, such as children's tantrums, are always in demand for child-development and psychology textbooks. Don't put down your camera when things get out of hand—too many other photographers do.

Scenes of every day. Such simple tasks as cooking dinner or doing the laundry are good stock subjects. Lots of textbooks for younger readers are written to familiarize children with the details of life, which older people take for granted. Subjects such as the family shopping or taking the kids to the doctor's or dentist's are in steady demand.

Changing norms in family life. Family life isn't all clichés. It's changing nowadays, and publications need contemporary illustrations of it. For example, a religious publication was recently looking for pictures to illustrate sterility in marriage (the example given was husband and wife standing over an empty crib), family members giving each other the cold shoulder, and the loneliness of divorced men. Sex and drugs among teenagers are becoming legitimate stock subjects for older audiences, as long as they are photographed discreetly. Picture researchers often have to plow through huge numbers of idealized family scenes to illustrate a problem area a publication may be discussing. Still, remember that the photographer's attitude should be positive rather than voyeuristic.

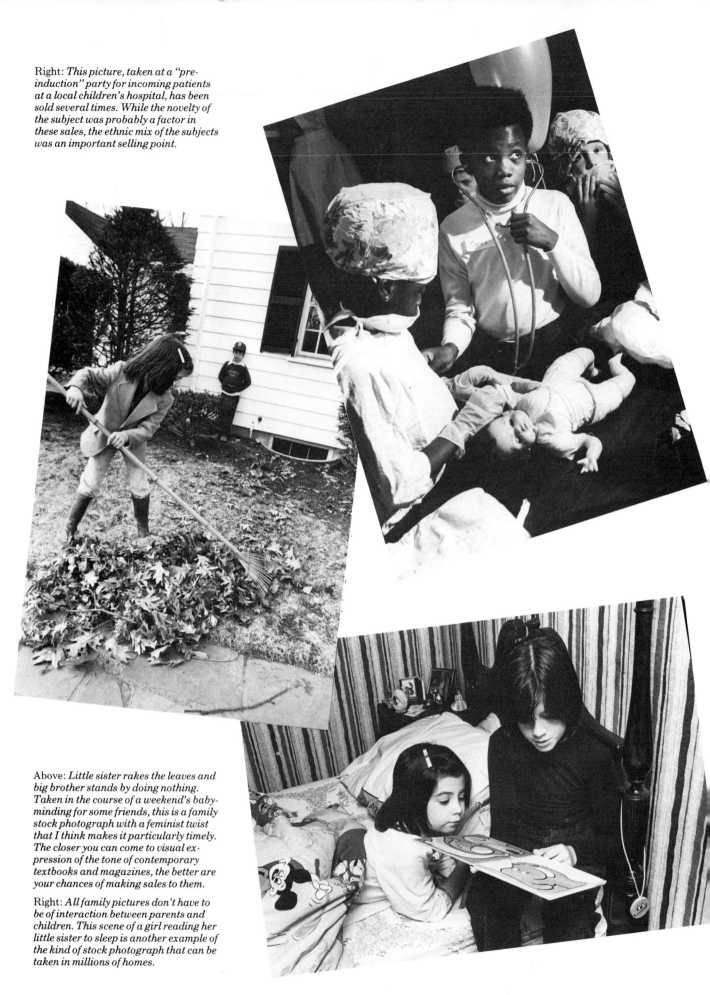

Right: *This picture, taken at a "pre-induction" party for incoming patients at a local children's hospital, has been sold several times. While the novelty of the subject was probably a factor in these sales, the ethnic mix of the subjects was an important selling point.*

Above: *Little sister rakes the leaves and big brother stands by doing nothing. Taken in the course of a weekend's baby-minding for some friends, this is a family stock photograph with a feminist twist that I think makes it particularly timely. The closer you can come to visual expression of the tone of contemporary textbooks and magazines, the better are your chances of making sales to them.*

Right: *All family pictures don't have to be of interaction between parents and children. This scene of a girl reading her little sister to sleep is another example of the kind of stock photograph that can be taken in millions of homes.*

Friendship and closeness can be expressed in many subtle ways. This little girl holding onto her playmate as they cross a Boston street is an example. The closer you look at details of such expressions, the more stock photographs you will see.

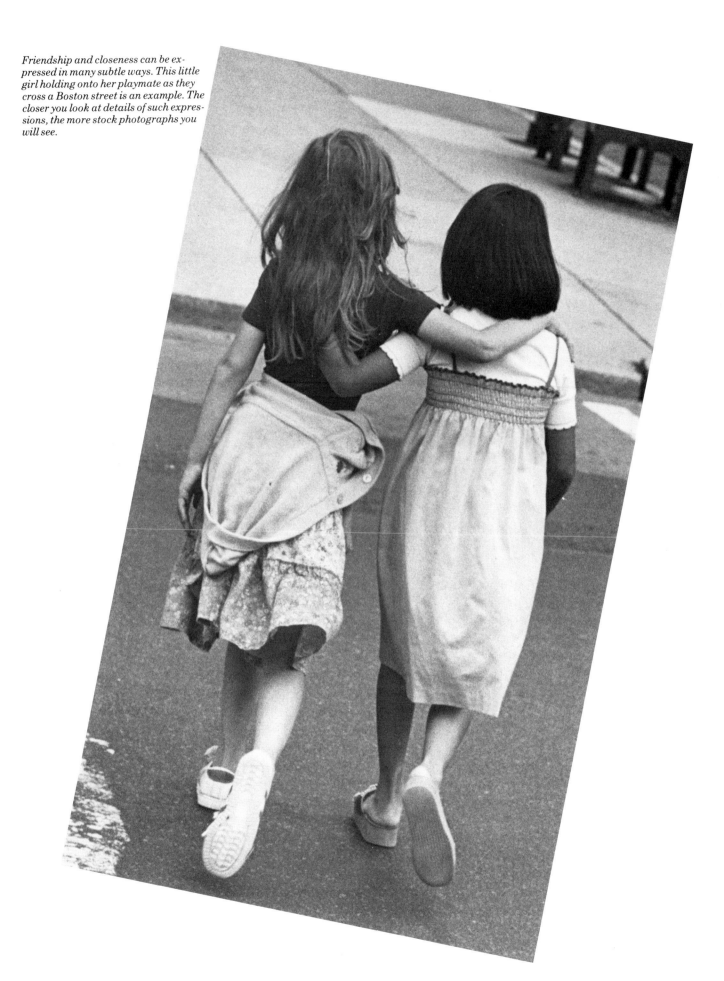

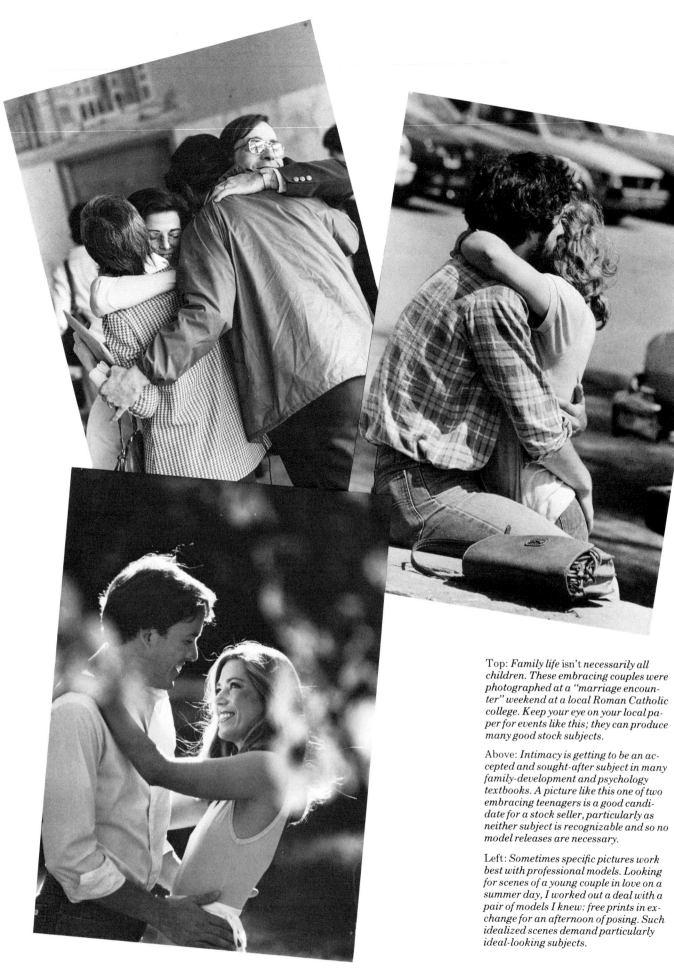

Top: *Family life* isn't *necessarily all children. These embracing couples were photographed at a "marriage encounter" weekend at a local Roman Catholic college. Keep your eye on your local paper for events like this; they can produce many good stock subjects.*

Above: *Intimacy is getting to be an accepted and sought-after subject in many family-development and psychology textbooks. A picture like this one of two embracing teenagers is a good candidate for a stock seller, particularly as neither subject is recognizable and so no model releases are necessary.*

Left: *Sometimes specific pictures work best with professional models. Looking for scenes of a young couple in love on a summer day, I worked out a deal with a pair of models I knew: free prints in exchange for an afternoon of posing. Such idealized scenes demand particularly ideal-looking subjects.*

View From Your Client's Perspective

Try putting yourself in the position of the publication's readers. If you want to sell to publishers of books for young children, look at family life from a child's point of view. It's different from the way you're accustomed to seeing family activities, and it suggests different photographs from those that would be appropriate for a psychology textbook for high school or college readers. A greeting card is expected to make its recipient happy. If you're intersted in this market, think of family scenes that could convey happiness—a soft-focus shot of a mother and her child, a family having a candlelight dinner, or a family going to church.

Family scenes for different-aged viewers also have to be varied in comprehension level. When your intended audience is young children, stick to simple subjects a child could be expected to understand: parents doing some household chore, an activity a child might be curious about, such as washing the car, or simply a colorful scene like a Christmas tree that a child would enjoy looking at. Captions are useless to viewers who can't read; the picture must express the idea on its own.

The same considerations are involved in greeting-card sales. Here again you can't expect to explain anything with a caption. The picture will be used to support a standardized sentiment printed inside the card. Only in textbook shooting will you have the luxury of a caption to explain content, and even that isn't much help for an unexpressive picture. Captions can only amplify existing picture content.

Where do you start?

You don't have to travel to exotic lands to find stock photographs. You don't even have to leave your own home. The family you're a part of is an inexhaustible supply of subjects with a huge potential market, whether your photographic tastes run to the realistic or the romantic. Some successful stock photographers shoot nothing but family life. They've found that the closer they look, the more pictures there are to take. Try polishing your photographic "seeing" at home.

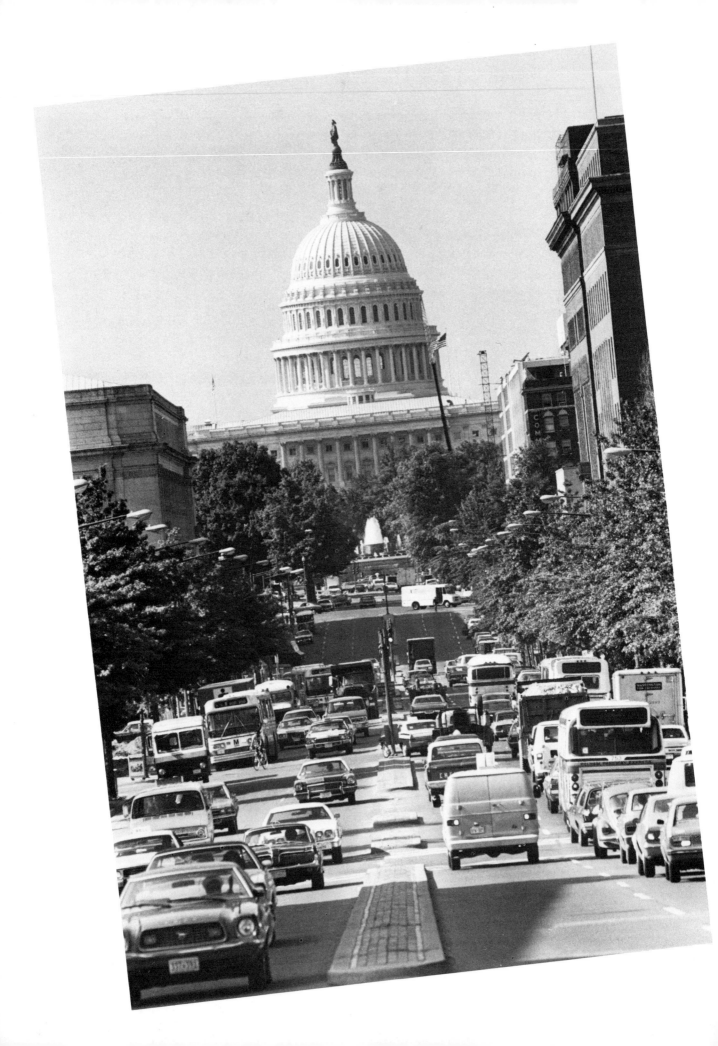

Chapter Five

STOCK PHOTOGRAPHS ON VACATION

YOU CAN FIND stock photographs around the corner or around the world. If the idea of making your vacation trips pay is appealing, stock photography is a way to do it.

Just as important as making money on vacation-shot stock photographs is the opportunity you will have to see more of the places you visit and meet the kinds of people tourists don't usually have any contact with. The average tourist experience is superficial. Successful shooting for stock is just the opposite: The more you know about your destination and the more carefully you plan your photography, the more productive and memorable the trip.

Given the short time you will have to photograph on a vacation, planning is particularly important. You'll be approaching your vacation destination with a fresh eye, and, while that makes it easier to spot stock material, it can also make you vulnerable to being carried away by superficial subjects. When you know in advance what subjects are most likely to sell, you can head straight for them.

What's Your Market?

Who buys vacation stock photographs? Two big users are publishers of travel pictures, such as brochures and travel magazines, and textbooks that need scenes of foreign countries. Before you pack your bag, do some research into these markets; their needs are quite different.

Textbook Pictures Look Alike

When you look over textbooks relating to the country you're headed for, you'll find an interesting fact: Their picture needs are similar to those of the textbooks dealing with your own country. For example, a textbook on child development in underdeveloped countries would probably be looking for at-home scenes of family life similar to the scenes you'd take of your own friends and neighbors. Excessively "foreign" or unusual scenes aren't of much interest to these buyers; they want to show similarities of people in other lands more than profound differences. A family scene in Nigeria would be as good a candi-

I pulled my car over the curb in Washington, D.C., to take this picture of the Capitol dome. Whether it's the morning crosslight, the traffic, or the compressed perspective from the 300mm lens on the camera, I couldn't say, but this picture was sold five times in the last four years for use in Government textbooks.

63

These three pictures—irrigated farm-land in the Sacramento River delta near Concord, California; an offshore oil rig in the Santa Barbara Channel, California; and a cluster of Vermont farms in the Connecticut River Valley—are all aerial photos. While renting an airplane sounds extravagant, it's actually not as expensive as most people think. A single-engine high-wing monoplane with a window that can be opened for photography, like the Cessna 150, rents for anywhere from $60 to $90 an hour, including the pilot. If you plan your shooting well, you can make enough stock photographs in that time to more than pay back your expenses. Many subjects look best from the air, and if you're serious about stock work, aerial shots are often worth the trouble.

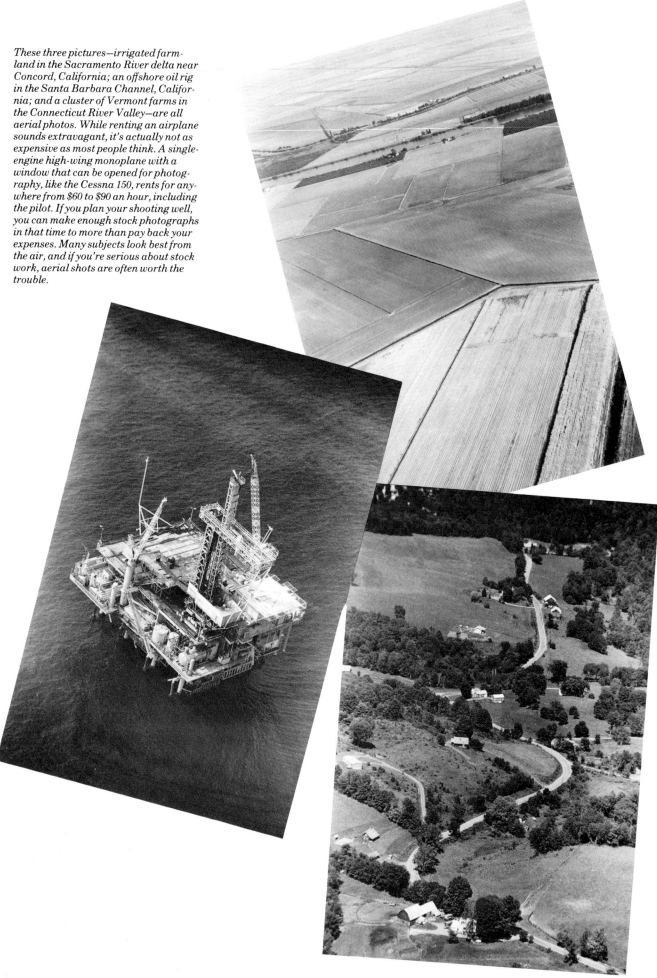

date as the same subject in Minneapolis. Factory scenes in Germany would be as desirable as factory scenes in Los Angeles to an American-published geography book. True, they'd want to show the novelty of foreign countries, but only as it could be compared to domestic models. When you take stock photographs for textbooks, you tend to wind up shooting the same subjects wherever you go. Many photographers go to foreign countries and shoot only pictures that show how unique these places are. Such pictures do have a market, but it is not as large as the market for the more mundane scenes the textbook picture researchers seek. Try working out a want-list from a geography textbook on a foreign country and see how similar it is to one about the United States.

Check With a Travel Agent

Visit your travel agent and pick up a collection of travel brochures. As you look over this collection of color shots of sunny beaches and ski slopes, remember that many of them were shot by photographers who took some vacation time to bring back useful stock photographs. Make a want-list from these brochures and you'll see that they all use similar scenes, scenes showing how that particular destination can be enjoyed. Sumptuous meals, sandy beaches, and happy couples figure in most travel publicity. Indeed, it's worth taking the time to discuss the current favorites in vacation spots with your travel agent. Such places are particularly good for stock photographs, for as tourist traffic increases, so does tourist advertising—which could buy your stock photographs. If following in the footsteps of everyone else doesn't appeal to you, ask your agent for ideas about vacation spots that will blossom soon. Those places will need more pictures as they grow, and there will be less of a selection than for a more frequently visited place. The odds can thus be played two ways: A popular resort can always use more stock photographs; one on the way up willflsoon start to buy.

Look at Travel Magazines

Travel magazines also buy stock photographs, but their needs are often coordinated with the writing of articles. While you are seeing the travel agent, look over some of the travel magazines. If you think your work measures up to the quality they publish, give the magazines a call and ask which countries and resorts they are planning to write about in upcoming issues. Then write a query letter and include samples of your work. Planning a trip to coincide with some of these editorial needs can be worthwhile if you follow up your trip with a well-organized and prompt submission to the magazines in question. You'll also find some travel-magazine stock requests in the *Photoletter*. Don't overlook the trade publications in the travel field that can be found at any travel agent's office. They are full of articles about popular resorts and countries, and they need stock photographs to illustrate them.

Examining travel magazines will also help you previsualize your shooting. What subjects did *they* run pictures of showing the country you're headed for? Check the back issues of travel magazines in your library (*National Geographic* publishes its own index, which most library reference departments carry). What sold to them will probably sell to someone else.

Keep this in mind: Look over the picture possibilities of your destination with a picture researcher's, not a photographer's, eye.

Just because cities have a lot in common doesn't mean that you do not need pictures of each one. A telephoto view of the suburbs of Anchorage, Alaska, and of a trailer park near Chino, California, are not unalike—and both are valuable. In each case I was looking for a single picture that would combine as many bits of information as possible.

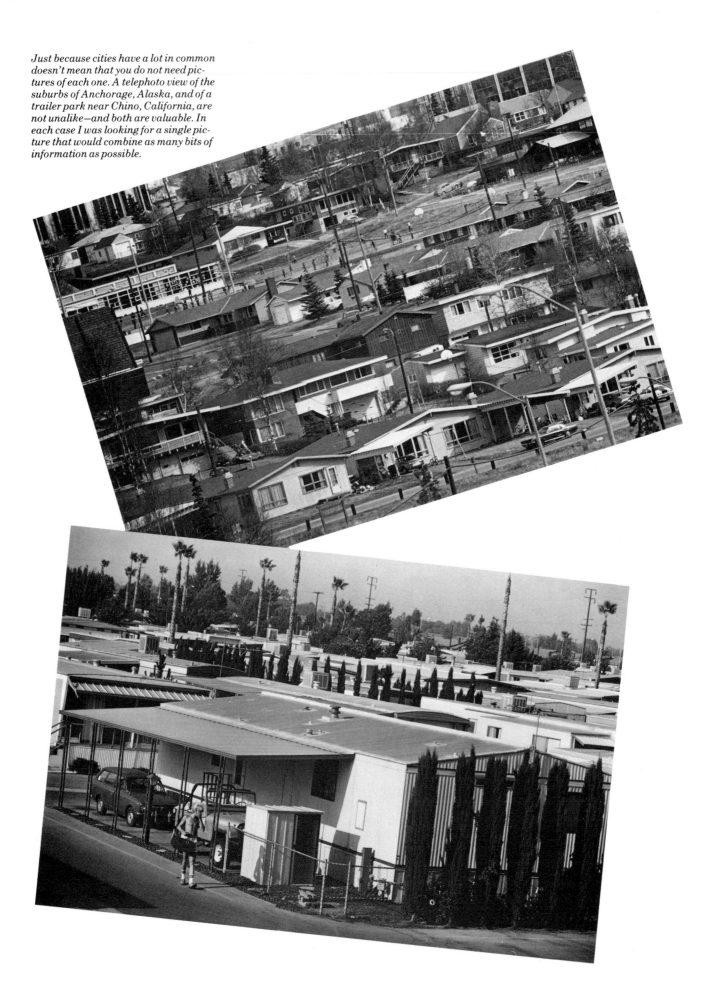

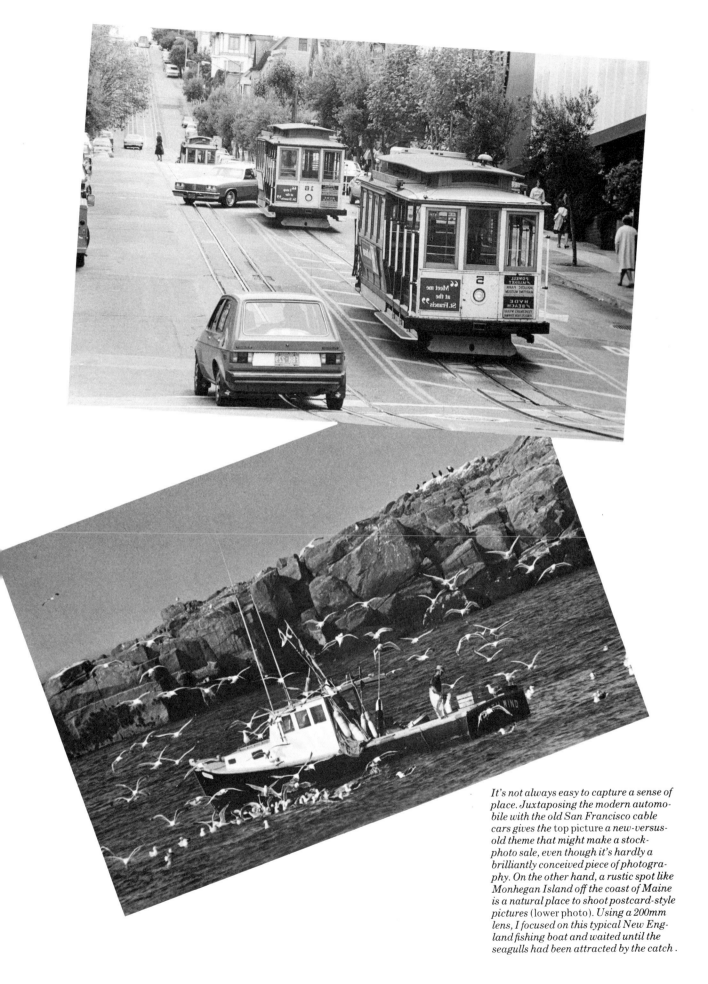

It's not always easy to capture a sense of place. Juxtaposing the modern automobile with the old San Francisco cable cars gives the top picture a new-versus-old theme that might make a stock-photo sale, even though it's hardly a brilliantly conceived piece of photography. On the other hand, a rustic spot like Monhegan Island off the coast of Maine is a natural place to shoot postcard-style pictures (lower photo). Using a 200mm lens, I focused on this typical New England fishing boat and waited until the seagulls had been attracted by the catch.

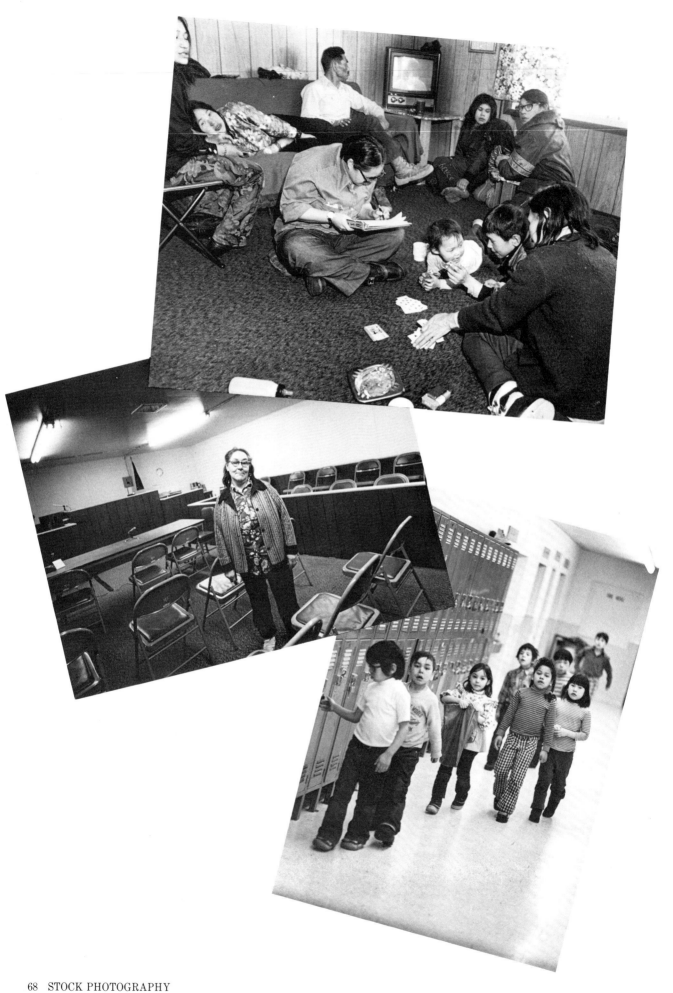

More Planning—Better Results

It's particularly important to plan your vacation stock photography because your vacation time is both limited and expensive. Furthermore, you probably want to take some time to relax and put your camera aside.

When you arrive at your destination with a well-thought-out shooting list, you can cram a lot of useful photography into a short period of time, particularly if you have some help waiting for you.

What kind of help? Most countries and resorts have a tourist bureau or department whose job is to spread to the media desirable information about the place. Chambers of commerce also do this. Write to the appropriate tourist bureau or C. of C. well before you leave on your trip. Send a cover letter along with a copy of the want-list you've developed after looking at the brochures and textbooks. Ask if they'll be willing to help coordinate your photographic efforts. It's worth trying. If you can persuade a stock-photo user with whom you've done business to write a letter requesting this cooperation in support of an ongoing project, you're that much more likely to get the help you need. Such organizations can smooth the way for you when you arrive by putting you in touch with their local representatives, and they can suggest additional subjects to photograph.

Standard Foreign Subjects

Classic views and "quaint" subjects in foreign countries are often overlooked either because photographers think they must have been overdone already or because they look surprisingly routine. For this reason, these views are often hard for picture researchers to find—and lots of photographers are missing paying shots. Use the hints that follow to make up your own list.

A local school. Cover several grades in making the pictures; you'll have the chance to sell to textbooks for that many more age groups. Pursue the school photography a step further: Would the school or tourist authorities help in arranging for you to go home with one of the students to photograph scenes of typical home life in that country? There's a ready market for this kind of subject in many textbooks. Needless to say, make photographs of foreign home life comparable to the ones you'd take in your own country. Avoid the very poor. As a social reformer you may think such scenes should be photographed, but you won't find much of a market for these pictures as stock. The stock-photography market is basically a positive market. When you've done your research into textbooks and brochures about your destination, you'll realize how true this is.

Typical or "postcard" scenes. If you're in doubt as to what constitutes a typical scene, check the postcard racks. If you think this idea is trite, bear in mind that it's been a standard ploy for stock photographers for decades. Postcard subjects are obviously the subjects that sell. Postcards can point out the most favorable positions and times of day for shooting the standard sights. Never be embarrassed to shoot pictures that have been shot before. There are lots of markets for them. Photographers sell similar pictures to different customers. An executive at a major New York stock-photo agency says she's sold a foot-high stack of pictures of the Statue of Liberty and she can always use more. She adds that many of the pictures her photographers bring back from foreign countries, although visually spectacular, are too unusual to be good *stock* sellers.

Eskimo life, Point Barrow, Alaska. Wherever you go, do your best to get some pictures at a local school. There's a big market for such education-oriented illustrations. Next to school life (opposite page, lower right), *home life is one of the big stock-photo winners wherever you go. With one day to spend at Point Barrow and not knowing anyone, I just asked the first Eskimo child who said "Take my picture" to take me home with him in exchange* (top picture). *After a little explaining, I was invited to take all the pictures I wanted. Whenever possible, I carry a to-whom-it-may-concern letter from my stock-photo agency. There are times when this extra bit of authority is helpful, as when I approached this Federal judge in her courtroom at Point Barrow* (center). *I doubt she would have cooperated if I hadn't had the letter, and I wouldn't have gotten this picture.*

Walk the streets wherever you happen to be and look for pictures—you'll find a lot of them. The two Indian women with baskets on their heads are standing on a street corner in Antigua, Guatemala; the conservatively dressed women in sensible shoes are obviously in London; and the long-haired Eskimo teenagers are crossing a street in Fairbanks, Alaska.

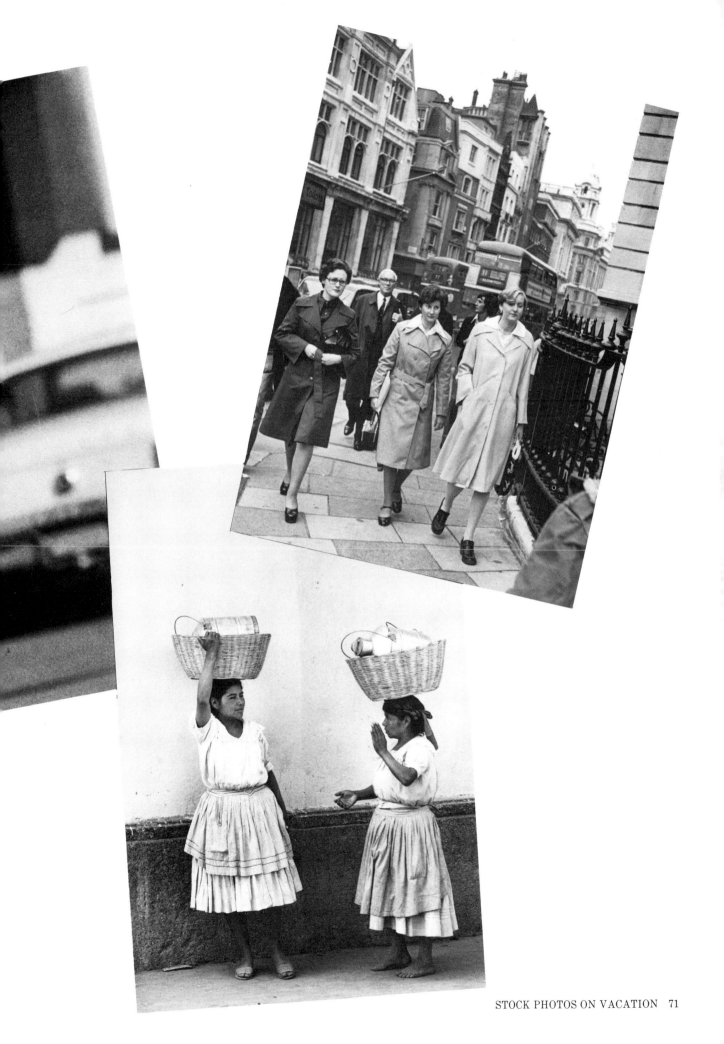

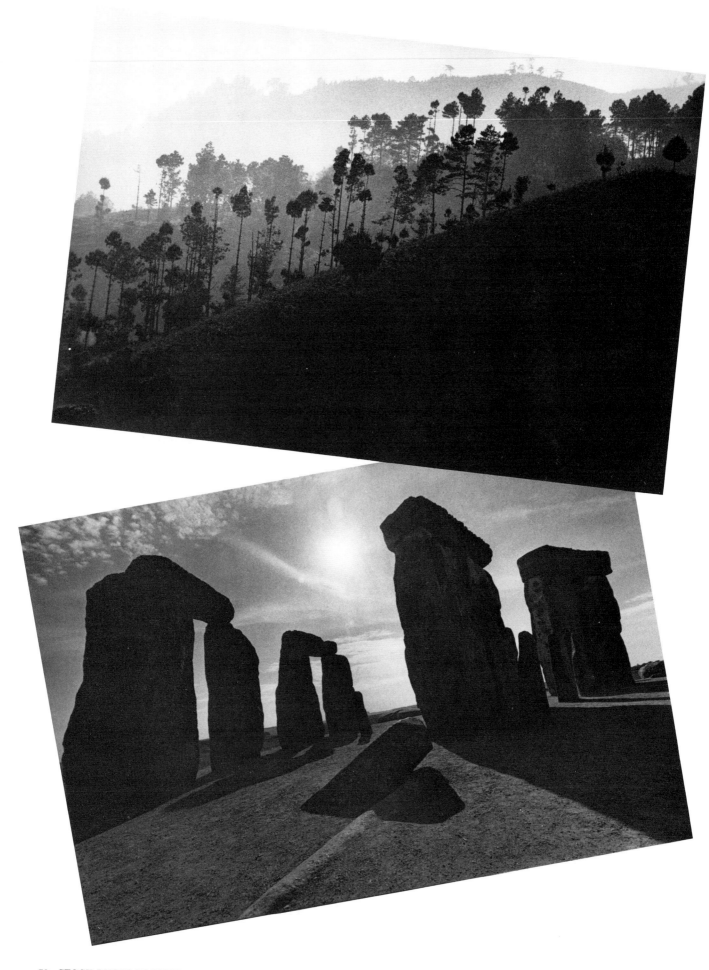

The lesson of this is that travel markets usually need pictures typical of a particular place, the scenes the average reader can be expected to identify with that region. An article or brochure about Paris would probably call for a picture of the Eiffel Tower rather than a more unusual picture that may have been taken in Paris but doesn't say "Paris!" to the average person.

Unusual subjects to illustrate particular magazine articles are generally shot on assignment. Where the stock photographer scores is in supplying pictures that should not have to be assigned.

For this reason, it's important to look for *generic* pictures—as many as possible. Keep looking for pictures that could illustrate a *type* of vacation spot. Palm trees against a sunset can be used in a travel brochure or magazine dealing with hundreds of possible locations, as long as there's no landmark to make the scene more specific. A skier headed down a snowy slope can illustrate ski vacations from Squaw Valley to Gstaad. These may not be spectacular pictures, but they're *useful*, and useful pictures are what stock photography is all about. Close-ups of deliciously set dinner tables are always useful, as are setup shots of gambling casinos, with employees posing as guests. A couple strolling on a moonlit beach can sell for decades to hundreds of buyers. Leave the spectacular shots to the professionals who work on assignment; that's what they're paid for. You're doing a different job.

Foreign-language versions of familiar sights. A classic, for example, is the Coca-Cola sign with the words underneath in another language, even another alphabet. Look for the same kind of subject on your vacation. It is not only foreign-language textbooks that need these pictures; they can also find their way into annual reports for multinational corporations. A fire engine that is obviously a fire engine but just as obviously not an American fire engine is certainly worth photographing. Or a picture of a local policeman can be juxtaposed with one of a policeman back home. Photography is useful for illustrating contrasts, as well as similarities.

Local people, as many as possible. Smiling head-and-shoulder portraits (but *not* with the subject grinning into the camera!) always sell well when the subjects are attractive. A full-length picture will show native dress, and a wide-angle shot will show the person in a background typical of the country. Here's where learning a few words of the language will stand you in good stead, if for no other reason than to tell your subjects not to look at you.

A stock photographer needs to think like a researcher who's trying to build up a body of useful pictures rather than like a photographer who's trying to make artistic pictures or editorial statements.

Plan Not to Shoot

When you go on a travel vacation, the odds are that you're also taking the trip to have a good time, and that means that you, your travel companions, or both will get tired of endless picture-taking. Plan when you will *not* take pictures, when you will relax and take it easy. This is when a well-written picture list is really helpful. You can shoot with the feeling that your time is being put to profitable use, and stop shooting with the feeling that you've done worthwhile work. Most people on vacations get overtired quickly. Don't let this happen to you. It will spoil not only your vacation but also your pictures. Disciplined photography is exhausting both physically and mentally, particularly in unfamiliar surroundings. Don't try to shoot everything. One professional who does

While attractive from a graphic-arts point of view, the Guatemalan mountain scene (top picture) *isn't much good as a stock photograph: No specific point is communicated or supported; it's not a generic travel photo in the sense of conforming to some preconceived idea of what a vacation spot ought to be; and it could have been taken in any of hundreds of different places. It's just a good-looking loser.*

To get to the lower *picture, I rubbed elbows with dozens of tourists at Stonehenge, the famous prehistoric monument on Salisbury Plain in Britain. I hung around until the tourists had left because crowds would have made the stones look too small. The result is a standard picture, but it's been a steady seller because it's the kind dozens of publications can use: They have to get a Stonehenge picture from somewhere; I figure it might as well be from me.*

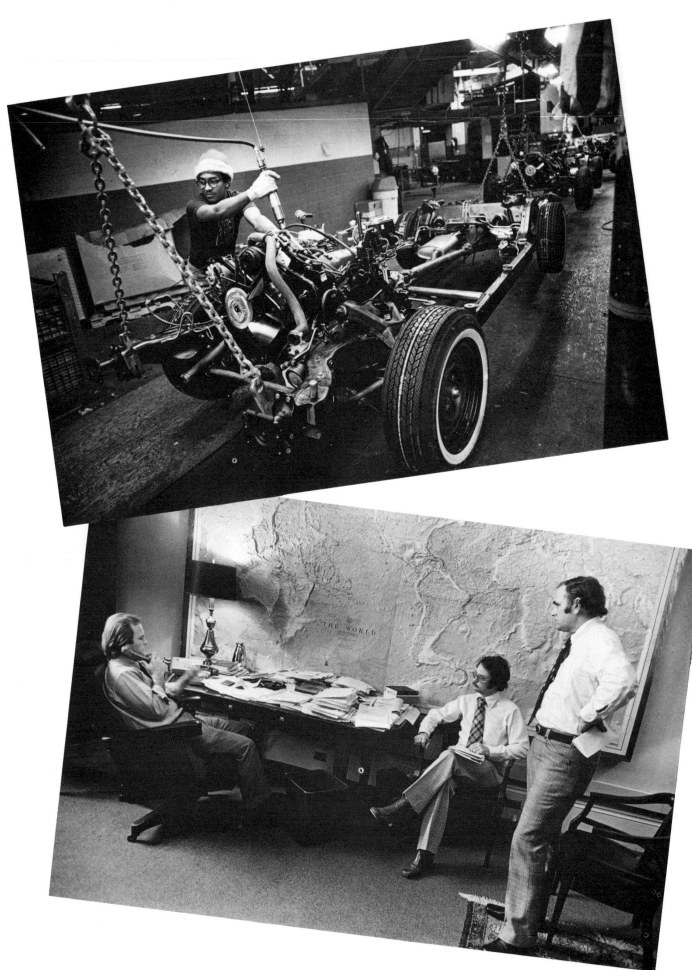

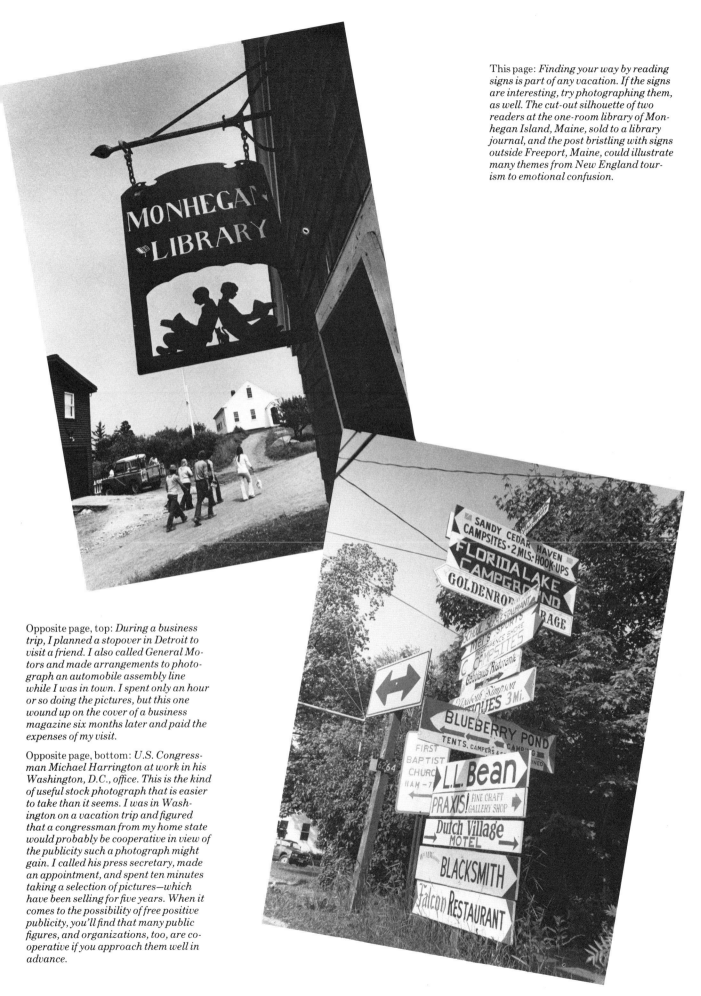

This page: *Finding your way by reading signs is part of any vacation. If the signs are interesting, try photographing them, as well. The cut-out silhouette of two readers at the one-room library of Monhegan Island, Maine, sold to a library journal, and the post bristling with signs outside Freeport, Maine, could illustrate many themes from New England tourism to emotional confusion.*

Opposite page, top: *During a business trip, I planned a stopover in Detroit to visit a friend. I also called General Motors and made arrangements to photograph an automobile assembly line while I was in town. I spent only an hour or so doing the pictures, but this one wound up on the cover of a business magazine six months later and paid the expenses of my visit.*

Opposite page, bottom: *U.S. Congressman Michael Harrington at work in his Washington, D.C., office. This is the kind of useful stock photograph that is easier to take than it seems. I was in Washington on a vacation trip and figured that a congressman from my home state would probably be cooperative in view of the publicity such a photograph might gain. I called his press secretary, made an appointment, and spent ten minutes taking a selection of pictures—which have been selling for five years. When it comes to the possibility of free positive publicity, you'll find that many public figures, and organizations, too, are cooperative if you approach them well in advance.*

much travel-stock shooting says that he has yet to end a day with the feeling that he's photographed everything there is to photograph wherever he happens to be.

The Payoff Is More Than Money

It's unrealistic to think that you can pay for your trip with stock photographs even though you can keep on making sales years after the pictures have been taken. Yet if you put serious effort into investigating the photographic possibilities of a vacation destination, make the right prior arrangements, produce professional-quality pictures, and follow through with effective salesmanship, your vacation stock photography will not go to waste. More important, the planning and photographing will lead to more interaction with local people, more familiarity with their way of life, and more respect for the things and people you encounter on that trip. When all is said and done, these dividends alone are worth the effort.

Top picture: *Driving around Washington, D.C., while looking for pictures during a vacation stay, I came upon this ruined housing block. It made a natural subject for the wide-and-shallow format of the Widelux panoramic camera. Like most successful stock photographs, this really does nothing more than recognize the obvious. It's not a great picture; but, considering how many textbooks on urban planning are written every year, it's definitely a useful one.*

Lower picture: *While driving past the Arlington National cemetery (outside Washington) I noticed this burial in progress. I stopped and, using a 500mm lens so that I could keep my distance, I waited until the man on the right had bowed his head and was unrecognizable before I took the picture. Somewhat to my surprise, it has sold several times.*

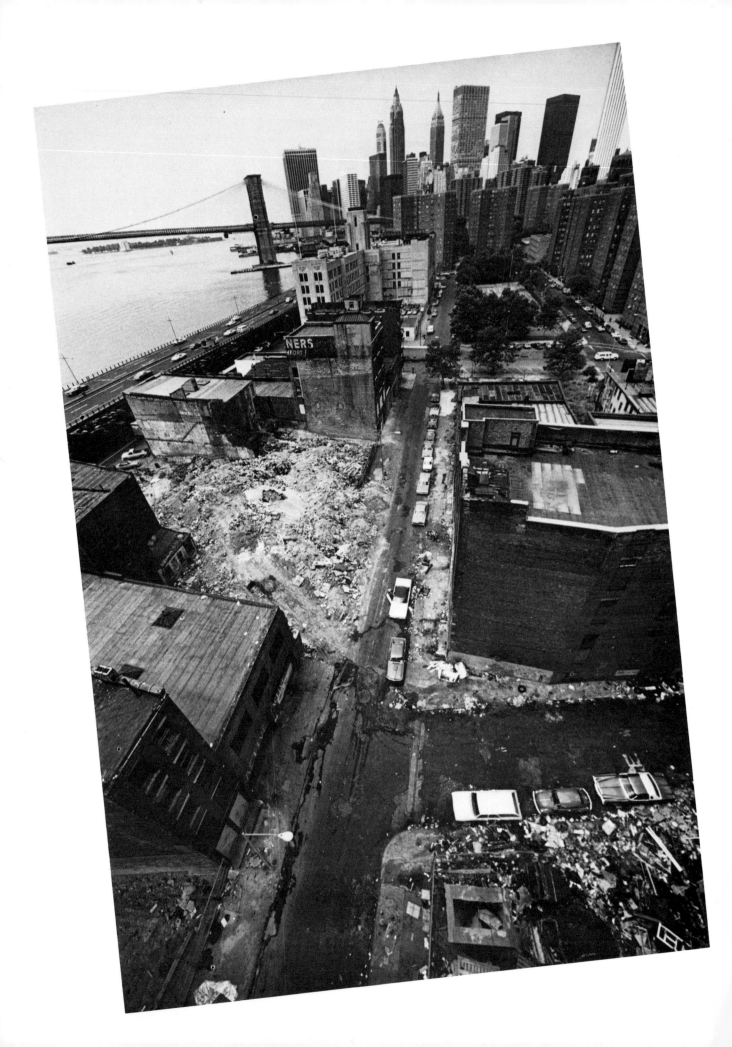

FILMS, CAMERAS AND QUALITY

THE STOCK-PHOTOGRAPH market is open equally to professional and to nonprofessional photographers, but it's the professionals who set the technical standards. Whether or not you're a professional isn't the point; all that matters is that you take pictures like one.

Professional Standards Are Standard

There's no room anywhere in professional-quality photography for amateurish mistakes. No one's interested in excuses for ill-composed, poorly focused, or incorrectly exposed photographs; they are rejected immediately. When you compete with professionals, you compete on their terms.

This doesn't mean that technical perfection has to become a fetish. No professional can let that happen and still produce quality pictures in the volume necessary to make money. There are no professional-quality techniques that aren't available to a reasonably-well-equipped amateur. All that's necessary is understanding what professional technical quality is and how to achieve it.

First of All: Sharpness

Your pictures are useless if they aren't sharp. In black and white this means crisp details and a top-quality 8×10 or 11×14 print as good as any from a custom lab: clean whites, rich blacks, and a full range of correct gray tones. Unlike exhibition prints, they should be on the light side. "Reproduction quality" prints must be light but snappy. They must be correctly captioned if they are to compete with the flood of work that picture editors sort through daily.

In color, the norm is high-quality color slides. Photography editors and picture researchers seldom consider color prints, which are more expensive and less satisfactory to reproduce. Keep your color prints for wall decorations. Shoot slides for selling.

Slides: Sharpness Plus Correct Color

Slide quality is just as important as print quality: sharpness, correct exposure, correct color balance, and accurate captioning are essential. That's what the

It took a super-wide-angle (15mm) lens to cover this scene of urban blight from a bridge in New York City. To get the foreground in I had to tip the camera down, and the result is the splayed-out look of the background buildings. Such distortions are a frequent problem with superwides, which should be held level for best results.

professionals are expected to supply on assignments and, if your pictures are to take the place of one of these assignments, nothing less is acceptable.

All this isn't difficult or unreasonable. Professionals and amateurs use the same films and cameras. As we'll be discussing soon, stock photographs call for the minimum rather than the maximum of equipment. The photographer overburdened with gear will miss more pictures than the one who travels light. The majority of stock photography takes place in adequate light, under photographically accessible circumstances.

Color vs. Black and White

The question of color versus black and white isn't just a matter of esthetics in stock photography. As we've seen, certain markets call for one or the other, depending on a variety of factors: age of readers, picture content, subjects to be illustrated, and cost of reproduction (each picture reproduced in color needs four plates, and so is much more expensive than a black-and-white illustration, which only needs one).

Understand what the requirements of your particular part of the stock photography market are. If you're hoping to sell to travel brochures and magazines, color would be logical, as it would be for greeting cards and books for young readers. Filling a want-list for a college-level textbook would be mostly a black-and-white job; you would miss sales if you shot in color, although covers and chapter openings are sometimes done in color.

Once again, remember that you're playing the averages. Lots of other photographers and agencies are submitting work to the same users who are looking at your work. The larger the number of usable pictures you supply, the better your chances against the competition. If a textbook is using primarily black-and-white photographs you're better off passing up the chance for a single well-paid color sale when you could score with several black-and-whites at a slightly lower fee for each one. Most successful stock photographers put all their energy into a few market areas so that they can deliver both quality and quantity. In stock photography, these two go hand in hand.

When shooting with color transparency material, you simply make a duplicate slide for your records and hand the original to the client for reproduction. It is returned to you later. There are no prints to bother with. When you compare this convenience with maximum productions of usable pictures under varied conditions, though, black-and-white is the winner.

□ Fast black-and-white film can record images in lighting conditions ranging from bright landscapes to dim interiors.

□ There's no color balance to worry about and there's more latitude for exposure error.

□ A black-and-white negative can produce an infinite number of prints.

□ Black-and-white prints are easier to caption than slides.

□ Black-and-white prints are less of a loss if they're damaged or misplaced.

The manager of a top New England stock-photograph agency points out that black-and-white work enjoys a five-to-two advantage in sales volume over color. That figure is impressive; but it's also important to bear in mind that that particular agency does a large volume of its business with textbook publishers who, on the average, buy more black-and-white than color. On the

other side is a New York agency that has many advertising and travel-brochure clients and handles color exclusively.

Where do you stand in all this? Remember that just because a picture looks good in color (or in black and white) there is no guarantee that it will be of use to a customer who doesn't need it or can't afford to reproduce it. Stock photographs must be useful first of all, and usefulness is as much a matter of the medium as of the contents.

Making the Choice

If you have the choice of shooting a picture in either color or black and white, what other considerations may determine your decision?

Rates for color are higher, but . . . A New York agent points out that rates for stock photos in color have remained static for several years, whereas rates for black and white have increased at least twice in the same period. This means that the economic incentive for shooting color is decreasing as black-and-white prices rise.

Some subjects lend themselves naturally to one or the other. Children playing on a gray street would make an uninteresting picture in color, whereas a sunset would look really good only in color. Stock photography requires good pictures, and if the medium isn't appropriate, there's no point in taking them. Some objects photograph well in either black and white or color. In those cases, take the needs of your market as your guide: Shoot what you can sell.

How big is the audience? An original color slide is unique; one buyer sees it at a time. A black-and-white negative can produce as many prints as you want, and the more prints you send out, the more potential buyers you can reach. One slide can be lost or damaged. The loss of a black-and-white print isn't serious as long as you have the negative.

Which film will give you the best quality? If light is weak or of an unknown color, you can't expect to make a quality color slide. Fast black-and-white film, on the other hand, can often produce good quality even under these conditions. If you can't get a good color shot, settle for a good black-and-white one. Poor technical quality dooms the sale of any stock photograph, black-and-white or color.

The Favorite Color Film

In color photography for stock, the choice of film is easy: Kodachrome 25. This slow (ISO 25/15°—formerly marked ASA 25), daylight-balanced color-slide film is the standard for most of the stock-photography industry, the standard by which all other color films are judged. Picture editors and researchers are aware of Kodachrome's fine grain and high resolution and will always choose a Kodachrome slide over a slide shot on any other film. If you don't shoot your color slides on Kodachrome, cautions the president of one stock-photo agency, you'd better have a very good reason.

One good reason is poor light: Kodachrome's slow speed is a handicap when the object is evening and night pictures. And there are lots of subjects for which fast film speed is more important than fine grain or high resolution, such as fast-action sports or resort interiors. Under these conditions, no buyer of stock photographs would penalize a photographer for passing up Kodachrome in favor of faster film. Just be *sure* the pictures you want to take can't be done on Kodachrome, because, if they can be, another photographer may

use Kodachrome and may submit to the same buyer—and those slides will have the sales edge.

The Best Black-and-White Film: Fast

Life is less doctrinaire in black-and-white photography. There are films in the neighborhood of ISO 400 127° (formerly, ASA 400) from all major film manufacturers, and when necessary they can be pushed in developing to even higher speeds without losing acceptable quality. Remember that stock-photo buyers seldom need anything bigger than an 8 × 10 print, and in this relatively small size even high-speed black-and-white films deliver acceptable quality.

By the same token, it doesn't make much sense to shoot high-speed film when speed is not necessary. In bright sunlight, fine-grained slow back-and-white film is as logical a choice as Kodachrome for color. Get the best quality you can. No stock photograph has ever been criticized for being too sharply detailed or too fine-grained.

Standardize on Standards

There are no technical secrets for well-made photographs. High-quality film, correct exposure, and proper development produce good negatives; it's as simple as that. Professionals have learned to standardize, using one or two films whose characteristics they're used to and sticking to methods they know to work. Stock photography is no place for theoretically perfect quality, just for everyday top quality.

Make life easy for yourself. Carry a fast ISO 400/27° black-and-white film for general shooting, some fine-grained black-and-white film in the range from ISO/50/18° to ISO 100/21°, Kodachrome 25 for as much of the color work as possible, and a roll or two of faster color-slide film (ISO 100/21° to ISO 400/27°) for the occasional low-light color shot. Expose and develop by the book; most professionals do.

First Choice in Cameras

When it comes to choosing cameras for stock photography, only the best will do. This doesn't necessarily mean the most expensive or complicated camera; it means the one that will produce the largest number of high quality photographs with the least concern on your part.

For film format, 35mm is the overall winner. Some specialists in landscape and scenic photography stick to large-format color shooting, but they represent the exception rather than the rule. The majority of people who use stock photographs have learned to accept the 35mm format in both black-and-white and color (particularly Kodachrome 25) and, although you might lose sales to a customer who wants a large-format color shot, you'll more than make up the difference by the volume the fast-working 35mm can produce.

Convenient Size Is Vital

The most important requirement for the camera for stock photography is that you have it with you as much as possible. You can go out and hunt for stock photographs (and find them), but even more will "find" you. Once you've schooled your eyes to seek them out, you'll start seeing them everywhere. When your camera is with you routinely, you can take those photographs. The more convenient your camera is to carry and use, the more pictures you'll get.

This calls for a camera you can slip into your pocket or purse and carry as easily as your wallet or keys. Fortunately, there is on the market a growing

Keeping a tiny pocket 35mm camera like this Olympus XA handy will not only guarantee you have a camera ready when you need it, but will also let you pass as an amateur rather than a professional photographer. The result, more often than not, is more relaxed, casual subjects.

selection of pocket-size 35mm cameras that fulfill this requirement. The results they produce in experienced hands are comparable to the best 35mm quality. Before you start buying more ambitious and expensive equipment, start with one of these little gems.

A pocket-size 35mm won't take all the stock photographs that can be taken, but it will probably take *more* good ones than a complex instrument. Not only is it convenient to have on hand when you happen upon a opportunity but also it is designed for amateur operation in the finest sense of the term: with a minimum of gadgetry to get in the way of picture-taking. And it offers the enormous advantage that it doesn't look like a professional camera. In fact, it looks like a toy. The less professional you look, the more relaxed the people you photograph will be—and it's the natural-looking pictures that sell best. A pocket-size 35mm camera is adequate for at least half the stock photographs you take. Other cameras may have greater technical capabilities, but their weight and bulk will cause them to be left behind while you'll still be packing your pocket 35mm—and if that's the camera you're carrying, that's the camera that will take the picture.

Next Quality Is Versatility

When you start thinking about the next step up in equipment for stock photography (to supplement but never replace your pocket 35mm), bear in mind that the most important requirement is versatility. Most stock photographs are not taken in poor light; so super-high-speed lenses aren't all that important. On the other hand, shooting for stock means getting a wide variety of pictures with a variety of focal lengths. You'll probably have to shoot quickly; so the more convenient your exposure metering is, the fewer problems you'll have getting good negatives and slides. In addition, you don't have to be festooned with cameras to take good pictures; you need the absolute minimum of equipment you can get away with. If you have to think twice about carrying your camera equipment, you have too much.

Lenses

The best compromise among weight, lens speed, and convenience is probably a 35mm single-lens reflex (SLR) with a medium-wide-angle to medium-long-focus zoom lens. There are half a dozen brands on the market, all of which deliver comparable quality and convenience. There is a growing choice among zoom lenses whose variable focal lengths run from 28mm to 80mm or 85mm with through-the-lens (TTL) exposure readings from eye-level exposure control. Next to a pocket 35mm camera, an SLR with a zoom lens will pull the most weight in shooting for stock.

Although they are bulkier and slower than fixed-focal-length lenses, zooms offer greater convenience under changeable shooting conditions. You can change the angle of view just by twisting or pulling an adjustment ring (methods vary with different makers), making one lens do the work of several. This means less to carry and fewer worries about having the "wrong" lens on your camera. Many zooms also offer a setting for close focusing, a useful feature for occasions when you must work within inches of your subject.

Get the Right Zoom

Convenience. Zooms come in two sorts: "one-touch" has the focal-length adjustment and the focusing combined in one ring in a twist-pull arrangement; on a "two-touch" these adjustments are made with separate rings. Try both to

Soft lens pouches keep your optics safe from damage when bouncing around inside your camera bag. These zip-top Perrin pouches are easier to open than the more usual drawstring pouches.

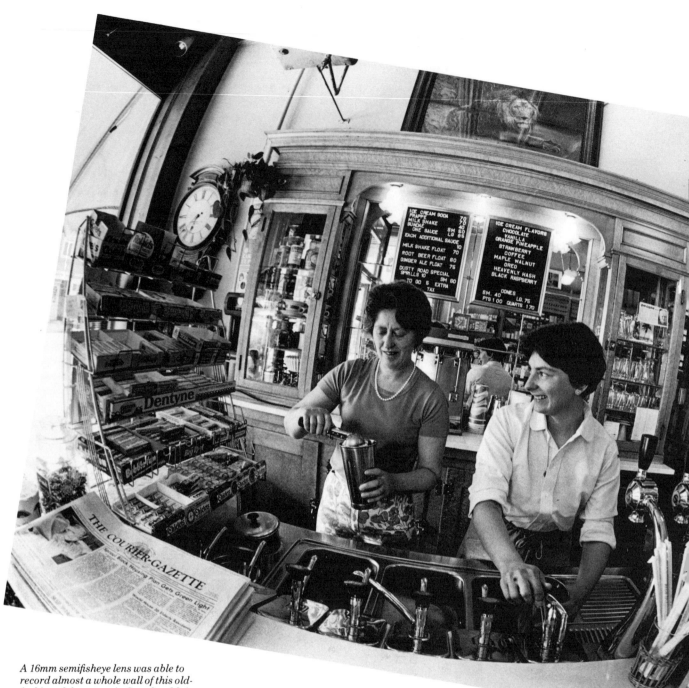

A 16mm semifisheye lens was able to record almost a whole wall of this old-fashioned drugstore in Camden, Maine, even though the two women were only about two feet in front of the camera. The curvature typical of this lens is obvious. Does it hurt the picture? That's for you to say, but such distortions are seen relatively often nowadays. Viewers have become subconsciously accustomed to them, as long as the distortion is not grotesque (which would have been the case if the subjects had been positioned near the edges of the frame).

see which you find easier to use, bearing in mind that an important point in using a zoom is fast operation. If you have to think about which ring does what, you'll miss pictures.

Range. Some of the "shorter" zooms run from 28mm to 85mm, some from 28mm to 50mm, and some from 35mm to 105mm. The "longer" styles of zoom run from roughly 80mm to 200mm. Some can be used close to the subject ("macro capability").

Which one to choose? Most stock-photography shooting is done close up and a wide-angle lens is an important consideration. A zoom that goes down to 28mm gives that wider angle when you need it. A 28-85mm zoom will give you a medium-long focal length as well, suitable for portraits and pictures of children from a few feet away. This range seems like a good choice, and there are now quite a few brands. Each has its own handling characteristics. Try out several before making your choice.

Durability. When one lens has to do the work of two or three, you can figure it's going to get two or three times as much wear and tear. Zoom lenses are both optically and mechanically complex. Money saved on the purchase may be lost in pictures you cannot take while the lens is being repaired. So buy a high-quality zoom; it's a worthwhile investment for all kinds of good photography besides stock.

Add One Lens at a Time
Although a 35mm SLR with a 28-85mm zoom lens will do for a lot of stock photographs, a few other lenses are worth considering. It's important to take things one step at a time, though; don't buy a second lens until you've learned to get all you can from one. Camera equipment is useful only when you're so familiar with its operation that you can take pictures without being aware that you're using the camera. The more equipment you have, the harder this is to achieve.

Long zooms. The other most useful lens is a longer zoom in the 80-200mm range. This lets you photograph people from across a street and makes possible long-range scenic shots beyond the capabilities of the 28-85mm zoom. Bear in mind that the longer a lens is, the more difficult it is to hold steady at slow speeds (between 1/125 second and 1/30 second) and the more carefully you have to focus to get a sharp picture. An 80-200mm zoom takes a lot of getting used to; but once you've mastered it you'll find it handy for fast shooting, for isolating people in a group, or for getting a variety of different pictures of the same subject. Lots of professionals who travel light find that the 28-85mm and the 80-200mm zooms together cover ninety percent of the pictures they're called upon to shoot.

Check the Wide Angles
There are times when you're shooting in a small room or a crowded street and the 28mm lens just won't do the job. This is when one of the super-wide-angle lenses can come in handy. Usually 17mm or 18mm in focal length, these optics cover a 100-degree angle and let you photograph a large area from very close up. The only problem these super-wide-angle lenses have is serious distortion: Foreground subjects look unnaturally large and background subjects unnaturally small. Unless you're careful about composition, the results can be grotesque—and unsaleable. You also have to be careful about holding your camera level when you shoot with a superwide lens because vertical lines (such as the

sides of buildings) will converge noticeably when the camera is tilted upward. The superwide is a useful but specialized tool, to be used only when absolutely necessary.

Semifisheyes. The same can be said for the 15mm and 16mm semifisheye lenses that are available for most 35mm SLRs. These lenses have built-in distortion, which causes them to render straight lines as curved. They cover enormous angles—as much as 150 degrees. This effect can be useful in the right pictures but it's inappropriate in others.

The only reason to consider the use of the semifisheye is that it's a favorite of professional magazine and commercial photographers, who have learned to use its distortions to produce impressive pictures under the right circumstances. As you page through magazines you will find some examples of semifisheye work (the curved-line distortion makes them noticeable). Study them carefully and analyze the way the pictures were taken. You'll see that most of them have carefully balanced compositions, with objects needing to be rendered with the least distortion placed near the center of the picture. The pictures don't look completely natural, but the wide coverage produces an effect so spectacular that the distortion is acceptable.

The semifisheye is a "now" lens, the latest specialized tool of professional photographers. It supersedes the fisheye, whose circular image and gross exaggerations were a fad years ago. The less-distorting semifisheye still takes a lot of getting used to; but in practiced hands the results are impressive. It's a lens to be approached with care, but not to be ignored.

Accessories

Stock photographs have been taken with lenses of any and every focal length, but the four types just described will cover most situations. If you do decide to acquire all four, they can still be carried conveniently with your camera and a supply of film. There are other accessories worth considering, too.

Automatic winder

Power accessories are available for many current 35mm SLRs. Auto winders advance the film automatically with a battery-powered motor at a rate up to about 2.5 frames per second. Motor drives add even more automatically powered capabilities.

These accessories run too slowly for shooting fast action. In color stock photography, however, you can put a rapid film winder to another use: shooting duplicate color slides. With one black-and-white negative you can produce any number of prints, but a color slide is unique—if you want extras, you have to either shoot more or duplicate the original. Of the two techniques, shooting extras is better as far as quality is concerned. "Repro dupes" that compare favorably with an original slide are expensive, and they almost never match the quality of the original. Picture editors are aware of this and won't accept duplicate slides any more often than they must. If you want the best quality in duplicates, shoot them of the original subject! A power winder makes it easier to shoot extra slides in a hurry. It's also convenient for fast exposure bracketing, when you shoot several slightly differing exposures of a subject to be sure of getting just the right one.

Power winders and motor drives are useful for fast-sequence shooting at slow shutter speeds because you can brace yourself and then shoot off a series of frames while holding the camera steady. The additional weight of the winder also helps to stabilize the camera.

A recent offshoot of the growing popularity of power winders is the new 72-exposure rolls being offered by Ilford in its HP-5 film type (ISO 400/27°). Using thin-base film stock, these normal-size film cassettes hold twice the usual length of film, allowing 72 exposures before reloading is necessary. The film is a big job to rewind after exposure (it was designed for automatic winders equipped with power rewinds) and must be developed on a special extra-long reel; but for a photographer who wants to pack the maximum number of pictures in the smallest space, these 72-exposure cassettes are an attractive idea. They're particularly useful in the pocket-size 35mm camera you carry around, allowing twice the usual number of frames for the unexpected subjects you run across.

Meters

The through-the-lens (TTL) meters in 35mm SLRs are *reflected-light meters*; that is, they meter the intensity of the light *reflected off* the subjects at which they are pointed. The trouble is that reflected-light meters give accurate exposures only when metering subjects of average contrast. For example, a reflected-light exposure reading of a dark-colored subject would result in overexposure because the meter is designed to render all subjects a neutral shade of gray. Conversely, a reflected-light meter reading on a very light-colored object (such as a white wall) would result in underexposure as the meter tries to turn the white into gray.

With black-and-white film, this error is sometimes compensated for by the exposure latitude of the film, but when you're shooting color slides, there's much less margin for error when your TTL meter goofs. It's wise to use a separate meter even when you have one in your camera.

An *incident-light meter* reads only the light *falling on* the subject. Thus, it's not affected by the color (and the reflectivity) of the subject. Using a hand-held incident-light meter for taking readings of *highlights* (the most brightly lit areas) of your color-slide subjects is the way to get accurate exposures on these unforgiving films, which don't give you a second chance in the darkroom. If you shoot a lot of color, an incident-light meter will pay for itself in film that you don't waste and in sales that you make as a result.

Filters

In stock photography, the "less is more" theory of cameras and lenses also applies to filters: Take only the ones you really need.

Ultraviolet. When you shoot color slides outdoors, you're working in light with a component of ultraviolet (UV). The human eye can't see this end of the spectrum, but film can. The result is a bluish cast over many bright sunlit scenes. For this reason it's wise to keep a UV filter on your lens as a routine precaution. It may look clear to you, but it makes a big difference to the film.

For black-and-white scenes. Stock photographs of people in black and white seldom call for any kind of filter, but if you like to take scenic pictures you may find that a yellow or even a red filter will snap up a sunny sky, from simply strengthening the clouds to making the sky dark and dramatic. In color, using a polarizer can darken a blue sky for dramatic effect, most pronounced when the sun is shining at right angles to the direction the lens is facing.

Fluorescent light. A fact of life in a growing number of indoor photographic situations is fluorescent light. This common but odd-colored light won't give natural-looking results with any kind of color-slide film. If you intend to shoot under it, you will have to use a correction filter.

Ultraviolet filters may look clear to your eye, but they make a big difference to your film: They warm up sunlight pictures that would otherwise have a bluish tinge from the ultraviolet rays that color film sees even if your eye can't. This filter is also worth keeping on your lens permanently for the protection it offers to vulnerable optical glass.

Fluorescent light filtration can be a very complex matter, involving special color-reading meters and a large selection of special filters. Several manufacturers have come up with filters that will give approximately correct rendering of colors under most common fluorescent lights with color film. There are two types: FLD for use with daylight-balanced color film and FLB for use with Type B color film. Filtration is not an ideal solution; but, given the prevalance of fluorescent lighting in store, factories, and homes, it's the only convenient technique available.

Stock-photograph buyers are more willing to tolerate slightly inaccurate color results from an obviously troublesome shooting situation than they are to except substandard results when there is no excuse. A low-light color shot on grainy high-speed film needs no excuse, nor does some slight color deviation from ideal in a color shot of a factory lit by fluorescents. FLD filters tend to be off-color in the direction of reds and yellows, and for some reason color that's warmer than it should be draws fewer complaints than color that is off toward the blue.

Remember that the density of an FLD filter reduces the amount of light reaching the film. This is automatically compensated for when the light is measured by the TTL meter in a 35mm SLR, but you should check the instruction sheet that comes with the filter to see how to compensate when you read exposures with a separate incident-light meter.

Tripod

No photographer likes to carry a tripod, but there are countless pictures that can't be taken without one. Night shots and evening street scenes of cities—often big stock sellers—require long exposures that are impossible without camera support.

A compromise is the pocket tripod. It provides a camera support that can be carried in your coat pocket or camera bag as long as you can find some solid object to support it. Some small tripods can be placed on top of mailboxes or fire hydrants; other useful devices are clamps that can be fastened onto tree branches or railings to give the camera steady support. Such accessories don't give the independence of a full-size tripod, but if you don't have a tripod with you, a clamp is better than nothing.

Bring Your Own Light

Most stock-photography situations are found under adequate lighting conditions both indoors and out. There are enough without sufficient light, however, that it is wise to have a basic minimum of artificial lighting equipment.

The most common problems are uneven lighting, with bright windows and dark corners where you can't photograph, and mixed light sources, with daylight, fluorescent lighting, and incandescent lamps all present in the same room. There's no way you can shoot color under these conditions, because no matter what filter you use on your lens, color film can give accurate results only under one color of light at a time, and fluorescent lights, incandescent light, and daylight are all different. The best way around photographically impossible lighting conditions is to bring lighting that you can control.

Flash Isn't the Answer

In these days of automatic-exposure electronic flash units that can be clipped conveniently to the tops of most 35mm cameras, the artificial-lighting problem looks easy to solve. Unfortunately, it's not quite that simple. The results of flash-on-camera photography are flat and uninteresting, with chalky, over-

Keeping a camera clamp in your gadget bag can often save the day for you when you don't have your tripod handy for a slow exposure. This customized job is a Leitz tripod head mounted on a pair of Vise-Grip locking pliers with a ½"-20 bolt. It's tough, and rock-solid as long as a suitable place can be found to clamp it—in this case, a street-sign post.

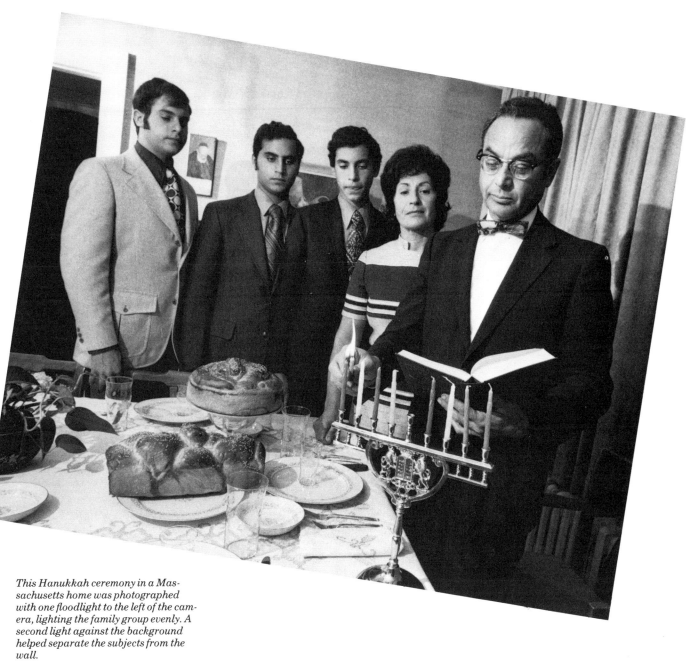

This Hanukkah ceremony in a Massachusetts home was photographed with one floodlight to the left of the camera, lighting the family group evenly. A second light against the background helped separate the subjects from the wall.

exposed foregrounds and dark backgrounds. No picture editor will accept such work, and no competent professional would even submit it. If you want quality results with artificial lighting, you'll have to put some more work into the project.

In fact, for most indoor photography flash isn't a good idea, anyway. It needs too many plugs, cables, and batteries to go out of commission at the wrong moment, particularly if you're shooting with more than one unit (frequently necessary for good results). It means toting a lot of hardware around when you'd rather be taking pictures, once you figure on light stands, slave cells, flash meters, and Polaroid test shots to see what you're getting. This last requirement is a real pain, but it's just about impossible to estimate your results during that brief pop of light while you are taking the picture. On top of all this, those bright flashes are anything but unobtrusive—and the best photographer is always the one who's noticed the least.

Incandescent Is Easier, Surer

Flash has its place when portability outweighs all other considerations (such as outdoor photography at night), but portable incandescent lights are an alternative that can pay off in more and better pictures.

□ These constant-burning lights let you see just what you're getting. They're bright but they don't flash, and people seem to get accustomed to them after a while.

□ There's less setting-up time. These lights can be plugged into regular household lines and either clamped to a convenient support or mounted on a light stand. After that, you're ready to start photographing.

□ Incandescent lamps are more reliable. They have far fewer parts to fail than electronic flash units have.

□ Much of your indoor photography will probably be done in a limited area—a dining room, a nursery, or a playroom. As long as you have an electric outlet nearby, you can illuminate these places without many problems.

What kind of incandescent lighting should you look for? As with your camera equipment, the requirements are convenience and reliability.

Photofloods. Although there are lots of the traditional bowl-reflector photoflood units on the market, they're neither convenient nor reliable. Their only real advantage is their low price. The reflectors are bulky—hard to transport and easy to damage. The photoflood bulbs used in these reflectors are delicate and have a short life (usually three or four hours). Furthermore, their color balance changes as the bulbs age, making color photography with reliable results chancy.

Quartz lamps. A better solution is the growing selection of so-called "quartz lights" on the market. These units give intense light and are extremely compact—you can carry one or two in a camera bag. The bulbs are small and well mounted to withstand shocks that would shatter a photoflood, and the color of the light remains constant throughout the long life of the bulb (usually fifteen to twenty hours).

Outstanding quartz lamps include the tiny Smith-Victor Model 700, which is only 3¾ × 3¾ inches in size but gives 600 watts of light (made by the Smith-Victor Corporation, 301 North Colfax Street, Griffith, IN 46319) and Lowel Tota-Lights (from Lowel-Light Manufacturing, Inc., 421 West 54th Street,

Two Lowel Tota-Lights with stands, cables, and umbrellas make an armful of light sufficient for many interiors. The lights can be used for direct illumination, bounced off a light-colored wall or ceiling, or used with umbrella reflectors to produce controllable bounce light whose direction is independent of the surrounding walls or ceilings.

New York, NY 10019). The Tota-Light is about the size of an ear of corn but can take bulbs up to 1000 watts. Both units draw less power than comparable photofloods; two can be used on a household circuit without blowing fuses.

These and other quartz lights are available with several useful peripheral accessories, including clamps to anchor them to a convenient support like the top edge of a door, stands for independent mounting, and silver cloth "umbrella" reflectors for throwing broadly diffused light.

Keep Lighting Simple

How do you illuminate for stock-photo shooting? Photographic lighting is a huge field, but some generalizations are in order for stock photographs, beginning with the assumption that the best lighting is the least noticed. What's needed for stock photography is simple, natural-looking light, preferably from a single source. Get all you can from one light before you try two.

For example, to light a scene of a family having dinner (Sound dull? Editors say they never get enough!), use one quartz lamp directed toward the ceiling to flood the room with indirect ("bounced") light. If it's a big room, which one light won't cover, put one lamp at each end of the room, either mounted on stands or clamped to supports.

If you're working in a room where walls and ceiling are too far away to bounce the light from, use the accessory umbrella reflector to throw a wide, soft light—it will look like window light. Set up the light source to one side of the scene to show depth, and remember to keep the light stands out of the picture.

Use fast color film. Shooting in artificial light is another time when shooting with color film faster than Kodachrome 25 is accepted practice. Artificial lights look very bright to the eye, but their light isn't actually all that strong after it has been bounced off a wall or an umbrella. Incidentally, be sure not to bounce light off a colored wall because the light will pick up the hue and give the subject an incorrect color rendition.

Be sure to match the color balance of your film to the quartz lamp: High-speed color films like Ektachrome 160 have what's called Type B color balance, meaning that they give correct results under incandescent light of 3200 K—that is, measured at 3200 degrees on the Kelvin color-temperature scale. The incandescent-light version of Kodachrome (Kodachrome 40), on the other hand, is of Type A color balance, which gives correct color rendition with lamps of 3400 K color temperature. Quartz lamps are available in both 3200 K and 3400 K.

Pack lights conveniently. Both Lowel and Smith-Victor supply neat kits consisting of a certain number of quartz lights with cords, stands, and various accessories, complete with a fitted case to hold everything. These kits are convenient, but they are expensive and probably not worth buying unless you expect to do a great deal of indoor photography. Since you will be using lights less often than you use the rest of your equipment, it makes sense to pack them separately in a suitcase or a padded cloth bag. Quartz lamps stand up to rougher handling than regular photofloods do, but they have their limits, and they are much more expensive than photofloods. Treat them with respect, especially when they are extremely hot just after use. In this condition they are vulnerable to shocks that can break the filaments.

Improve existing light. If you don't want to bother with toting lights and stands, an old trick of magazine photographers is to replace the bulbs in the

regular household fixtures with more powerful ones, like 200-watt bulbs or No. 1 (250-watt) photofloods. Be careful not to singe lampshades or blow fuses by overdoing this. You'll find that you can boost indoor illumination considerably without sacrificing the natural "available light" look, and if you use photofloods, you'll be working under light of the correct color for Type B film (be sure you get 3200 K photofloods, rather than 3400 K). Don't forget to turn out any fluorescent lights that might be on along with the incandescent fixtures, because they'll register a bright blue on Type B color film!

Comfortable Shooting Means Better Pictures

For carrying cameras and equipment, no camera bag really seems to do the job. Most bags are hard to open in a hurry, besides being bulky to carry. For this reason, the one thing you *shouldn't* carry in a camera bag is your camera. You're bound to miss pictures while you wrestle to get the camera out of the bag when an unexpected photographic opportunity materializes. For the same reason, don't carry your camera in its "ever-ready" case. Those cases are anything *but* ready! They have a nasty habit of flopping over the lens when you're shooting in a hurry. Then, too, the camera must be removed from the case for reloading.

Keep Your Camera Accessible

What's the best way to carry a camera? Just hung around your neck and resting on your chest puts the camera out in plain view, which isn't necessarily desirable for candid shooting. This method also advertises the fact that you have something valuable.

Most professionals have gotten into the habit of slinging the camera over the left shoulder, so that it hangs under their left hand. The camera isn't so noticeable, and there's a hand nearby to protect it if a thief makes a grab. It's also easy to take hold of the camera with the left hand and bring it up to eye level, ready to shoot when an opportunity comes along. If you're wearing a jacket and have your camera on a shoulder strap that can be conveniently unsnapped, you can carry the camera under your jacket over your left shoulder. When you get ready to shoot, unsnap the strap and pull the camera free without removing the jacket. It's more work, but the camera is covered.

When you're shooting stock pictures in public, remember what's required: natural-looking pictures of people doing everyday things. Posed pictures are usually losers; it's the candid approach that wins in street photography. You won't get good candids until you are comfortable with your equipment and comfortable with your subjects.

Keep Your Thinking Positive

It's surprising how differently people react to self-confident photographers and to uncomfortable photographers: The self-confident one can get pictures where the uncomfortable one gets the cold shoulder.

When you photograph people you don't know, all your personality traits are on display. If you are uncomfortable about your task your state of mind will be instantly apparent to others, who will react by being uncomfortable too . . . and maybe even angry. The self-confident photographer sends a different message: that the people being photographed are desirable, important subjects. The reaction to this is positive and cooperative. For this reason, photographers learn never to ask, "May I take your picture?" if it's ever necessary to get someone's cooperation. That question demands a decision, and when

An army surplus gas-mask bag is a convenient and inconspicuous way to carry extra lenses, film, and accessories. Keep your camera at the ready, slung over your shoulder and riding under your left hand, with your thumb hooked through the straps of both the bag and the camera. You'll be able to get your camera into shooting position quickly yet without having it on display around your neck.

people are forced to make decisions most of them seek the fastest way out of the situation by saying, "No!"

A better approach is to say, "I need your help to take this picture." This is a different message: The picture is going to be taken. The person in question is necessary to that picture, and the photographer is asking that person's assistance. It's the positive versus the negative approach.

The point of all the cameraless looking for pictures should have had the effect of making photographic opportunities more obvious. When you have a camera in your hands, the picture you're taking has to be the most important task at hand. Don't feel diffident and guilty about taking a picture; you're a professional photographer building up your stock. Don't be afraid to point your camera at people. People like attention when it's complimentary. If you feel you're doing something dishonest by photographing people, don't even bother to take the picture—the results won't be good.

Master Your Equipment

It's particularly important not to be tripped up by your equipment. When you start shooting pictures, you have to forget that the camera is there, which means that you must take the time to practice using your equipment. Practice focusing, so that you won't be twirling the focusing ring while the picture gets away from you. Practice framing with your zoom lens, so that you won't have to think twice about what focal length to set it for. Practice setting exposures in advance, so that you won't have to think about it when you should be taking pictures. This is why having the absolute minimum of equipment is so important: The less gear you have to worry about, the more you'll count pictures instead of lenses.

The best cameras and films are useless if you don't feel comfortable about taking pictures. That's why it's so important to look for subjects that you genuinely enjoy photographing. Trying to fulfill a want-list with grim determination is not only hard, unpleasant work but also bad business, because you won't make good pictures of subjects you don't like to photograph. You're in stock photography because you'd take those pictures anyway, whether you got paid or not.

Say You're a Nut

People will sometimes ask you why you're taking pictures. Just say you're a camera nut—people can identify with that. With luck, you'll look so amateurish that no one will give you a second thought. Don't be humiliated by such a misconception; the less seriously people take you, the more natural they'll act in your presence, and stock photographs are best when they're genuine.

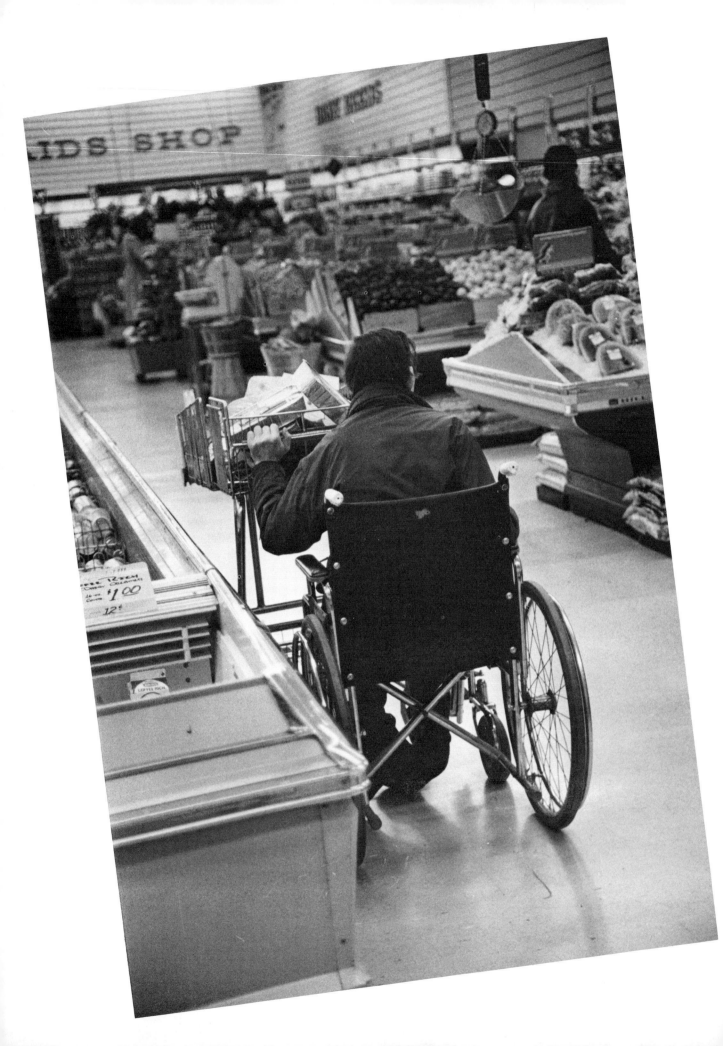

Chapter Seven

PICTURE PROFESSIONALISM

Edit your contact sheets carefully, taking time to pick out the best work for each client. Sending in inferior work wastes everyone's time and will wear out your welcome very quickly with any busy stock-photo buyer.

Opposite page: *One day when I was shopping at the supermarket, I saw this man in a wheelchair pushing his own shopping cart. Purposely, I took the picture from behind: A head-on shot would have been discourteous and in bad taste, and it would have required a model release. I couldn't make myself ask for a release in this case. To me, it would have been a bad way to do business. Taking advantage of people never seems to work, in the long run.*

TAKING GOOD PICTURES is just the beginning of the process that results in stock photograph sales and money in your mailbox. Your pictures must be edited, processed, captioned, and presented correctly. You need to know the legalities of copyright and model releases.

Pick Out the Best

Once you have developed your black-and-white film and gotten your color slides back from the processing lab, edit the best pictures out of the collection. For black-and-white work, begin by making a contact proof sheet of all the negatives on each roll. Since contact sheets are sometimes sent to prospective clients along with enlargements, a bit of window dressing is in order. Go over your negatives carefully and try to snip out all the unprintable and fuzzy frames before you start dividing the roll into negative strips for the contact sheet. Your contact sheets will look neater and, besides, you won't be wasting your time (or an editor's) evaluating pictures that were substandard to begin with.

The same standards apply to your color slides: edit out the unfocused ones before you make any other decisions. Keep them for your own slide shows if you want, but don't waste editors' time and your potential reputation by submitting slides that lack this most basic professional requirement.

In 35mm work, you'll have a hard time checking for sharpness in details in negatives and slides without a magnifier. There is a wide variety of these at prices ranging from a few dollars to over a hundred. As with other precision tools, you get what you pay for.

The World of Magnifiers

The most common magnifier photographers and editors use nowadays seems to be the Agfa 8× loupe, an egg-cup-shaped collar of clear plastic supporting a magnifying lens in a black plastic ring. When you set this down on a print or slide and put your eye to the lens you see an enlarged detail of the picture. Selling for less than $4 at most camera stores, the Agfa loupe is a useful basic

tool for examining both slides and prints because of the clear collar, which lets the light through, and its high magnification. For judging prints, though, it gives a rather dim view. Often a regular hand-held magnifying glass will be more useful because it allows you to see an entire frame while the Agfa loupe shows only a part. For even easier viewing of contact prints, Keyan Industries, Inc., makes a 3× Flash Magnifier that has a built-in flashlight to give a bright view of contact sheets (model No. 1987). (If you can't find one in your local camera store, you can order one directly from Keyan at 196 Plain Street, Braintree, MA 02184. The 1981 price was $17.95 plus $2 shipping. Ask for a catalog when you write—Keyan makes 200 different magnifiers of all different prices and styles.)

Another popular, but expensive, magnifier for use with 35mm color slides is the Schneider 4×. Costing a bit more than $50 (in 1981) from SBI Sales (739 Boylston Street, Boston, MA 02116), this is for the committed photographer; but one look at a slide through it and you'll see why it's standard in most magazines and picture agencies: Its clear, crisp viewing is superior to that of cheaper units. If you want to see your slides at their best, an expensive magnifier is worth the price.

Aside from being sharp, color slides also have to be correctly exposed and have correct color balance, meaning that the colors in the slide should look natural. Working under fluorescents without a correction filter or mismatching daylight or Type B color film with the light source will ruin the color balance and make the slides useless. Slides don't give you the second chance in the darkroom that black-and-white film does. It's important to take them correctly when you can.

The Right Viewing Light

You'll need a reliable light source for evaluating your slides. Since they are viewed by transmitted light, using the wrong color of viewing light will make it impossible to judge color balance. Many camera stores have color-corrected light tables (oversized light boxes) for customers' use. If your volume of slides is small, this is a cheap way to evaluate your slides. If you're willing to spend close to $50, the Idealite Model B1010 from the Richard Manufacturing Company (5914 Noble Avenue, Van Nuys, CA 91404) is the cheapest color-balanced light source on the market. It's also useful for inspecting negatives.

It may sound extravagant to spend something like a hundred dollars for a magnifier and a viewing light, but the fact is that your work will be evaluated by professional picture editors and researchers with exactly this kind of equipment. You don't have to start off with such expensive gear, but you might soon wish you had. The professionals use it because it makes their work evaluation easier and more accurate.

Slide Protection

Once you've edited your slides down to the sharp, correctly exposed, correctly color-balanced ones, you feed to take care of them. Unprotected slides are delicate and can be scratched or marred with a fingerprint. The standard procedure is to store slides in plastic slide sheets that have pockets to hold twenty slides safely. These sheets are available at most large camera stores and come in two basic styles: one with clear plastic on both sides of the pockets and one with frosted plastic on the rear to diffuse the viewing light. Those who favor the frosted-back sheets say this type can't be looked at backwards because the slides can be seen clearly only from the viewing side. The clear-on-both-sides supporters say that the clear back doesn't interfere with checking the slides

The expensive Schneider 4X magnifier will cost you a lot more than the inexpensive Agfa 8X; but, as in many other choices in life, you get what you pay for.

The colorful scene opposite was shot in Iceland, but it's a good example of late afternoon color photography anywhere: The light is warm in color, and its low angle emphasizes the perspective that leads to the children carrying their boat down to the Reykjavik waterfront. Taken with a 28mm lens on Kodachrome film, this picture could sell to textbooks, travel literature, or even a children's book.

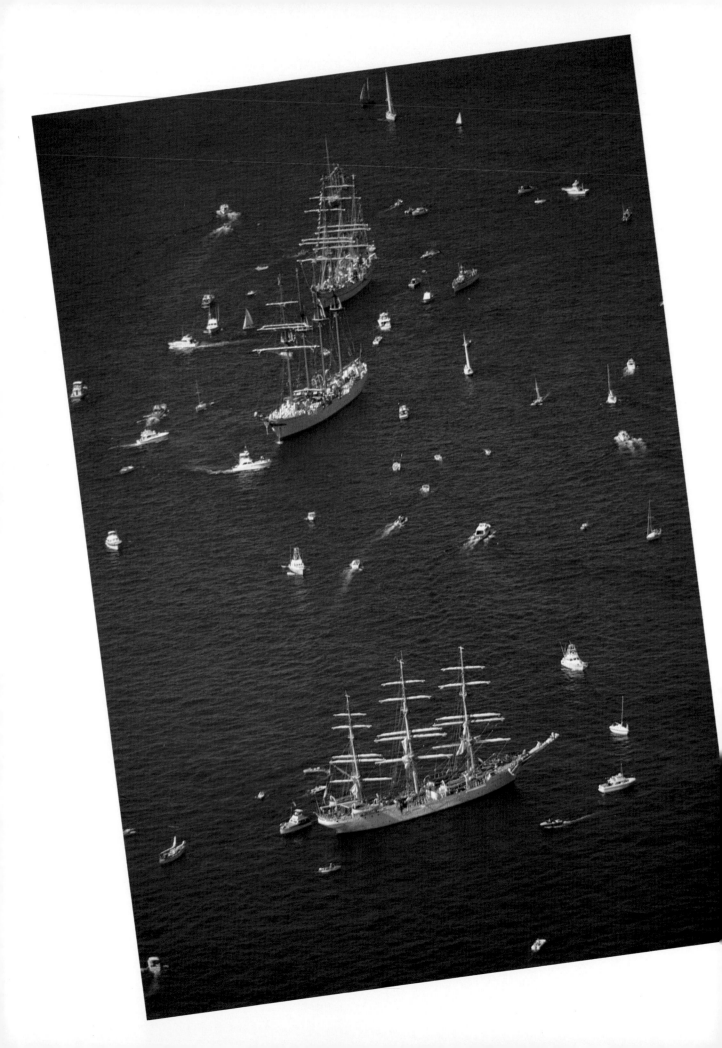

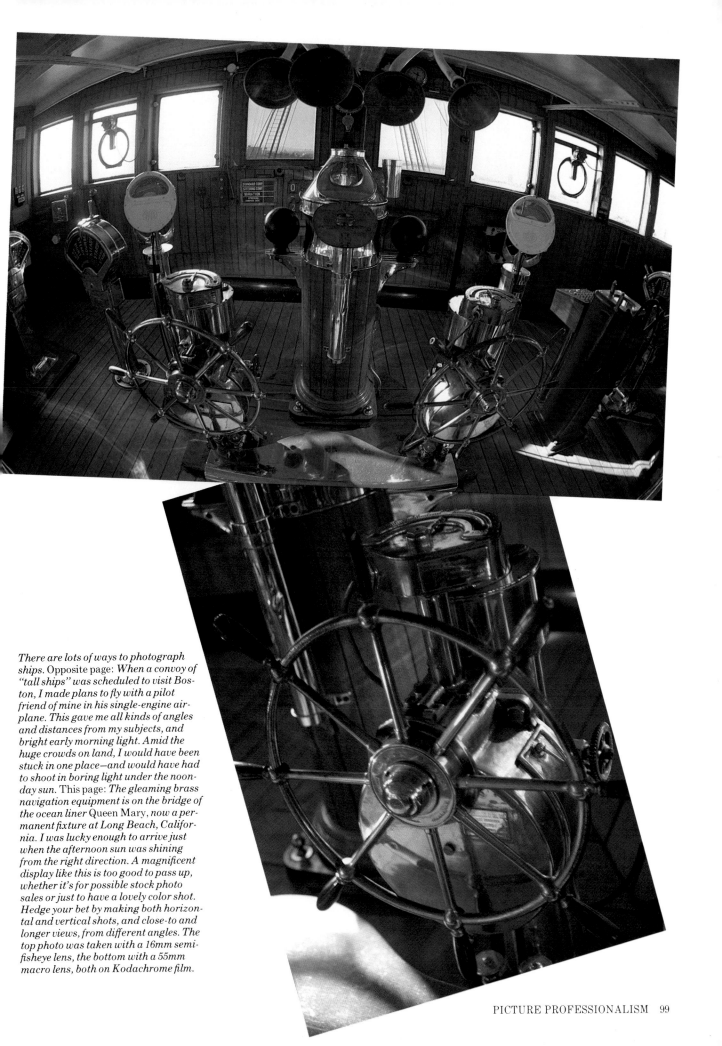

There are lots of ways to photograph ships. Opposite page: When a convoy of "tall ships" was scheduled to visit Boston, I made plans to fly with a pilot friend of mine in his single-engine airplane. This gave me all kinds of angles and distances from my subjects, and bright early morning light. Amid the huge crowds on land, I would have been stuck in one place—and would have had to shoot in boring light under the noonday sun. This page: The gleaming brass navigation equipment is on the bridge of the ocean liner Queen Mary, now a permanent fixture at Long Beach, California. I was lucky enough to arrive just when the afternoon sun was shining from the right direction. A magnificent display like this is too good to pass up, whether it's for possible stock photo sales or just to have a lovely color shot. Hedge your bet by making both horizontal and vertical shots, and close-to and longer views, from different angles. The top photo was taken with a 16mm semifisheye lens, the bottom with a 55mm macro lens, both on Kodachrome film.

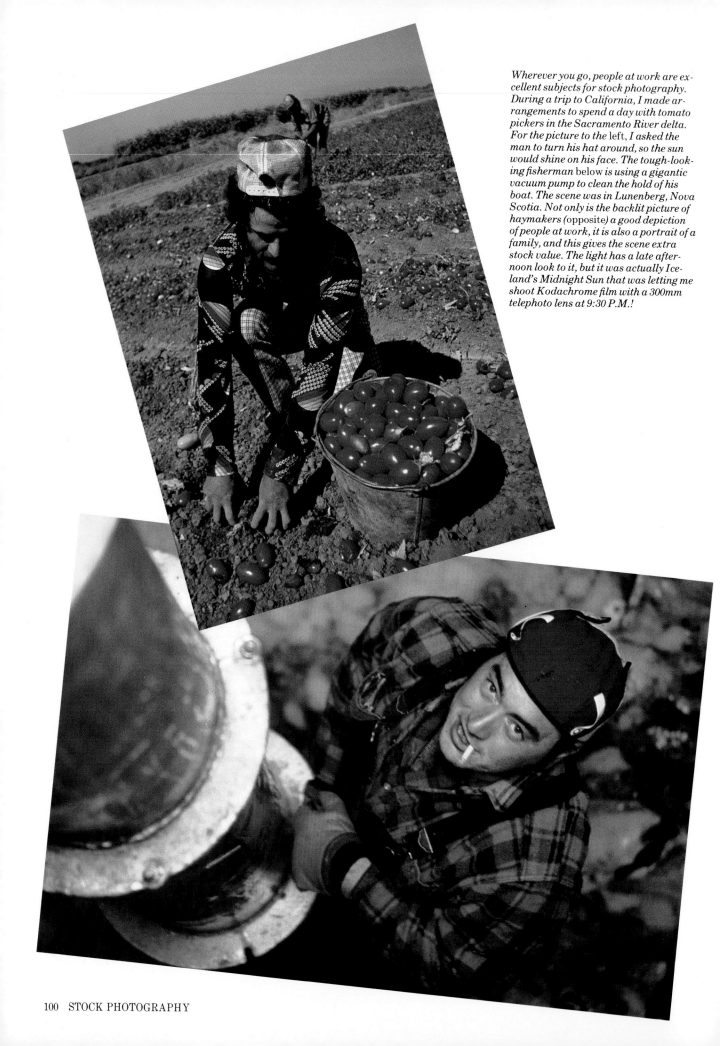

Wherever you go, people at work are excellent subjects for stock photography. During a trip to California, I made arrangements to spend a day with tomato pickers in the Sacramento River delta. For the picture to the left, I asked the man to turn his hat around, so the sun would shine on his face. The tough-looking fisherman below is using a gigantic vacuum pump to clean the hold of his boat. The scene was in Lunenberg, Nova Scotia. Not only is the backlit picture of haymakers (opposite) a good depiction of people at work, it is also a portrait of a family, and this gives the scene extra stock value. The light has a late afternoon look to it, but it was actually Iceland's Midnight Sun that was letting me shoot Kodachrome film with a 300mm telephoto lens at 9:30 P.M.!

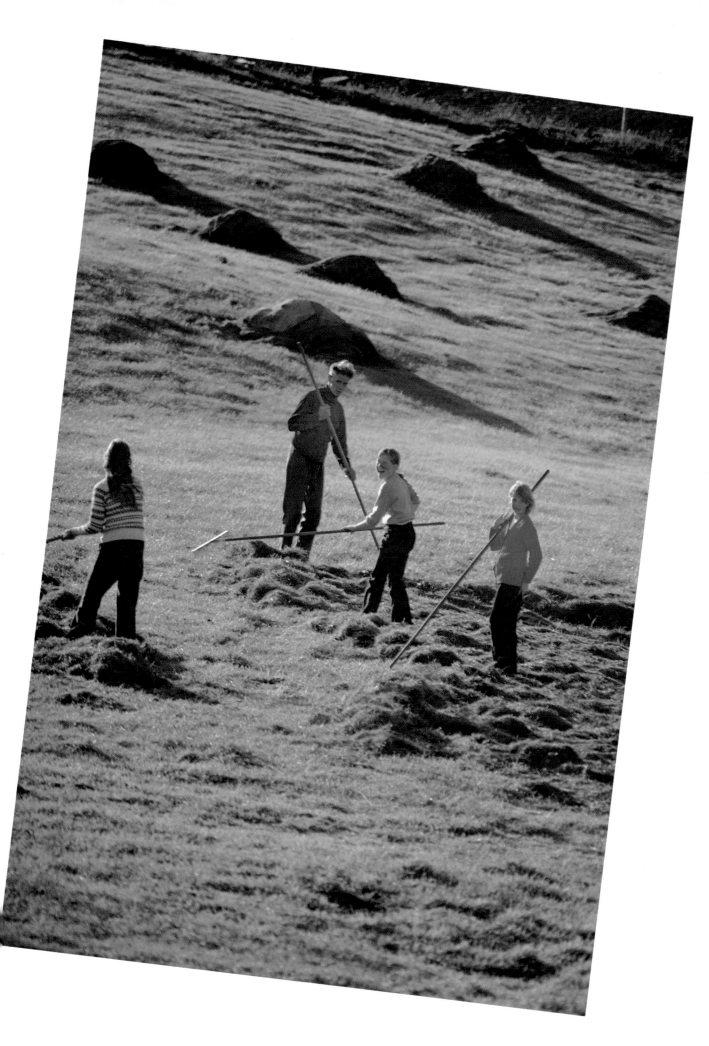

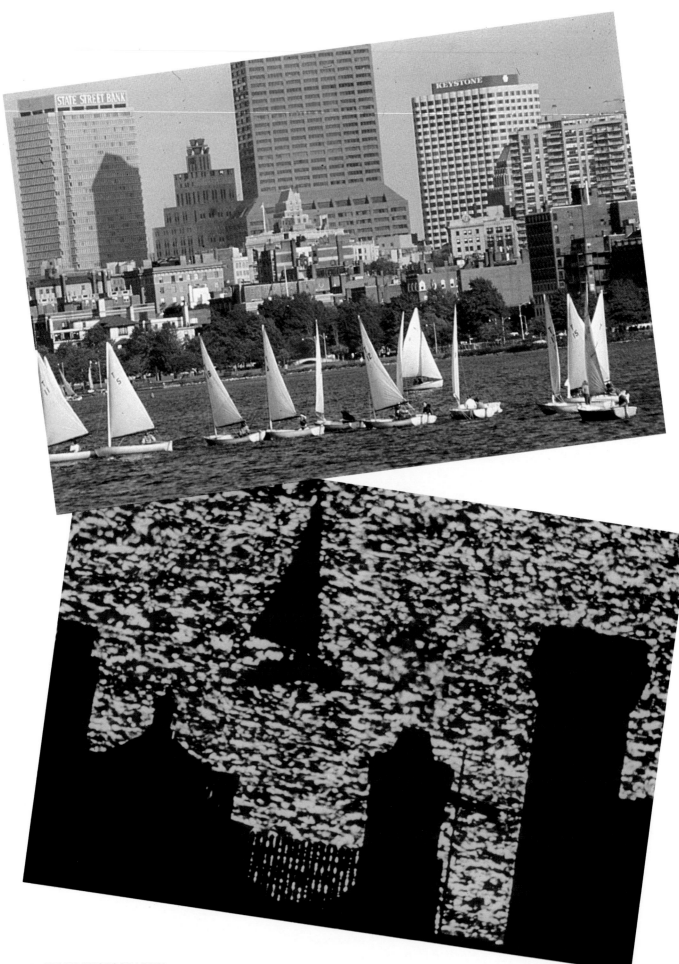

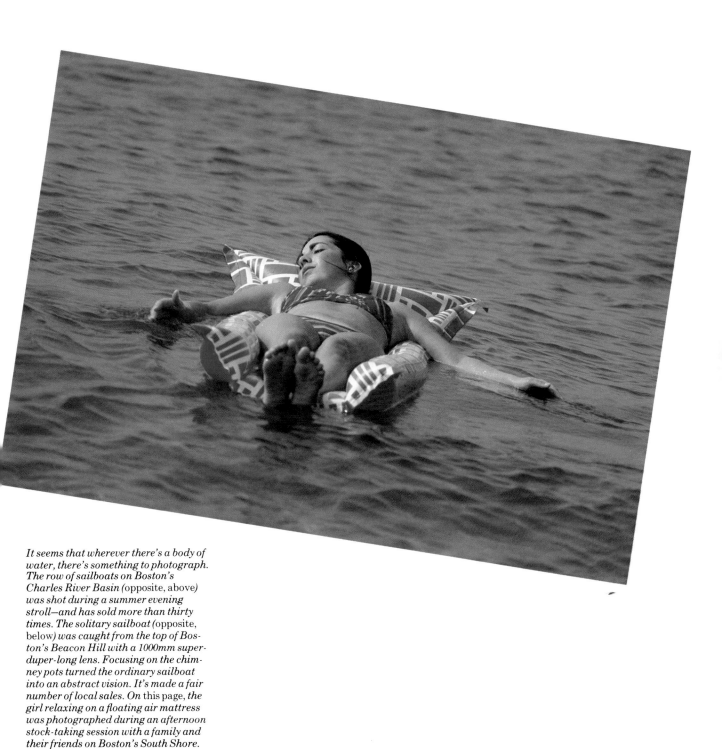

It seems that wherever there's a body of water, there's something to photograph. The row of sailboats on Boston's Charles River Basin (opposite, above) was shot during a summer evening stroll—and has sold more than thirty times. The solitary sailboat (opposite, below) was caught from the top of Boston's Beacon Hill with a 1000mm super-duper-long lens. Focusing on the chimney pots turned the ordinary sailboat into an abstract vision. It's made a fair number of local sales. On this page, the girl relaxing on a floating air mattress was photographed during an afternoon stock-taking session with a family and their friends on Boston's South Shore. This is my favorite kind of stock shooting—lots of pictures and a good time, too.

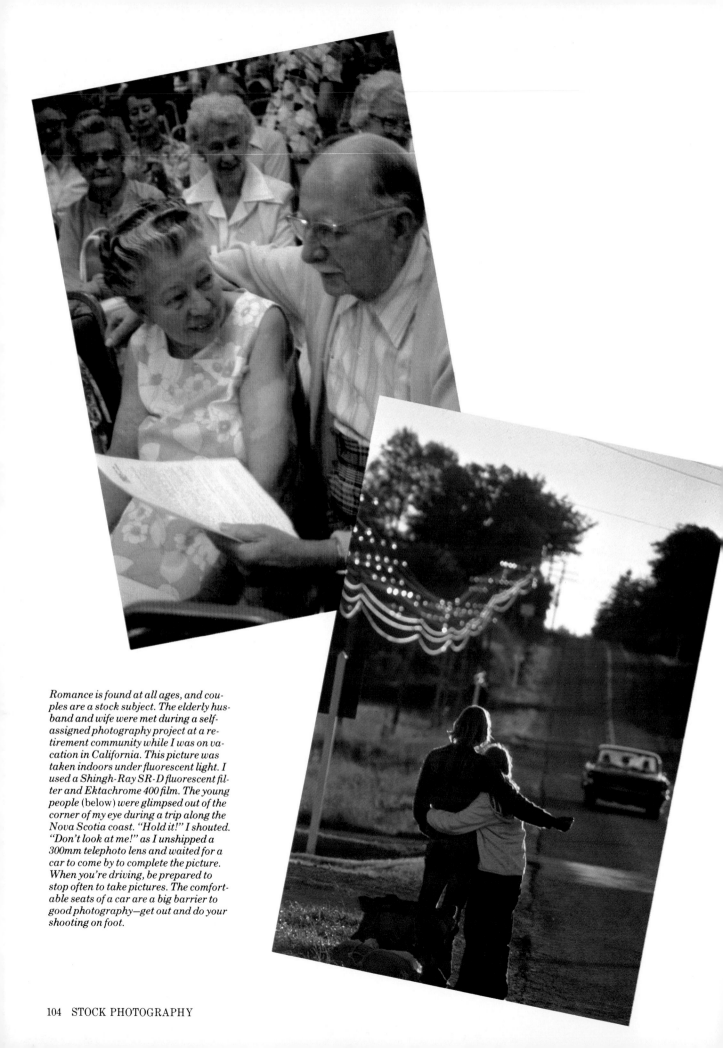

Romance is found at all ages, and couples are a stock subject. The elderly husband and wife were met during a self-assigned photography project at a retirement community while I was on vacation in California. This picture was taken indoors under fluorescent light. I used a Shingh-Ray SR-D fluorescent filter and Ektachrome 400 film. The young people (below) were glimpsed out of the corner of my eye during a trip along the Nova Scotia coast. "Hold it!" I shouted. "Don't look at me!" as I unshipped a 300mm telephoto lens and waited for a car to come by to complete the picture. When you're driving, be prepared to stop often to take pictures. The comfortable seats of a car are a big barrier to good photography—get out and do your shooting on foot.

with a magnifier, the way the texture on the frosted back does. It's a subjective decision. 20th Century Plastics (3628 Crenshaw Boulevard, Los Angeles, CA 90016) supplies a complete line of sheets for 35mm and larger formats.

Once a slide has been taken out of a protective sheet, though, it's vulnerable again. For this reason, photographers often protect their slides doubly by inserting each one in Kimac Slide Protectors. These are clear plastic sleeves that fit tightly around the slide and protect it for individual handling. Slides in these protectors still fit into the pockets of slide sheets. (They can be ordered from the Kimac Company, 478 Long Hill Road, Guilford, CT 06437.)

Plan for Captions

Once you've edited your slides and inspected your contact prints, it's time to make your black-and-white enlargements. Working on 8 × 10 paper and printing the full 35mm negative, you'll find that with ¼-in. (64-mm) borders at the short sides of the paper you can have a 1¼-in. (3.2-cm) border on *one* of the long sides. This space will accommodate your caption.

It can't be repeated often enough that black-and-white prints for stock use must be light and clear. Reproduction processes for most publications simply cannot handle dark prints, particularly in the small dimensions common in books. The prints should be made on a glossy-surface paper, finished either glossy or matte. This paper makes blacks look darker and whites look whiter. It is important to have a full range of crisp grays in between. If you use fiber-based paper instead of resin-coated (RC), double-weight stock is a better choice than single-weight. Stock photographs are subject to hard use; the tougher the paper they're printed on, the less reprinting you'll have to do.

Extra Prints

When you make a print, it's just as easy to make several from each negative. You increase your chances of making sales when you can submit your good pictures to many clients (as long as they're not competitors, of course!). It's always more trouble to reprint a negative later; so make up a bigger volume of darkroom work when it's easiest to do.

Catalog Your Work

Once you start making prints and selecting slides for stock submissions, it's time to start a system for organizing your work so that you can find negatives you need to reprint and keep track of what pictures you have submitted to what clients.

You can make this system as simple or as complicated as you like. Some photographers use full-scale library-style classifications for their negatives, with numbers that are repeated on the backs of the prints for easy retrieval of the negatives when extra prints are needed. Other photographers number and date their contact sheets and repeat the numbers and dates on the envelopes in which they store the negatives. For people with good memories, this simple expedient is often all that's needed. As time goes by and the contact sheets mount up, they can be subdivided into categories for subject research.

Codes for Color

For color slides, the simplest system is to come up with a series of numbers based on a subject code and a caption that can be keyed into a master list, on which you can make marginal notations as to where you have consigned a slide. Some photographers make up a 3 × 5 file card with the slide number and description, the current consignee, and the date of shipping.

Above: *A color-corrected light box and a Schneider 4X magnifier will set you back more than $100. Are they worth it? Considering that these are the tools used by picture editors at all professional picture-handling organizations, such as the New York stock-photo house seen here, the odds are that money spent to get the best is a good investment for the serious photographer.*

Photocopies

When you mail prints or slides to potential clients, it's important to keep track of which ones you send. A simple way, used by many stock-photograph agencies, is to make a photocopy of slides or prints that are to be sent out. The result is hardly picture-perfect, but you have an approximation of contents and composition, and the caption reproduces clearly. This is particularly helpful when you're trying to trace the whereabouts of a picture. A written description can be subjective and easily misunderstood; but if you have handy a copy of the picture, however poor, it's much easier to talk to an editor who's searching through a picture file to find that shot for you.

Captions Are Vital

No stock photograph is complete without a caption. Remember that, unlike fine-art photographs (which are expected to be complete on their visual merits alone), stock photographs are an adjunct to words. Stock photographs are almost never used without some sort of accompanying text; yet you can't make assumptions about an editor's ability to infer caption information from your photograph. Someone will probably have to write a caption for your picture if you sell it. The more information you supply, the better that caption will be, and the more likely it is that your picture will be chosen. Stock photographs convey information; that requirement covers the caption as well as the visual content.

Identification

A caption's first job is to identify the subject of the picture. It should give as much information as possible, touching on points that would help a picture editor or researcher find a logical use for it. Captions aren't expected to be great literature. They're concerned with who, what, why, where, and when. They assume that the stock photograph will illustrate a written statement. Even if your caption information isn't used, it at least serves the purpose of telling a potential user what it's *not* a picture of and what it *shouldn't* be used to illustrate. As we'll see later, the inappropriate juxtaposition of photographs and words can lead to unintentional libel, and a clear, accurate caption can be all that stands between liability or exoneration for a photographer.

Information

As an example, let's use a photograph of a crying baby being comforted by his grandmother. A logical caption might say: "six-month-old Adam Jones of Worcester, MA, is comforted by his visiting grandmother during Thanksgiving dinner." This caption supplies information useful to a caption writer: the age and sex of the child, what he's doing and where, and the identity and relationship of the other person in the picture. With this information a picture researcher might find a use for the photograph in texts about child behavior, extended families, tension in the home on holidays, or even geriatrics. Without the caption, it's just a picture of a crying baby. The caption, while supplying useful information, has also increased the stock value of the picture by increasing the information it conveys.

Let's try a caption for a photograph of two nurses adjusting some complex-looking machines. They could be doing any of a dozen different things, but a caption that reads, "Nurses adjust heart-monitoring equipment in ward of Waltham (MA) Hospital," narrows the field immediately. It makes the picture useful to a text on heart disease, medical instrumentation, hospital management, or, since one of the nurses is Black, on affirmative-action programs in the health-care field.

For shipping color slides, use plastic sheets that are clear on both sides. These not only protect your work but also allow your clients to examine the slides with a magnifier without removing them from the pockets. Make sure you keep in touch with the recipients of the slides—use the telephone a lot. These personal contacts are your best way of keeping aware of market trends.

A wide-area view of a city with a hazy gray sky is just that until it's captioned, "Afternoon smog shrouds downtown Los Angeles." You can't expect an editor to recognize the city, and California smog is described in many books and magazine articles dealing with urban planning, ecology, meteorology, and automobile pollution. A picture showing two men looking at a big piece of paper doesn't mean much until the caption explains, "Computer science student *(left)* goes over trial printout with instructor at Boston (MA) University." Now the picture can be classified in categories as diverse as modern technology, education in general, growing technical specialization at liberal-arts colleges in particular, and human relations (teacher-student).

Point of View

Belief in the utility of captions is not universal. Some editors and stock-photography executives feel that a caption narrows the appeal of a picture, preventing a fanciful caption writer at a publishing company from using the picture to illustrate ideas that actually have nothing to do with its content. There's something to this—and, indeed, many pictures in young children's books have no captions—but on the other hand there is the convenience clear captions offer in the way of classification for both you and your clients, not to mention the protection against libel. Once you start making calls to potential clients, it's worth asking their views on captions and modifying your practices in accordance with what you learn. The stock-photography market is big enough to accommodate widely varied procedures.

Easy Retrieval

Other jobs for captions include whatever filing information you need to reprint a particular negative or find a particular original slide if you're sending out duplicates (always clearly marked as such!) for editing purposes. It should also carry your name and address and two more items we'll discuss later: your copyright notice and a statement as to whether you do or do not have a model release.

Type captions on stick-on labels and attach them to the front of the prints. This makes for instant, clear caption information, which can be reproduced with the image by photocopying for convenience in filing and identification.

Stick-With-It Captions

The ways of attaching captions to a print vary as much as theories about the desirability of captions altogether. The traditional technique is to type the caption on the *lower* half of a sheet of paper. The upper half of the sheet is taped to the back of the print, so that the typewritten part hangs below the bottom and can be read like a printed caption. When the picture is filed or shipped, the protruding piece of paper is folded up over the face of the print.

The trouble with this technique is that a piece of paper attached this way is easily ripped or damaged when prints are stuffed into an envelope or a file folder. If the paper contains all your caption information, including your name and address, the print automatically becomes an orphan in the crowded world of stock photographs. You'll probably never see it again.

A more durable captioning technique is to use pressure-sensitive labels that stick onto the wide border you've left on one side of 8×10 black-and-white prints or on one or both of the wide borders of 35mm slide mounts. Pressure-sensitive labels are available at most well-stocked stationery stores. The 3×1-in. (76×25mm) size gives you a lot of space in which to write a caption for an 8×10 print, and the 1¾×½-in. (44×13mm) size fits neatly on 35mm slide mounts. Since these labels are supplied on sheets of waxed paper, they can be easily run through a typewriter for neat, readable captions. The labels can be peeled off prints and slides if the time is ever ripe to update or rewrite the captions.

The result is a stock photograph with all the information securely mounted on the front. If either you or your client has occasion to photocopy your work for filing purposes, all the caption information will be reproduced as well, making filing and retrieval of the original print that much easier.

Photocopying Has Many Uses

Photocopying for file purposes is a common technique and one worth encouraging. A client often receives prints for which he anticipates a future need. Rather than hold your original prints until then, he can photocopy the print and file it appropriately. When the time comes to get the original back from you, a phone call to you can supply caption, file number, and a visual description, making it easy for you to send the right picture quickly and your work isn't tied up until then in someone's "hold" basket.

Submit Copies

Another use of photocopying is for submission of color slides. Original slides are one-of-a-kind and valuable. If there's any way to keep them safely in your files yet send out an approximation of them to a potential client, so much the better for you. As we've said, some photographers send out clearly identified duplicate slides to give editors an idea of what they have to offer without risking the originals; but an even neater—and cheaper—way is to put your captioned slides into clear-on-both-sides sheets and have them photocopied on a three-color copier. The quality is only just passable, but the result is good enough for an editor to make a rough evaluation and contact you for a *particular* slide that looks promising. Since the copier also reproduces your caption, retrieval of the original from your files shouldn't be much of a problem.

Some black-and-white copiers give such high-quality results from prints that many photographers have begun using these duplicates for initial submissions, instead of sending prints. It's worth discussing this idea with clients in your early conversations with them. Some like the idea and some don't, but it's yet another way to stretch your collection of original images and, considering the price of photographic paper these days, such copies are cheaper than reprints.

How to Submit

Now that your prints and slides are processed, edited, organized, classified, and captioned, it's time to ship them off to potential users. But don't just drop them in the mail. Not only do they still have to be properly packaged, but also you have to let the right people know that they're on the way.

Unsolicited submissions ("over the transom," as the trade terminology goes) are usually a waste of time. Not only is it unlikely that you'll happen to send your pictures at just the right moment to coincide with a need for them, but it's also unprofessional and discourteous. Assuming you have done your market research thoroughly, you probably have certain customers in mind. Better yet, you've probably had initial contacts with them when you read samples of their publication and submitted some of your work to see if they felt it was up to their standards. Therefore, it's more appropriate to call or write and describe what work you have available and ascertain the best time to send it. You may find out that a client may be interested next month but not now, giving you a month to find another client. More important, you've shown your willingness to tailor your procedures to your client's needs. This is professionalism. Just sending off your work without paving the way is amateurish; editors have plenty to do besides inspect submissions they didn't ask for.

The Query Letter

The standard way of "testing the waters" to see if there's an interest in the subjects of your work (remember that in stock photography esthetics comes second, content first) is to write a query letter. It doesn't have to be complex—in fact, it shouldn't be. Its purpose is to describe your work, your reasons for submitting it, the price you are looking for (based on your research into what prices the publication pays), and some simple, basic information about the kinds of subjects you like to photograph, your experience, and your technical capabilities. You might include a few good photocopied samples of your work.

Personal Contact

If a particular client isn't interested, you'll probably receive a form rejection letter after a few days. If not, it may well be that you and your material are being given further consideration. At this point it might be worthwhile to place a call to the editor or researcher involved. Don't be shy. You're selling something these people need and are accustomed to paying for. Furthermore, these personal dealings are the most enjoyable part of marketing stock photographs. Ask the editor or researcher about your letter and his or her reactions to it. If it seems appropriate, ask about the client's current picture needs. You might be trying to sell the wrong pictures, but you might have the right ones in your stock. Make it clear you're there to serve the client's needs, and the more needs you know about, the more likely it is you can meet them. If you finally arrive at a match between your resources and the client's requirements, then it's time to send your work—duplicates, photocopies, or originals, depending on what the client wants to see. Before you start sending your pictures out into the world though, it's important to give your legal status the once-over.

What's a Copyright?

The most important legal matter for stock photographers is copyright—the question of who owns your pictures. As of January 1, 1978, when the current copyright law went into effect, the answer is clear and positive: *You* do! In essence, the law says that unless you have produced your photographs while employed for that purpose in a full-time capacity, or signed a work-for-hire agreement (in which you surrender ownership of your work), exclusive rights to every photograph you take belong to you as soon as you click the shutter on your camera.

What are those exclusive rights? You have the right to reproduce your work, to sell and distribute it, to prepare derivative works, and to display the work publicly.

Division of Rights

Furthermore, you can subdivide these rights, selling only part of them as you choose or none at all. It's not uncommon for professional photographers to sell certain rights but retain the rest in return for some particular consideration from a client. For example, a photographer hired to take color slides for an audio-visual production might sell the audio-visual rights to the client in exchange for an increased fee, but would retain all other rights, meaning that the extra pictures from the assignment wouldn't be sold to other audio-visual producers but would be fair game for all other stock-photo markets—markets that don't compete with the original audio-visual client.

What You're Selling

But as a freelance stock photographer you're selling only one right: one-time use. Very simply, this means that what the buyer is buying is a single use of

When I began in stock photography, I never anticipated how big my files of negatives would grow. As a result, I never got a decent filing system organized and I wind up spending lot of time digging up negatives for reprints. Learn from my mistake and start off with a simple but reliable filing system. Any file clerk or librarian can help you design such a system, and it's well worth the trouble.

your photograph. The client is actually renting the picture, and when it's returned after use you are fully entitled to sell its use anywhere else as many times as you can. This privilege has enabled some stock photographers to rent the same photograph to dozens or even hundreds of users over a period of time—without ever surrendering ownership. It's the legal cornerstone of successful stock-photograph marketing.

Work for Hire

It's not likely that you'll ever be asked to sign a work-for-hire agreement—and you shouldn't. Some professionals are asked to by clients who want to have complete ownership of the photographer's work from a given assignment. There's nothing illegal about this, but no knowledgeable professional would sign such an agreement without asking a much higher fee for the assignment (two or three times normal) because all future sales are thereby surrendered. The photographer cannot add the pictures to his or her own stock files. What *may* happen is that a check for a sale of use of a stock photograph will have a rubber-stamped statement on the back saying, in one way or another, that endorsing the check signifies your willingness to surrender all rights to your work. Don't sign this! Return the check and ask for one without that stamped statement, or cross the statement out before you endorse the check.

One-Time Rights

Actually, the vast majority of stock photograph users are concerned only with one-time rights. If nothing else, they're cheaper. When a client starts talking about owning all rights to a picture, the negotiations traditionally *begin* at $1500 per picture. This, incidentally, is the same as the minimum figure charged when a color slide or other unique photographic work is lost or damaged; the assumption is that selling all rights to a picture is the same as losing it, as far as the photographer is concerned.

Copyright Stamps

How do you safeguard your copyright? It's easy: Have a rubber stamp made that says, "© 19__, [your name]." Why "19__" instead of the actual year? Because your stock photographs can be expected to sell for many years to come. Putting a date on them can diminish their value in the eyes of a picture editor who doesn't want to use an "old" photograph, no matter how good it is. According to the fine print of the copyright law, the copyright must be dated only on publication. In theory, a picture editor would pencil the date in that blank space when the picture is published. In fact, this is almost never done, making your pictures copyrighted but timeless—and the term of the copyright is your life plus fifty years. If for any reason you do actually have to use a dated stamp, write the year in Roman numerals—most people can't read them. The longer the "life" a stock photograph has, the more profitable it will be.

Use your copyright stamp freely on all the work you send out: prints, slides, and contact sheets. You don't have to register your copyright in Washington—the copyright is legally in force from the moment your picture is taken—but you may do so for extra protection. Since it costs $10 per picture for copyright registration and there are a lot of forms to fill out, however, save this refinement for the few blockbuster pictures you take for which you expect enormous stock sales; these are the ones that tempt stock-photo users. When you're ready to copyright one or a series of photographs, write for the Copyright Information Kit from the Library of Congress, Washington, DC 20559. You will receive all the forms and information you need. But even without full registration, you have the law on your side if anyone uses your picture without paying.

Are there any other ways to increase your copyright protection? A prominent New York attorney who specializes in photographic litigation suggests adding the phrase "All Rights Reserved" to your copyright stamp. These words place your photograph within the copyright protection of the Buenos Aires Convention, covering it in South America as well as the United States. True, it's a refinement, but why not?

There are many other provisions of the 1978 copyright law that are more interesting than necessary to a stock photographer. *The Visual Artist's Guide to the New Copyright Law,* by Tad Crawford (available for $5.50 from the Graphic Artists Guild, 30 East 20th Street, New York, NY 10003), is a concise and easy-to-read rundown of the law's ramifications. It's money well spent for the occasions when you have to stand up for your rights because, as the old saying goes, "He who is forewarned is forearmed."

Unauthorized Use
The most common abuse of the copyright law is by unauthorized multiple users of your work. Picture editors are surrounded by thousands of photographs, many of which can be used without regard to copyright: staff-produced work exempted by work-for-hire agreements and free-use handouts from public-relations departments who are only too glad to see their pictures published. Mixed in with all this are your pictures, and the more prominent your copyright stamp is, the more likely it is that the editors will get the message and not use your work more times than they've paid for.

You can do your part to avoid copyright abuses by keeping close tabs on the status of your work. If an editor or researcher is holding your pictures, ask how long he or she intends to keep them, and ask that the works purchased and used be returned as soon as they come back from the printer. The longer a picture lies around an office, the more chances there are that someone will pick it up and use it.

Reuse Sales
When you sell the one-time use of a photograph to a textbook publisher, you're selling the rights only for a particular edition of the book. Sometimes textbooks go into second, third, and even more editions, and each reuse of your photograph must be renegotiated and paid for. You should also make it clear that your print or transparency may not be copied without your permission. There are times when a color slide is to be used as a black-and-white reproduction (although the color price must still be paid, if it's higher) and an internegative and a black-and-white print are made. That print doesn't have your name and caption on it, and it can wind up in a photograph file when the original slide is returned to you. Who's to say that at some later date an editor won't use the print again and not know who took it? Keep in contact with your clients and make sure that you get back what you send out, and make sure that you know what has been done with the work that was bought. This isn't being tiresome to the client—it's being professional, as long as your inquiries are polite and knowledgeable. Also, the more contact you have with your clients, the better the relationship you build with them and the more mutual trust you establish. On such foundations are built all successful businesses.

Permissions
Watching out for unauthorized use of your copyrighted work is only one of the legalities you have to be aware of in marketing stock photographs. Another is the ways in which your pictures can be used. On this detail hinges the whole question of model releases.

*Early one morning I saw unemployed
people filing into a social-service office in
San Francisco. I was very low-key about
taking this picture, not wanting to pro-
voke anger among my subjects, yet want-
ing to come up with a usable picture. I
waited until the line had begun to move
and everyone's back was to me before I
took two quick pictures with the Wide-
lux panoramic camera.*

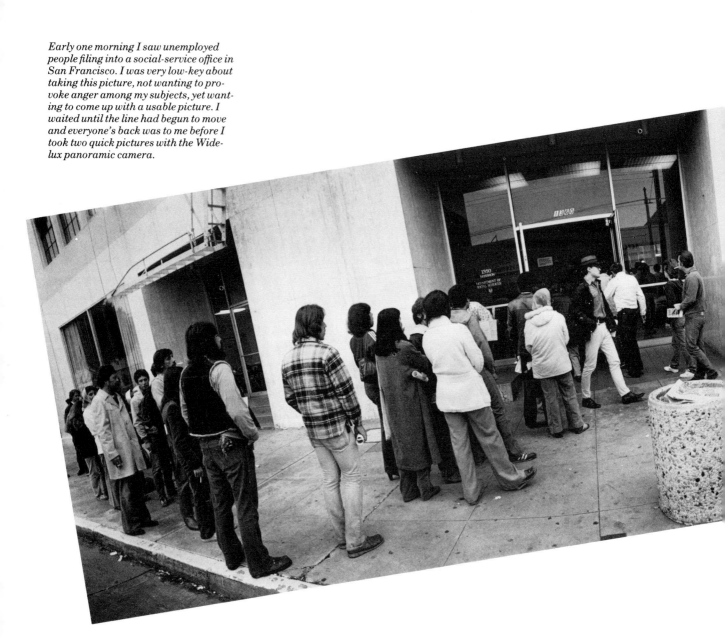

Basically, the law states that if your photograph is used to "inform and educate" the public and does not hold the subjects of that photograph up to ridicule or libel, you don't need special permission to publish it. This proviso allows you to sell to textbooks and news publications without a release.

But it's not quite that simple. First of all, what's a model release? It is a legally binding agreement, signed by the subject of the photograph (or that person's legal guardian, if the subject is a minor), that he or she relinquishes all personal legal rights connected with the use of the photograph. The most important of these rights is the now legally established right of people to be left alone—the right of privacy. This extends to pictures of people, and if releases aren't obtained and the pictures are used in such a way as to violate that right of privacy, the people have the right to bring suit against the publishers of the photographs.

Invasion of Privacy

What use of a photograph constitutes an invasion of privacy? To spell it out, this is Section 50 of the New York Civil Rights Law, which is echoed by similar statutes in other states: "A person, firm or corporation that uses for advertising purposes or for the purposes of trade the name, portrait or picture of any living person without having at first obtained the written consent of such person, or if a minor of his or her parent or guardian, is guilty of a misdemeanor."

In other words, if you're selling the use of stock photographs with recognizable people in them for advertising purposes, you'd better have a signed permission—a model release—from those people or you'll run the risk of a lawsuit.

"Ridicule"?

But that's not the only area where model releases are necessary! Remember that caveat about holding people up to ridicule. What constitutes ridicule? This is a gray area, but to be on the safe side it can be defined depicting the subject of a photograph to his or her possible disadvantage or embarrassment. For example, a picture of a blind or crippled person reproduced in a textbook isn't for the purpose of advertising, but using such a picture could raise the question of whether or not the person would be subject to ridicule or embarrassment as a result of the picture's publication. A textbook editor might ask for a release before using such a picture. You'd run into similar problems with pictures taken in a hospital, mental institution, or prison (assuming you could even get permission to do so)—the pictures might not be marketable without releases.

Libel

In libel cases, the publication of incorrect information is said to result in injury to the reputation of the person depicted in the text or photograph. This is another gray area where the wise tread carefully. Suppose you have a picture of a mother and daughter that a book publisher or magazine would like to use to illustrate some text on adopted children. You'd have no way of knowing just by looking whether the child in the picture was adopted or not. If it was a desirable picture in some other way, could it be used to illustrate that text on adoption? The answer is, "Maybe." *If* the child in the picture has actually been adopted, you could indeed run the picture for nonadvertising purposes without a release. If the child is *not* an adopted child and you run the picture, just about any jury in the land would concur that such misrepresentation is libelous and could soak the publication in question for some serious money. Notice

the difference: Truth is complete defense against a suit for libel. If you tell the truth, you aren't breaking any laws; but if you imply or state a damaging untruth, watch out!

By the same token, if the picture of the mother and daughter were used in some textbook about family life where the child's parentage was not an issue, there would probably be no grounds for any kind of lawsuit—always assuming that the child or the mother was not depicted in an embarrassing way. Conversely, if you had a signed model release from the mother for herself and another for the girl (if under age), you could probably use the picture to illustrate an article about adopted children whether the child was adopted or not: By signing away all rights, the subjects theoretically give their permission for the picture to be used for any purpose whatsoever. Don't push this too far, however. If even a released picture is used in a potentially embarrassing way that is substantially different from the usage the subjects were told about when they signed those releases—and the subjects can prove it—there's a good chance they could successfully sue both the photographer and the publication, model release or not.

The way a picture is presented on a printed page can also constitute libel. Newspapers have juxtaposed pictures of people near headlines of another story, and juries have called the resulting combination of words and pictures libelous. Even though neither the picture nor the headline was libelous in itself, the combination rendered the publication liable.

Protective Captions

Accurate captions will protect you, whether they're quoted in the book or magazine's caption or not. If a publication presents a picture of yours in a libelous way, that's their problem. On the other hand, if the publisher can produce the original picture with a caption by you that gives incorrect information, which the publisher had accepted in good faith, the publication is off the hook and *you* are liable! But if your caption is correct, you're safe. Here, again, truth is defense against libel. It is basic common sense to make your captions complete enough to discourage fanciful interpretations by an overzealous copywriter. Remember that when a publication gets sued for libel they look for someone else to blame, and as an outside (and expendable) supplier, that someone could well be you. Write complete, accurate captions for your own protection.

Model Releases

Model-release forms can be purchased at large camera stores and come in many different phrasings. Some are the so-called "blockbuster" forms that cover every possible eventuality. If you can get someone to sign one, so much the better.

Several shorter model-release forms are available, and these are adequate legal protection in most cases. Their advantage is that they are less intimidating reading for the uninitiated. You're more likely to get a person to sign a short statement than something that looks like an apartment lease. Here are examples of both short and long model releases; you can see how different they look. One is good, the other is better.

How important is it to have a model release? Will you lose sales if your pictures aren't released? There's no doubt that getting releases is difficult, time-consuming, and frequently embarrassing. Is it worth the trouble? That depends on the kind of market you aim for.

EllisHerwig
technical writer/commercial photographer

89 Trowbridge Street, Cambridge, Mass. 02138 (617) 868-6093

---MODEL RELEASE---

For valuable consideration, I hereby consent irrevocably to the use and reproduction of any and all photographs taken of me on this date by Ellis Gannett Herwig, his assigns, licensees and legal representatives, in any form or media whatsoever, including advertising, promotional or trade purposes. The same consent is granted for the use of any printed matter used in conjunction with these photographs. I also waive all rights to approval of the finished product and/or printed matter accompanying its use. The copyright for, and ownership of, all photographic images relevant to this document remains the sole property of Ellis Gannett Herwig.

I hereby warrant and represent that I am of legal age to enter into the contract which this document constitutes. I further warrant that I have read this document and am fully aware of its contents and implications, legal and otherwise.

legal signature of model:

address:

Date:

Signature of parent or guardian if minor:

This is the release form I use for human subjects.

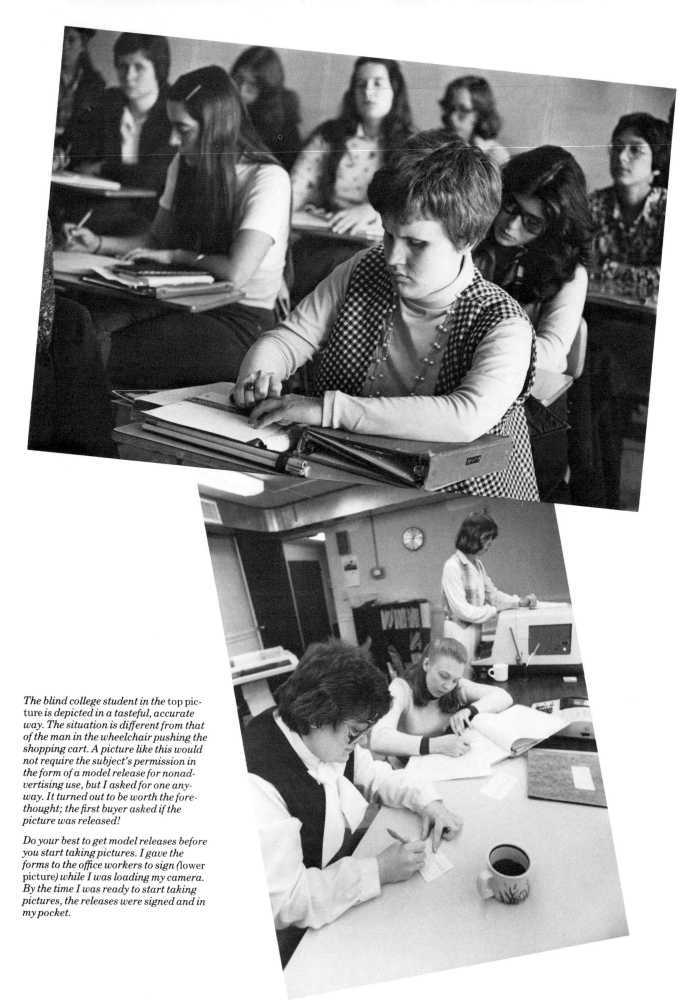

The blind college student in the top picture is depicted in a tasteful, accurate way. The situation is different from that of the man in the wheelchair pushing the shopping cart. A picture like this would not require the subject's permission in the form of a model release for nonadvertising use, but I asked for one anyway. It turned out to be worth the forethought; the first buyer asked if the picture was released!

Do your best to get model releases before you start taking pictures. I gave the forms to the office workers to sign (lower picture) while I was loading my camera. By the time I was ready to start taking pictures, the releases were signed and in my pocket.

Your Audience

Stock photographers who deal with textbook and magazine clients seldom bother with model releases and don't miss much business as a result. These markets are covered by the "educate and inform" exemption. Stock-photograph agencies dealing with these markets are tolerant about unreleased pictures as long as the subjects aren't depicted in a questionable way. You can make a lot of safe sales of stock photographs without having releases.

On the other hand, lots of money is spent for stock photographs in advertisements, and if your subjects are recognizable you must have releases or you won't make sales; it's as simple as that. There are also some areas where releases are important outside advertising, the most notable one being greeting cards. Since you have no control over the interior text that will accompany your photograph in a greeting card, you run a risk of libel in selling the use of an unreleased picture. Since most greeting-card stock photographs are posed, it shouldn't be a problem to get releases from your subjects. Just don't put it off and forget to do it, for it's always the one time you forget that causes problems later on.

Good Habit No. 1: Get a Release

In fact, make it a policy to collect model releases before you even start taking pictures. If you're photographing a family at home, for example, pass the forms around for signing while you unpack your equipment and you can start shooting with this task out of the way. Never put off getting a release from a subject; human nature indicates that you'll postpone it until the person in question has moved away or changed his or her mind about signing.

Good Habit No. 2: Classify It

Some form of classification is useful, allowing you to produce a specific release for a specific picture if it's asked for (some stock users want to *see* the release and have a copy on file before they use a picture—which makes sense). The easiest way to handle this is to integrate your model-release file into your negative or slide file. If you want to refine the technique a bit more, try filing the model release along with a contact print, a photocopy of an enlargement, or a low-price duplicate of a slide to make identification more precise. This kind of classification is particularly helpful for rolls of negatives on which some subjects are released and others are not. Keying your model-release files to specific pictures is the only way you can pinpoint specific people and, although the occasions when you must actually produce a release are rare, it's worth being prepared for them.

Making the Request

It's fine to talk about getting model releases from your photographic subjects, but it's something else to approach people and ask them to sign a legal document, thereby surrendering all their rights in connection with a picture they've never seen. How is this done?

If you're dealing with people you know, there's usually no problem. If you plan a photographic project using a group of cooperative people, signing releases will be the first item of business. But suppose you're taking pictures on the street and you have to ask a stranger for a release?

As with photographing on the street, the positive approach usually succeeds best. A embarrassed photographer who asks a stranger to sign a release will be lucky to escape with nothing more unpleasant than a resounding "No!" The photographer who recognizes both the value of a model release and the feelings of someone who's being asked for one may fare better. Let's say you've

just taken what looks like a good stock photograph of a man walking down the street. He heard the click of your shutter and is looking at you in surprise. Be sure you get in the first word. Make it count.

"Excuse me," you say, "but the law says I have to pay you a dollar," as you get out one of a handy wad of singles.

"Huh? What for?"

"Well, I just took your picture and I'm trying to cover this list I got from a schoolbook publisher who's looking for pictures of someone like you," you say as you pull a handy want-list from your pocket. "You're exactly what I need," you add, "but these pictures have to be released or they can't be used in the book. I can't ask you for a release without paying you a dollar." At this point, get out a copy of the most unintimidating release form you can find.

"What's a release?"

"It's your permission to sell the picture. I've got to pay you a dollar for it."

"A dollar? To sign that? That's what those models in *Playboy* sign, huh?"

"Yeah. Same thing." At this point, stop talking! You've made your pitch, offered money, complimented your subject, and handed over the release form. The rest is up to him or her.

Don't force the issue. No single picture is that important. But you'll find that offering to *pay* for a release and being informative about what you're doing and why can allay a lot of suspicion. You're being honest, and what you're asking for sounds reasonable.

"If I sign this, do I get a free print?"

"Sure."

"Okay. Where do I sign?"

This approach doesn't always work, of course. Lots of people won't become any more cooperative by the offer of a dollar. In fact, some will be *more* suspicious. But this approach is a vast improvement on the outright request for someone's signature on the bottom line of a document. Furthermore, it makes sense to offer to pay for a model release; if it wasn't valuable to *you*, you wouldn't be trying to get your subjects to sign. Spread the wealth around a bit. A dollar for a release not only isn't very expensive, but it's also good discipline. If you pay a dollar to every good subject, you'll shoot more carefully.

If you feel sheepish about this whole procedure, comfort yourself with these thoughts:

☐ The more you ask for releases, the easier it gets.

☐ Being open and honest—and offering money for the release—works more often than it doesn't.

Releases Are Worth the Trouble
An executive at a major New York stock-photo agency that has many big-money advertising clients says that a released picture is *ten times* more saleable than the same one without a release. Think of that statistic as you fork over your money and regard it as a minor investment in a valuable property: your pictures.

Houses, Pets, and Land
There are a few more refinements about model releases, the chief one being the property release. This specialized document is a release for a thing rather than a person, which you need when you photograph recognizable private property of all kinds.

Let's say you've taken a picture of someone sitting in front of a house. If

EllisHerwig
technical writer/commercial photographer

89 Trowbridge Street, Cambridge, Mass. 02138 (617) 868-6093

---PROPERTY RELEASE---

For valuable consideration, the undersigned permits the photographing of the property known as:

by Ellis Gannett Herwig and grants him, his agents, assigns, licensees and legal representatives the full right to use and copyright the resulting photographs in any form for all purposes including advertising trade and promotion without limitation, including the use of any printed matter in conjunction therewith.

The undersigned further waives all rights to inspect or approve the finished product or any printed matter which may accompany its use.

The undersigned hereby warrants and represents that the property in question is under his/her legal purview and that his/her signature on this document will be binding. He/she further warrants and represents that this document has been read prior to affixing his/her signature and its contents and implications are fully understood and agreed to.

Date:

legal signature:

address:

witness:

This is the permission form I use for private property and livestock.

you need a released picture, you ask the person to sign a release; but that house is private property and *it* has rights of privacy, too—at least as far as its owner is concerned. You have to get a property release for the house if you want the picture to be fully released.

Here's an example of the kind of property release in use today:

Property releases may seem silly, but there have been just enough cases in which they have become an issue to make them worth knowing about. In one celebrated case a well-known animal photographer photographed a dog as a favor for a friend who owned the dog. So far, so good. But the picture also wound up at that photographer's stock-photograph agency, which sold its use for an advertisement. The dog's owner sued—and collected—saying that the photographer had no right to use his dog to advertise a product.

You may be photographing land that is both recognizable and private property. There have been times when landowners objected to having their property photographed, saying that increased public knowledge of the land's desirability would stimulate unwelcome tourist traffic. In this case, the lack of a signed property release could put you on the spot for diminishing the value of the land. It might be worth the trouble under these circumstances to simplify your caption and not disclose the location. It's a detail, but the law is based on such details.

Make It Clear

Be sure the captions on your prints and slides specify whether the subjects of the picture—both animate and inanimate—are released or not. Have a pair of rubber stamps made up, one saying "R" and the other "NR," to differentiate released and nonreleased work. If you want to make extra sure of getting the point across, have another rubber stamp made up that says, "This photograph cannot be used for purposes of advertising or trade." Add this second warning to the backs of nonreleased pictures.

For more detailed reading in the field of photographic law, both *Photography: What's the Law?*, by Robert M. Cavallo and Stuart Kahan (Crown Publishers, revised edition, 1979), and *Photography and the Law*, by George Chernoff and Hershel B. Sarbin (Amphoto, fifth edition, 1977), are important reference texts that every stock photographer should read. They cover not only copyrights and model releases but also correct shipping and consignment procedures.

Your Shipments Are Valuable

When you send your photographs to a client you are entrusting him with a valuable commodity. If the work is lost or damaged, you are the loser. How do you protect yourself against this possibility?

The most basic requirement is that the photographs be packaged securely. The traditional technique has been to ship slides (fitted into the plastic sheets described earlier) and 8 × 10 prints sandwiched between two cardboard stiffeners held together by a rubber band looped around the corners. This assemblage is then put into a 9 × 12 manila envelope, which is then sealed. It's a perfectly sound procedure that is used every day. A neater way is to ship your work in Calumet envelopes (available in three sizes from the Calumet Carton Company, South Holland, IL 60477). These cardboard envelopes need no stiffeners and can hold a larger load of prints and slides than a 9 × 12 envelope. They're also much more durable than envelopes and can be reused because of their tab closures, which don't have to be ripped open. They cost more

than envelopes with stiffeners, but these professional-looking packages are a wiser choice for your valuable work.

The Consignment Memo

Along with your photographs, you must enclose a consignment memo. Be sure to reserve a copy for yourself. This document is crucial: It is your proof that certain pictures were delivered to a certain person under certain conditions, which that person acknowledges. What are these conditions?

1. *These photographs are offered for one-time use only.* The copyright remains the property of the photographer.

2. *The recipient is responsible for the safety of these photographs while they are in his or her possession.* If a black-and-white print is lost or damaged, the penalty is a certain fee, ranging from $50 to $200, depending on the policy of the photographer or agency. Since a black-and-white print is usually replaceable with a reprint from the original negative, the loss fees for such prints are essentially token penalties. On the other hand, color slides, which are unique and have no negative from which reprints can be made, are another matter. The standard industry fee for a lost or damaged slide is $1500!

3. *All shipping of photographs will be done by a process involving documentary proof of shipping and receiving,* such as registered mail, certified mail, a bonded messenger service, or United Parcel Service.

4. *The photographs may be kept only for a specified time.* Depending on the client, this can range from two weeks (in the case of short-deadline publications) to a matter of months (in the case of textbooks whose picture research can take a long time). If the photographs are held longer without any other arrangements being made, a "holding fee" of so much per day will be billed automatically.

Don't send out any stock photographs unless they're accompanied by a consignment sheet for the recipient to sign and return (in your stamped, pre-addressed envelope!). This is the best way to keep your work legally protected in case of loss by the client.

These are the basic conditions of a consignment. Additional ones can include the type of credit line you desire, if any (you have a right to ask for this, and some photographers build in a penalty clause if the credit is omitted), and whether or not you will be sent tear sheets of the reproduced picture. This second condition is worth including for two reasons: A collection of your published work is useful to you when you start looking for assignments in addition to stock sales, and most payments for stock photographs are based on the size a picture is used—the bigger it is on the page, the higher your fee. Having a tear sheet to compare with the purchase order you've received with the payment allows you to confirm that your fee was in keeping with the way the picture was used.

Additional information on writing consignment sheets and on all other aspects of shipping and handling stock photographs can be found in *Professional Business Practices in Photography*, available for about thirteen dollars from the American Society of Magazine Photographers (A.S.M.P.), 205 Lexington Avenue, New York, NY 10016. You also might ask for a copy of the September 1980 "White Paper" on stock photography, which is a write-up of a seminar held by a group of professional stock photographers and agents for the membership of the A.S.M.P. It makes interesting reading, but bear in mind that both the business guide and the White Paper were written with full-time professionals in mind. The beginning stock photographer doesn't deal in most of the markets described in these publications, but the tips on shooting and discipline are valid for all photographers.

Importance of Letterhead

Give some thought to what you type your consignment sheet on. Investing some money in letterhead stationery and printed address labels for your Calumet envelopes is no affectation but another example of the professionalism that can mean the difference between acceptance and rejection by your unseen client. When you mail your work, remember that your packaging represents you and that the neater it is, the better you look. When a picture editor's mail arrives in the morning, it makes sense that the best-looking envelopes will be opened first and get the most attention.

A good way to save yourself the trouble of typing a complete set of consignment conditions every time you ship out work is to type them on a sheet of paper, leaving blanks for such variables as the length of time your work may be held, take a handful of your letterhead stationery to a photocopying shop, and have the list photocopied onto the back of the stationery. From then on, all you have to do is refer to "the conditions on the back of the sheet."

Records

Aside from setting conditions, a consignment sheet must describe which photographs are being sent. If you use a numbering system for your prints and slides, making out a list shouldn't be too much trouble; but it's also worth your time to add a very brief description of each picture for quick reference—just a few words to jog your memory and allow you to recall the shot in question. Another technique for making a consignment's contents specific is to photocopy all the pictures you're sending and staple the copies onto the consignment sheet along with the written descriptions already there. Keep a set for yourself, too.

Proof of Delivery

A completed consignment sheet has a space for the signature of the editor or researcher to whom you are shipping the work, preceded by the statement, "I, _____, accept full responsibility for the photographs described here under the conditioned detailed on the back of this sheet. Date: _____." Include a stamped envelope addressed to yourself. In your cover letter, describe generally what you're sending and why, closing with a request to the editor or researcher to sign the consignment sheet and return it to you immediately in the enclosed "S.A.S.E." (self-addressed stamped envelope). Enclose a second copy of the consignment sheet for the client's use. Once the signed, dated consignment sheet is returned, you're covered. The recipient has acknowledged responsibility for your work, and if any of the conditions are violated you are in a solid legal position to seek redress.

Shipping and return shipping are still to be considered. There is no reason to insure photographic shipments sent by the U.S. mail. If they are lost, you won't recover more than the value of the photographic paper and film—hardly worth the trouble. For this reason registered mail, which is designed for items of high intrinsic value, is unnecessary for stock photographs. What you're looking for is *documented* shipment, not money insurance. Certified mail, which is cheaper than registered and offers similar documentation (including an optional return receipt, which you should ask for), is adequate for shipping photographs. An alternative is United Parcel Service, which routinely documents both shipping and receiving and for larger packages is cheaper than certified mail.

The point of a return receipt is to prove that your work arrived. In most cases this isn't in dispute; so having that proof available even if you don't use

it is enough. United Parcel Service does not supply this proof of delivery unless you ask for it, but you can get it if needed. The result is cheaper documented delivery.

For shipping only black-and-white prints, the need for documented delivery is debatable. The odds are that the package will arrive, and lost black-and-white prints are less trouble to reprint than to initiate lawsuits over. For this kind of shipment, ordinary first-class mail is fine. You can save even more money by shipping them by third-class mail with "special handling," which arrives almost as fast as first-class. Remember that the recipient will send back your signed consignment sheet—that's the proof of arrival you really need, because it details not just that a package arrived, but what its contents were.

Returns

Calumet envelopes are heavier and a bit more expensive to buy and mail than regular manila envelopes with cardboard inserts, but they are neater and easier for both photographers and editors to use—and also to re-use.

Photographers who make stock submissions commonly enclose return postage. The question is what form this return postage should take. The usual practice is to enclose a stamped, pre-addressed envelope of the same size as the one in which you ship the work, with the same amount of postage as you use to send it. This is all right as far as it goes; but as often as not photographs are returned by the company mail room, which runs one of its own envelopes with your address on it through the postage meter and throws your own stamped envelope away. Instead, try including with the shipment a check for the correct amount of postage. The odds are pretty good that your submission will be returned at the client's expense and your check will be either returned or thrown away, meaning that you wind up not having to pay anything for return postage. With postal rates going up all the time, these savings can add up when you send out many submissions.

Submitting Is Work

If all this—cataloging your work, writing query letters and making follow-up phone calls, photocopying your work, listing it on a consignment sheet, and packaging and shipping it correctly—sounds like a lot of trouble, you're right. If you think it's more trouble than it's worth to make money in stock photography, fine; stay out of stock photography. Anyone who can't tolerate business routines will never succeed in this field because, to work effectively, stock-photo shooting and selling must be organized on a businesslike basis. That's why you can't think of yourself as only a photographer—you're a picture researcher and an office manager just as much as you're a taker of pictures. If using stock photographs isn't made convenient for potential clients, they won't take advantage of them. When you sell convenience, it should extend to the way you deliver your work and follow up on delivery.

The brighter side of the necessary business routines in stock photography is that they will help you to meet a group of interesting and appreciative people—your clients. You'll get the same courtesy and interest that a full-time professional photographer gets, but you'll probably enjoy yourself a lot more. Enjoy the difference. In the long run it will turn out to be your most rewarding payoff.

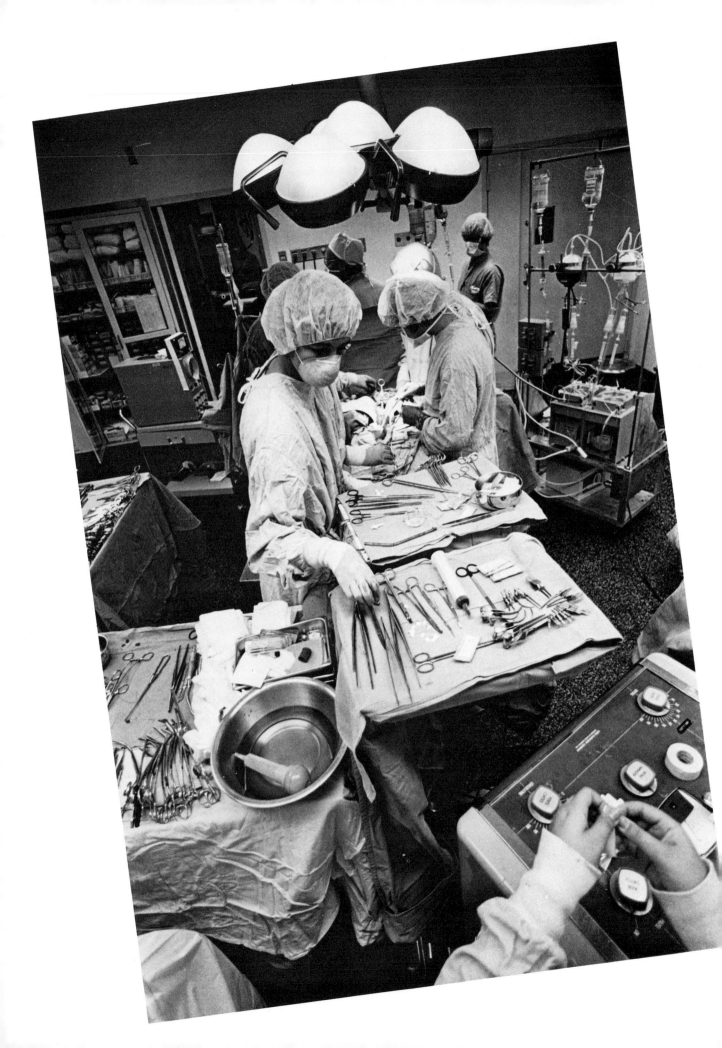

STOCK MARKETING: YOURSELF OR AN AGENCY?

THE MORE RESEARCH you do into the market's needs for stock photography, the more similarities you'll find. The vast majority of requests fall into such areas as family life (including children), interaction between family members, and grandparents. Other commonly requested subjects are

scenic and pictorial subjects
ethnic subjects
school activities, including classroom scenes
close-ups of people of all ages, everywhere
adult activities, including both leisure and employment
travel.

There's no secret about this list; It's been standard in the stock-photograph industry for decades. Most of these subjects are accessible not only to you but also to thousands of other photographers, some of whom can be expected to have the technical competence and business acumen to photograph them and send the results to a carefully researched group of potential buyers. You can expect competition in stock photograph selling.

Can an Agent Help?

Once the amount of work necessary to make a dent in the stock photograph market becomes apparent, reasonable questions are: "Is there any way I can get an agent to handle all the market research, initial contacts, picture research, shipping, follow-up, and billing? Wouldn't my time be better spent behind the camera?" The answer to both is, "Maybe"–depending on your style of working.

The president of one New England stock-photograph agency likens the market to a big roulette game: "Some good pictures never sell, while some 'hot' ones, combining good photography with the right subject, sell immediately. A stock agency can be in there putting the chips down for the photogra-

While photographing a specific type of surgical equipment for a medical magazine, I took this standard shot of an operating room in use. It's general enough to have become a steady seller.

pher while he or she is out taking pictures." He adds that the percentage of submissions that are actually sold is in the single numbers. He makes the idea of joining a stock-photo agency sound very attractive.

Advantages of Selling Stock Yourself

No commissions. The first advantage of personal selling is that you don't have to pay the fifty-percent commission most agencies take out of every sale they make for you.

Deal direct. When you do your stock selling yourself, you deal with the buyers of your work personally. Not only are these contacts rewarding in themselves; they allow you to build up a working relationship. The result can be successful photography on speculation for a client whose needs you keep yourself informed on. It can also lead to assignments when that client becomes convinced of your competence and reliability.

The more top-quality stock photographs you produce, the better your sales prospects are. Stock photography works best as a volume business.

Low turnover. With a small inventory, you can't expect results from a big agency. When you market a few hundred pictures by yourself, you will be keeping more of them in circulation and your selling rate can be higher. You have greater control over your work than you could expect when your pictures are just that many more of thousands in an agency. When you send out your work yourself, you know that it's not just sitting in a filing cabinet.

See result. When a sale is made, you get the satisfaction of hearing from the client, cashing the check, and all the other pleasures associated with a successful business.

Learn saleability. You keep close tabs on what is selling and what isn't. You can fine-tune your submissions more effectively. When your work is at an agency, you have no way of knowing why it's being accepted or rejected by the agency's clients—clients who don't know you and don't want to.

Practice. You have the chance to become a more astute businessperson. You are participating in the marketing process of the stock-photograph industry. The result is a "feel" for the market that many agency photographers never achieve. You may shoot fewer pictures, but your work is more likely to be just right for your clients. You may make more sales. Just because agency photographers take more pictures doesn't mean they take more marketable ones.

These are the positive aspects of self-marketing. There are negative ones as well.

Disadvantages of Selling Stock Yourself

Carry the burden You assume all the work and expense of running a business. Stationery, postage, telephone bills, and all the other overhead come out of your pocket.

Face rejections. Along with all the acceptances, you have all the rejections. You can't expect to make a sale every time you send out your work. The failures require a thick skin and dogged persistence to overcome.

Heavy homework. You have the full burden of market research. All the compilation of likely clients, all the query letters and initial contacts, are yours to make. Often you'll find that the people you talk to aren't interested. It can get depressing.

Small pickings. The money you make may not be very encouraging. The

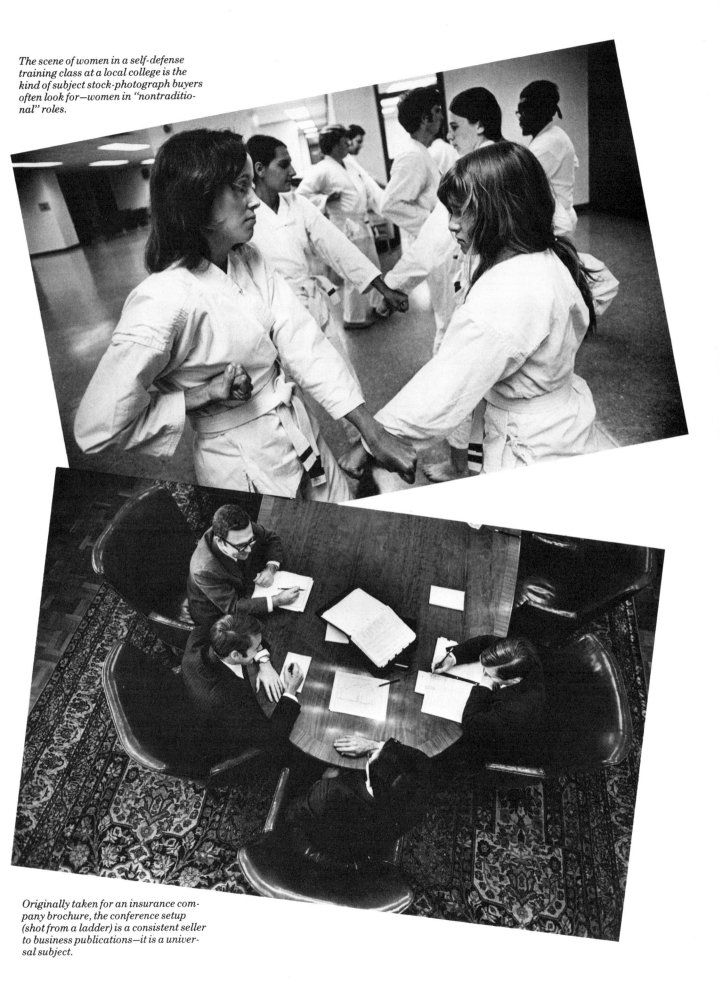

The scene of women in a self-defense training class at a local college is the kind of subject stock-photograph buyers often look for—women in "nontraditional" roles.

Originally taken for an insurance company brochure, the conference setup (shot from a ladder) is a consistent seller to business publications—it is a universal subject.

bulk of the clients you deal with are people who can't afford the so-called minimum prices you'll find in the ASMP business guide mentioned in Chapter Seven. Some stock sales can be as low as ten or twenty dollars. You may think such a sale hardly worth all the phone calls and shipping it takes to make it.

Advantages of Using an Agent

Now does having an agent begin to look attractive? There are more than one hundred stock-photograph agencies in the United States, from small offices handling the work of one or two photographers to huge New York firms representing thousands. What do these photographers get for the agency's fifty-percent commission?

Full-time professionalism. Stock-photo agencies offer full-time professional commitment to sales. It's the only business they do.

Centralization. The organizational advantages of agencies attract many clients who value the cross-referenced filing system that allows fast, efficient picture research. A picture researcher can expect a choice of pictures by different photographers in most subject areas. As a result, more picture research can be done in one place faster.

Business staff. Agencies are businesses with the staff and facilities to deal with greater numbers of clients than an individual photographer can handle. They can expect to make more sales.

Market savvy. Because stock agencies do business with a wide variety of clients, their overall perceptions of the market are likely to be accurate and sophisticated. A photographer whose work is handled by an agency can expect to benefit from this knowledge.

Emotional protection. An agency is an effective buffer against many disheartening aspects of selling stock. You don't get those rejection slips—the agency does. All you hear about are your successful sales.

Shipping and other facilities. Stock agencies save you money. The agency pays the postage, the rent, the phone bills, and the staff salaries.

This rosy picture has another side, however. Not every photographer can expect to find happiness with a stock-photograph agency.

Disadvantages of Using an Agent

Heavy requirements. Stock agencies demand large numbers of top-quality photographs. An inventory that could be expected to make sales for a non-agency photographer might be swallowed up in the huge inventory of a major stock agency, resulting in only occasional sales.

Selectivity. Agencies are choosy about the photographers they handle. Not only do they reject the work of many photographers whose work doesn't meet their standards; they also reject competent photographers whose work duplicates material already in their files. Stock agencies interview thousands of photographers every year. They accept only a handful for representation.

Commitment. Success with a stock photograph agency calls for serious commitment on the part of a photographer. He or she must maintain a steady supply of new, useful material. Prints must be made, slides processed, captions written, and shipments organized for quick evaluation by agency editors. Reprints of successfully sold pictures must be supplied. The photographer is expected to keep up a close relationship with the agency.

Opposite page, top: *Keep an eye out for patterns that are particularly meaningful. A spider's web has many implications: delicacy, precision—and threat, too. Multiple applications make a picture like this one of a dew-dripping web a worthwhile stock photograph.*
Bottom: *I was surprised when this arty aerial stock photograph of Boston's Logan Airport made three sales; however, the sales were all to local users whom one could expect to be interested in a new look at an old subject. It's understandable that no buyers outside Boston were interested—such an abstract picture wouldn't mean much to people who'd never heard of Logan Airport.*

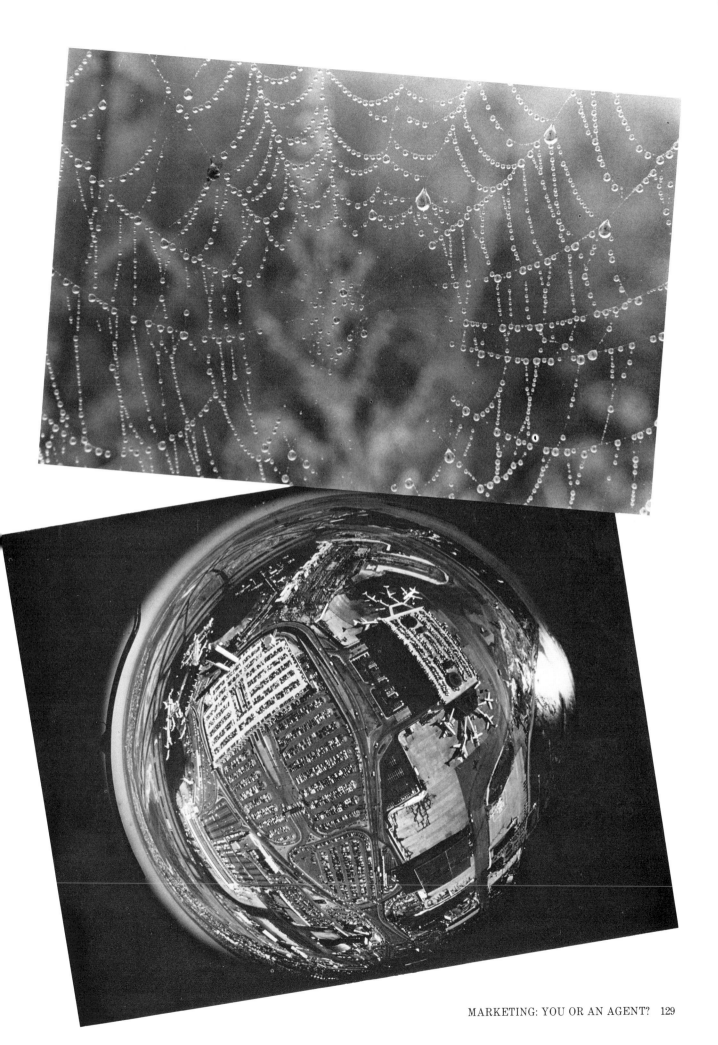

When a stock-photograph agency's inventory is in the millions and its client list in the hundreds, picture organization becomes a big job. This New York agency uses a $50,000 minicomputer installation with a full-time staff to keep track of which clients have which pictures. Information is available on a video screen, and incoming and outgoing picture shipments are carefully logged into the computer.

Some low returns. Even in big stock agencies there are lots of low-price sales. Half of a $40 sale isn't very encouraging after a lot of time spent shooting pictures, making prints, and writing captions.

Hard to monitor. You have no way of knowing the status of your work. Some agencies can take months to edit new submissions and months more before they're correctly filed. All that time your pictures aren't making you any money. You probably won't even be aware of the fact.

Time lag. There's a long time between initial submission to a stock agency and the first sale. It's seldom less than a year, and one well-known stock agent with offices in both New York and Washington, DC, cautions new photographers to expect to wait up to *three* years for the first sales! In this time you can have a lot of self-doubts and second thoughts.

In-house competition. The presence of a large group of top-quality photographers in a stock agency gives rise to feelings of pressure and competition that can quickly turn into bitterness and anger. A lot of the enjoyment of taking pictures can disappear, to be replaced by the cynicism from which enjoyable stock shooting should be free.

Little personal attention. Personal attention in big agencies is minimal. Although stock agencies are dependent on photographers for the material they sell, the big ones give little feedback to their contributors. You may be shooting the wrong subjects and not realize it because your agent is too busy making money to spent time evaluating your work.

Making Up Your Mind

In short, there are two sides to both self-marketed and agency-marketed stock photographs. How do you make up your mind which is better for you?

Pleasing yourself. If you are content to shoot subjects you enjoy and make an occasional stock sale, stick to self-marketing. The personal contacts you make are the biggest payoff.

Special markets. If your areas of photographic interest are specialized, you may reach your markets more effectively on your own. Agencies serve a wide variety of clients. If your work enjoys a narrower clientele, there's little an agency can do that you can't do yourself.

Low volume. If your photographic output is small and you have neither the time nor the inclination to shoot more, you'll do better on your own. Agencies need a lot of pictures.

Personal satisfaction. If you enjoy doing business on a personal basis, self-marketing will be more rewarding than agency selling.

Freedom from pressure. If you don't function well under pressure, self-marketing can be tailored to the way you like to work.

Summary

If you can produce large amounts of high-quality photographs, do market research on a serious scale, and commit time and money to organizing and maintaining shipments of this work to a stock photograph agency that you trust and enjoy doing business with, agency representation may make sense for you.

Here's why stock-photograph agencies need large consignments. These thousands of prints are just part of a New York agency's inventory. It takes volume to make a dent here.

Don Abood, co-owner with his wife, Barbara (background), of The Picture Group agency in Providence, Rhode Island, checks over some slides in his files. This small agency doesn't have computerized filing systems or a midtown Manhattan address, but Don and Barbara's hard work and loyalty to their contributors have put their small agency on the map in less than a year. It's the new agencies, with inventories and client lists to build up, that are particularly interested in productive, disciplined newcomers.

Finding the Right Agency

The first idea most photographers have is usually the worst: Try for one of the famous New York houses. Considering that these agencies are the most famous names in the business, why is this such a bad idea?

Big Stock Houses

The biggest agencies have the biggest inventories. Unless you can weigh in with thousands of acceptable pictures, your work will have a hard time getting established. The biggest agencies handle the work of many prominent professionals who contribute thousands of "out-takes" from their commercial assignments—pictures they were paid to take, including expenses. This is serious competition when your expenses come out of your own pocket.

There is little personal attention at the big stock agencies. The cost of doing business in New York is astronomical, and competition is the sharpest anywhere. The result: Agencies spend as much time as they can making money and as little time as possible talking with photographers. Photographers are expected to know the refinements of the stock-photograph market without being told.

Although the big agencies have their share of four-figure sales to advertising clients, many of their sales are surprisingly small—often less than $100. Stiff New York competition encourages low bidding and quantity discounts. Big agencies don't necessarily make big money.

And Small Ones

If you compare the want-lists of the biggest and the smallest agencies, you will be surprised at how similar they are. Just because an agency is in Providence instead of New York doesn't mean it doesn't need the same subjects. It also doesn't mean that a smaller or newer agency can't serve you as well as a bigger, older one. Many older agencies are inundated with work and have poorer staff organization than new ones, who may have a small inventory of pictures but an energetic staff with a reputation to make. Stock photograph buyers don't care what agency they get their pictures from as long as they get them, and a growing number of small, enterprising agencies are proving that bigger isn't necessarily better.

A small agency has more time to talk to you, more time to explain its needs and markets.

A small agency probably needs to build up inventory. More of your top-quality work will be welcome because it's less likely to duplicate work already in the files.

Smaller inventories make for faster editing, filing, and shipping. When a client needs a picture in a hurry, the small agency can often deliver a picture while the bigger agency is still having researchers wade through the files.

With fewer photographers' work already in the small agency's files, your work will start selling sooner than it would in a big agency.

Many buyers of stock photographs pay the same prices whether they are dealing with a big New York agency or a small local one.

The majority of stock sales are made not from walk-in visits from buyers but through the mail. This means that most stock agencies are competing on equal footing wherever they are. Being in New York is no asset when a customer is in St. Louis. The sale goes to the agency that comes through with the best picture.

The closer a stock agency is to where you live, the more of your work may be useful to it. Local clients go to local agencies for pictures of local scenes. Your

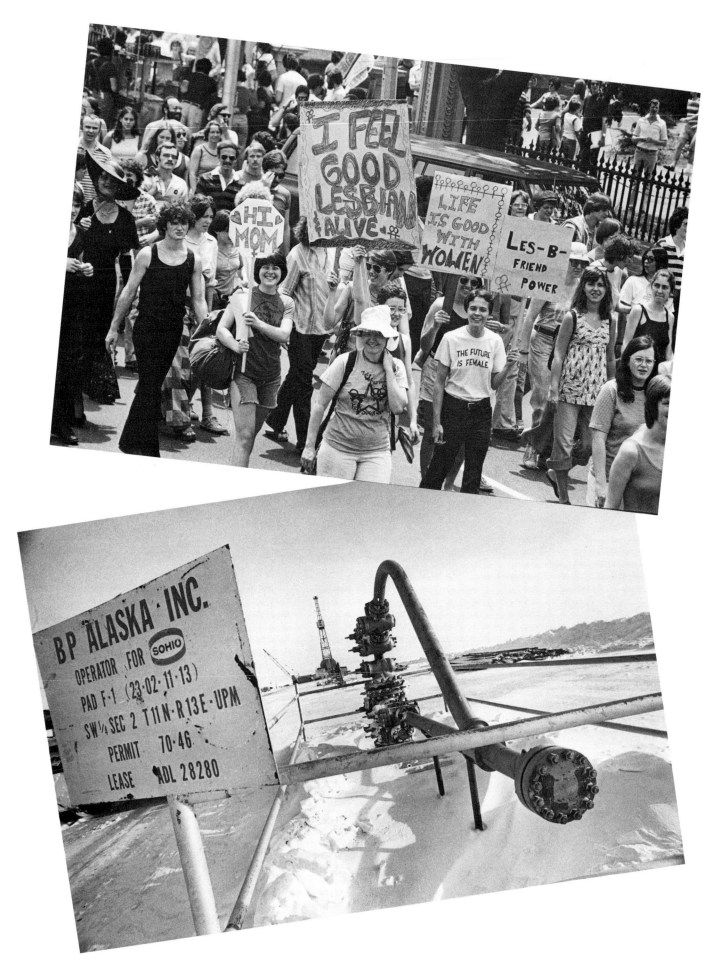

photographs of local subjects are more marketable close to home. A nearby agency can do better with this material than a distant but bigger agency.

How Do You Start Looking?

The first step is to check your local classified phone book under "Picture Agencies." The next step is to check the latest annual *Photographer's Market* and the other directories listed in the back of this book, which list stock agencies all over the country. You also might consider becoming an associate member of the American Society of Picture Professionals. This organization is composed of photography editors, stock-photography executives, researchers, art directors, and other picture users. There are branches in Boston, Chicago, New York, and San Francisco. The society publishes a newsletter that carries much useful market information and is helpful for evaluating different agencies. An associate membership in the A.S.P.P. (P.O. Box 5283, Grand Central Station, New York, NY 10017) costs $20 a year (as of 1981).

You can ask if the local advertising agencies and publishers deal with any nearby stock agencies. You should also ask their opinions of these agencies, as well as what pictorial subjects they have requested.

Query and Follow-up

When you have collected the names of a few likely agencies, write each one a query letter describing your interests, capabilities, and inventory. Send a *few* carefully chosen samples of your work and ask if they would be interested in talking with you. Give it a couple of weeks, then follow up with a phone call if you haven't had a reply. Don't be discouraged if you are turned down. An agency might reject a competent photographer whose work is similar to one they already represent. Other agencies may not have the staff to handle a large group of contributors. Some may just not be interested. There are other agencies you can try, and you can always sell on your own.

As with market research, it pays to be thorough. When you query a stock agency, spend some time checking out what kinds of clients it serves and what subjects it specializes in (both *Photographer's Market* and the A.S.P.P. can help you with this). If your interests don't match, you could hardly expect that agency to have any use for you.

Again, pay special attention to *new* agencies. Such places are more likely to seek contributors than established organizations with longtime contributors and large inventories. In the past few years there has been a spurt of growth in new stock-photograph agencies. The market is expanding and a new, young group of agency entrepreneurs is responding. Your interests may be similar to theirs. What counts is not an imposing office or a Manhattan address. Market perceptions, expert editing, and well-organized business procedures are what sell good stock photographs.

What They Want to Know

Assuming that stock agencies are interested in your query letter ask you to come in for an interview, what will they want to know about you and what will you want to know about them?

An agency will want to see more of your work, but still a representative sample. Don't bring in cartons of prints until you're asked to do so.

Is your work of the quality the agency needs? Substandard technical and visual quality won't even get to first base.

Be prepared to describe the range of your interests. An agency wants photographers who are likely to produce the sort of pictures the agency's clients ask for.

Stock photography is often obliged to deal in oversimplified clichés. In the upper picture, modern causes can offer such classic images: I spent two hours shooting a gay-rights parade and sold a dozen of the pictures over the next two years. The lower scene is the standard one all photographers seem to take when they visit the Alaskan oil fields and, besides, it has the identifying sign nice and big in the foreground. For all that, it's been a frequent seller.

How well organized and reliable are you? If the agency needs a fast reprint or some additional caption information, will you be available to supply it? Stock-photo agencies are convenience businesses, and if you want to make use of their services, you'd better be in the same business.

How productive are you? While the average agency would like a minimum initial submission of anywhere from 300 to 800 organized, captioned, top-quality pictures from a new contributor, it is just as concerned with how much *more* work to expect from you over a period of time. This isn't just for its own financial good (and yours); it's for your mental well-being. Small inventories in an agency's files can't be expected to make big sales, no matter how good they are. Making one or two sales a year, you're unlikely to maintain the enthusiasm necessary to keep shooting, captioning, and contributing good pictures. Tales have been told of angry phone calls, nasty letters, and even threatened lawsuits by photographers who don't understand that a dozen good pictures won't make many sales when they are mixed in with 50,000 others. The more good pictures you can be expected to keep contributing, the more use an agency has for you. When you consider that submissions are subjected to tight editing—a major New York agency estimates that it accepts seventeen percent of submitted work for its files—you can understand the need for volume.

A stock-photograph agency that handles your work is going to invest time and money in you: Your work must be edited, filed, researched, and submitted. Someone has to be paid to do all these tasks. You may take photographs on faith, but an agency has to have the same faith in you if it's going to promote those photographs to your mutual benefit. The agency has the right to expect professional qualities from you. You have the right to expect the same from the agency.

What You Want to Know

Here are some questions you should ask about the agency. What kinds of client needs does it handle? Are these the kind of pictures and subjects you like to shoot? How many photographers does the agency handle? Will the agency put you in contact with some of them to get an outside opinion of the agency's quality? How much personal attention can you expect to get? Will the agency help you refine your photographic skills to serve your mutual needs better?

How much money can you expect to make? This is a very difficult question to answer. It's not ethical to ask how much each of the agency's photographers made last year. More important, such figures would be meaningless without interpretation; you'd need insight into inventory size, subjects, time with the agency, and rate of contribution. It's reasonable, however, to ask an agency executive to make a *conservative estimate* of how much you *might* expect to make from a picture inventory of a particular size work over a certain period of time *after* the preliminary start-up period (when you can't expect to make any sales at all). Bear in mind that this figure would be approximate, and that you have no right to ask for it in writing. Picture selling is governed by many factors that are beyond the control of even the most professional agency: changes in subject needs by clients, financial condition of clients, and the vagaries of human taste exhibited by picture editors and researchers.

Along with this estimate, it's appropriate to ask for a guess of how long the start-up period will be. As has already been said, it can range from a year to three years at most agencies. On the other hand, some photographers have

made sales in the first few months with small agencies where new work is sent out for submission almost immediately.

Does the agency pay quarterly or monthly? Do you get invoices describing what pictures have sold? This is vital for your market sense. If you don't know what's selling, you won't know what subjects to keep shooting.

What's the policy on pictures that sell? Many agencies routinely ask for one or two reprints of every black-and-white print sold, on the logical theory that one good seller deserves another. This means that having a well-organized negative filing system can make a big difference in the speed with which you meet an agency's requirements—and in the number of sales you make.

Does the agency routinely send out original color slides for submission? This can make a big difference in how much you spend for color film, not to mention in your shooting habits. Since original color slides are unique, one slide can't be sent to more than one prospective customer at a time. Given the low "buy rate" in stock-photograph submissions, this means that a single original color slide is much less likely to make a sale than a comparable black-and-white shot that can produce countless prints of equal quality and be submitted to many clients simultaneously. Some agencies try to get around this problem by keeping original slides in the office and sending out to clients duplicate slides for editing purposes. In some cases these duplicates are of reproduction quality, obviating the need for an original. If the agency in question has this policy, it means that one color slide *can* be submitted to several clients.

If the agency sends out only originals, however, it means that you'll be wise to shoot extra originals when you're taking pictures. This means more film expense for you, plus a preference for subjects that will hold still for extra pictures. On the other hand, agencies that do extensive duplicating charge the photographers for this service. Be sure to ask how this billing is done. One big agency with an extensive duplicating program advances the expense of duplication, taking twenty percent of each quarterly sales payment until the "repro dupes" are paid for.

Does the agency handle black-and-white and color, or only color? Most handle both, but some agencies with many advertising clients handle color only. Not only does this mean a difference in your inventory and working habits but it can also make a difference in whether or not the agency demands an exclusive contract.

"Exclusive" contracts. An exclusive contract says that for a certain period of time (usually five years) the agency will be the only agency handling your work (although you are still free to make sales yourself). The idea behind this is that the agency will be spending money to handle your work and wants to be sure no other agency is competing to sell the same pictures.

Opinions on exclusive contracts vary widely. Many stock agencies do not ask for them. Some impressive ones do, saying that making an agency your exclusive seller encourages more agency commitment and discourages competitive bidding for your work, which would inevitably lower the money paid for it.

The other side of the argument is that various stock-photograph agencies serve different parts of the market. Having your work in only one agency means that, no matter how effectively that one agency markets your work, you will be missing out on sales that the agency doesn't even try to make.

If an agency you are considering requires an exclusive contract but handles only color, you naturally have the right to take your black-and-white prints elsewhere. If the agency does not require exclusivity, a certain amount of eti-

quette is in order. Play fair: Don't give your work to two agencies that serve the same market unless both agencies consent. On the other hand, photographers frequently supply different work to agencies that are in different parts of the country or that serve different markets. This isn't unethical, just enterprising.

Approach exclusive contracts with a certain reserve. Some agencies make much of exclusivity, saying it's the only ethical way to do business (in fact, the A.S.M.P. has a model contract drawn up for the purpose; it's in the A.S.M.P. business guide). Is this true? That depends as much on the agency's organization and effectiveness as it does on the theoretical advantages of exclusive representation. If an agency wants an exclusive, make sure they deserve it. Talk to some of their photographers (and clients). Some very good agencies do not warrant an exclusive contract.

Incidentally, the model exclusive contract from the A.S.M.P. allows the agency involved to drop you and your work at any time if your sales are not up to what it regards as the correct level. On the other hand, *you* can't get out of the contract unless the agency lets you out.

New vs. Old Agencies

The agency wants to know a lot about your record and reliability; you have every right to know the same about the agency. What's the history of the agency? How long has it been in business and how successful has it been?

These are important questions for both new and old agencies. New agencies are often started on slender capital and may have trouble maintaining the staff and facilities to market stock photographs effectively. On the other hand, the dedication and enthusiasm of a new and enterprising staff may make up for short capital. Ask how much the agency's sales have *increased* over a given period. Ask what its cash-flow situation is (always a crucial matter to a business—is the money coming in fast enough to pay the bills?). Ask about the background of the agency executives: Does their experience seem to be appropriate for the kind of work they're trying to do?

Old agencies, on the other hand, can suffer from huge, ill-organized inventories and sluggish management. Like any other long-established business, they may feel that the old ways are still the right ones. Sometimes this is true. Other times, old agencies have revamped their procedures and are doing better business than they ever did (the booming stock-photograph market certainly makes this possible). Still other times, an old agency with a multimillion-picture inventory can't compete with new, young agencies with small but well-managed inventories. Question both new and old agencies very carefully. Bigger and older isn't necessarily better, for the smaller agencies have access to the same markets as the others.

Stock photo users want pictures. Which agency or photographer they get them from is of secondary importance, as long as they are the right pictures at the right time.

How Do You Feel About It?

All these considerations are unimportant if the personal chemistry is sour. Do you like the agency executives? Spend some time in the agency watching the staff do their work. Would you feel comfortable having them handle *your* work? When you don't get any sales for months or even years, do you think you can maintain your trust in that agency? Do you feel the agency will put its market knowledge to work for you, not only in selling your work but also in

The guard at Whitehall, London, makes a postcard scene. So take it! Someone has to shoot postcards; it might as well be you.

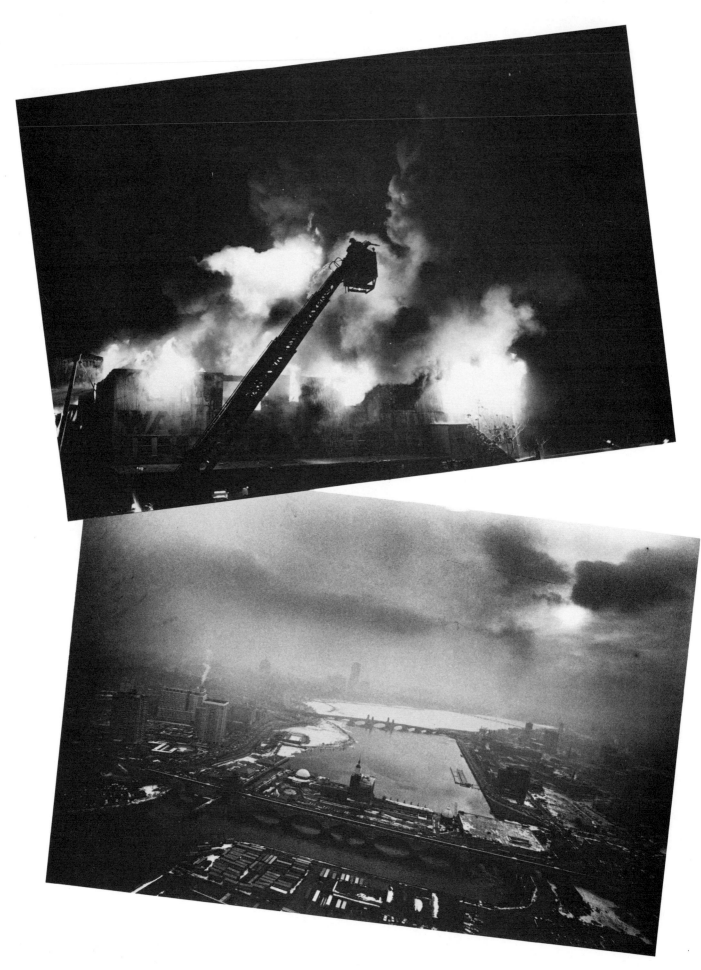

keeping you apprised of market trends that can determine what subjects you should be shooting? Are these the kind of people on whose behalf you would be willing to take thousands of professional-quality photographs?

Distance From Your Market

When you sell stock photographs yourself, you have a choice of thousands of markets. Some will buy, some won't, but you have the advantage of market feedback from all of them. An agency photographer has only the agency. It may promote your work in a businesslike way, but it robs you of the feedback you'd get from personal selling. Therefore, you have to feel comfortable with the feedback you get from that agency. The agency is your alter ego. The relationship between you and the agency can encourage you to produce great work or make you bitter and distrustful, destroying your productivity and eventually your interest in stock photography.

Don't make this choice of agencies lightly. Don't be overly impressed when an agency president trots out impressive figures for so-and-so's stock sales last month or last quarter. That's someone else, not you. Just as much as a marriage, this is a relationship that has to be right to work, and what makes it right is different for each individual.

Be Cynical About Agencies

Finally, don't be overly impressed with the idea of stock-photograph agencies. They aren't right for everyone, and they can be counterproductive for the kind of person who takes only a few pictures that he or she truly enjoys taking, selling them to one or two clients who appreciate the skill and enthusiasm that makes the stock photography field open to any photographer with the talent and discipline to take advantage of it.

Upper picture: *Many fire pictures show a specific, recognizable locale, and are thus poor choices for stock. This silhouette could be symbolic of any fire and is therefore a much better stock possibility.*

Lower picture: *Traveling with my camera handy, I caught this smog-ridden scene of Boston from the window of a returning airliner. It was a miserable job to print; but this spectacular view of urban pollution has sold dozens of times over the years. It illustrates a subject people are always writing about—and need to illustrate.*

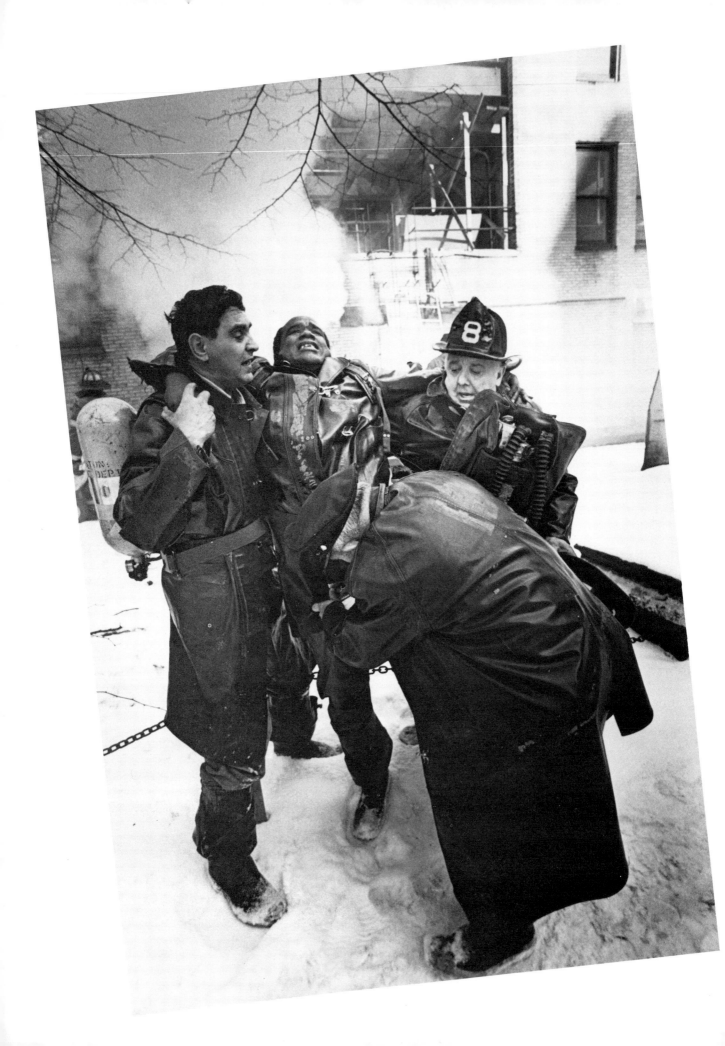

THE STOCK PHOTOGRAPHY SUCCESS LIST

THE FOLLOWING CHECKLIST is not intended as a textbook-style review of this book. Rather, it is meant to share some of the author's thoughts on things the successful shooter of stock photographs would like to know.

1. The less you think like a photographer and the more you think like a picture researcher with a camera, the more good photographs you'll take. The conventional orientation of most photographers is heavy on esthetics and art, light on content and market appeal. Remember that stock photographs are *components* of communication, seldom communications in themsleves.

2. Don't read photography magazines except for the technical features and mail-order equipment ads. Photography magazines are like movie fan magazines; they tend to depict photographers as superstars. Stock photographs seldom wind up in these magazines, and stock photographers seldom get written up in them. The minuscule minority of photographers you'll read about there probably have nothing in common with you beyond the fact that you both take pictures.

3. Don't look upon stock photography as the road to wealth. Even the productive professionals with large stock inventories don't make anything close to a full-time living out of stock. They regard it as an enjoyable extra payoff. The biggest attraction of stock photography isn't money but the fact that both amateur and professional are equally welcome as long as their work is equally good.

4. There are few big-money sales in stock photography. A fortunate few can brag about thousand-dollar prices for a single picture, but the vast majority of sales are under a hundred—sometimes *way* under.

5. Fight the tendency to regard abstract pictorial beauty as the most important consideration in your photography if you expect to make stock sales. Content counts for more than beauty, and enjoying the process takes precedence over both. Many dull-looking stock photographs sell, and if you don't enjoy the whole stock photography game, you won't enjoy taking them.

Spot-news pictures are usually too topical to be good stock sellers, but the lack of identifying detail in this one made for a stock sale.

141

6. Therefore, never be too proud to shoot routine pictures—and enjoy them. These are the ones most photographers pass up. Which feels better: the self-righteous glow of superartistic achievement or the pleasure of endorsing a check from a successful sale?

7. Portfolios have a legitimate place in the pursuit of photographic assignments when you're selling the likelihood that you can be trusted to produce a photograph on demand. In stock photography, though, you're selling your pictures, not yourself. Don't show anyone pictures that aren't likely to be immediately useful. You're not trying to impress anyone; you're trying to make sales.

8. When you shop for a stock-photo agent, don't be unduly impressed by the big-name outfits. Much more important is your relationship with the agency. If the agency likes you and your work—and has a *need* for it—you're headed in the right direction. When your stock photographs are handled through an agency, you sacrifice contact with the market. The photographer-agency relationship must therefore be positive and productive.

9. Don't take an agency a few dozen pictures, however good, and then get upset if they don't sell. An inventory of this size is almost not worth handling (and many agencies won't do so). Unless you produce a large volume of top-quality work, agency selling isn't for you.

10. Stock photography is a convenience business. Some conveniences worth offering include

maximum caption information
fast service on requests
fast printing and reprinting when necessary
high technical quality
well-organized files
close, perceptive contact with clients
sales follow-up
productivity.

11. The more personal contact you have with the people who buy or may buy your stock photographs, the better off you'll be. Don't just mail your work in; call and talk to the people involved. This is not only basic professionalism, but also a crucial lead to understanding your clients' needs, both current and future. Effective follow-up leads to assignments and guaranteed money. More important, it's very rewarding to deal on this personal level with people who take you and your work seriously.

12. Before you spend your money on long-distance phone calls, check to see if your clients have a toll-free "800" number by calling the 800 number information service at 1-800-555-1212. It can save you a lot of money.

13. You'll find that most habitual stock photograph users have a certain price range for a given need. If you're making your first or second sale, price yourself low. You can raise your prices later once your foot is in the door, but a newcomer has no right to ask for top dollar.

14. Don't spend any more money than you have to on postage. If you're sending a heavy shipment a long distance, you may find that third-class postage marked "special handling" is cheaper and not much slower than first-class mail. But check at your post office. For short distances, first-class may be cheaper. Another option is United Parcel Service, which also keeps shipping records on everything it handles.

Opposite page, above: *Taken for, and rejected by,* Time *magazine, the classic shot of police escorting school busses has sold at least fifty times to textbooks and magazines on urban life, sociology, racial integration, and other subjects.*

Opposite page, below: *Some photographs just cry out to be taken. I had a few hours to kill in Baltimore and was driving around town in a leisurely way when I caught sight of this census taker at work. The shoulder-bag emblem made the scene perfect. Hurriedly I parked my car and grabbed the picture. Unlike most stock photographs, which usually spend a year or two in agency files before they sell, this one wound up in a news magazine only two months later.*

15. If you expect to write a lot of similar captions, a "base lock" adjustable rubber stamp, available from large stationery stores, can speed things up by allowing you to create a special phrase of your own.

16. News pictures are often too topical for stock photographs, but news *situations* are often highly productive. Look past the topicality to the human universals exemplified in many news situations (happiness, achievement, everyday life, and so on). That's where you'll start to see useful subjects to add to your inventory.

17. Doing volunteer or part-time work for a local paper is a very good way to find stock photographs. Pass up the hot-news work (which all the other photographers want to do) and take the routine assignments instead, such as cake sales and check-passings. These everyday situations can produce stock photographs that you'll keep selling forever.

18. Beware of making too many comparisons between news photography and stock photography. Both require simple, effective compositions that evoke fast viewer recognition, but stock photographs are best when they lend themselves to wide, diffused applications. The topicality of many news pictures militates against their usefulness in a stock file.

19. Seeing stock photographs is an acquired skill that can be practiced. Make it a habit always to look around you at details, looking with a picture researcher's eye, even when you aren't taking pictures. The more you school your looking, the more you'll see.

20. Stock-photo shooting should be looked on as a way of structuring your photographic efforts just as much as a way of making money. Stock photography is well paid only in large volume, but it's enjoyable at any level. Use want-lists and market research to lead you to subjects you enjoy photographing. Money is secondary. (And no, this does not contradict No. 6 in this list.)

21. The more market research you do, the better stock photographs you'll take. Make it a habit to research at least one new potential stock photograph client per week. Send for sample copies, want-lists, or submission guides. Cultivate as many contacts as you can—there's an infinite number of them.

22. Don't try to cover the whole market. Stake out the parts of it that interest you and where your work is welcome. Good photography is needed everywhere, but it's unlikely that the same photographer can expect to be welcome everywhere. If you spread yourself too thin you'll never make any progress because you won't have the time to be persistent.

23. The more you plan your stock photography work, the more you will benefit from serendipity: the chance of coming on photographically desirable situations that you *didn't* plan. Careful planning usually is the first step toward good luck.

24. Read want-lists with care. Don't attempt to cover every subject or need because you'll be setting yourself up for disappointment. You're not the only photographer to get that list. Stick to subjects you like to photograph whether or not you can get paid.

25. The more information you can put into the letterhead on your stationery, the more selling you can expect it to do. If there are certain subjects or areas of stock photography you specialize in, say so. Who knows? It might make you an extra sale.

26. Cultivate as many local clients as you can. You'll find that they use more locally shot material, and because of their proximity, you'll enjoy closer personal ties.

27. Try to make your stock photographs as timeless and universal as possible. Avoid fashions that may change, including cars, hairstyles, and topical mannerisms. The less dated a stock photograph is, the longer its life.

28. Try to keep identifying details out of your stock photographs unless they're essential to the success of the pictures. Dated calendars, prominent street signs, advertising billboards, and company trademarks all limit the applications of your work—unless they are wanted for *historical* interest.

29. The wider the variety of pictures you can supply, the more convenient your inventory will be for a client to utilize. Don't shoot one version of a picture when you can shoot several (vertical, horizontal, wide-angle, telephoto, black-and-white, color).

30. Make stock photography a group effort whenever possible. For example, get a family together, show them some want-lists, and see how many photographic situations you can come up with. People enjoy participating in projects like this. Get all the help you can; you'll be surprised how willing your subjects can be.

31. Keep an eye out not only for traditional scenes such as mothers and children but also for more contemporary manifestations of the same—such as fathers taking an active role in parenting. If they represent ethnic minorities, so much the better. The same themes crop up time and again in stock-photograph requests and modern variations are needed, particularly for constantly revised textbooks.

32. Keep a pad of model releases in your camera bag along with a wad of dollar bills and several ball-point pens. You'll find these fingertip resources make it that much more convenient to ask for signed releases when you're out taking pictures.

33. Model releases may make your picture more saleable, but there are thousands of legitimate markets for nonreleased work. If asking for releases cramps your style severely, just keep shooting pictures and forget the releases. It's better to have good unreleased pictures than no pictures at all.

34. When you take stock photographs while on vacation in foreign countries (or elsewhere in the United States, for that matter), be sure to get complete caption information:

exact locations
names of buildings or historic structures
correct spelling
any other relevant information, such as resort amenities

This kind of information is easy to forget if it isn't written down, and its lack can mean the difference between making and losing a sale because producers of travel brochures have to be sure they know what place they're selling. Furthermore, the more complete the caption information, the easier your filing tasks.

35. Never go anywhere without your pocket camera. It won't be right for every picture; but if it's the camera you're carrying, it's the camera that will take the pictures that find you.

36. Always assume that your stock photographs will be reproduced under the worst possible conditions: used very small and printed with low-quality inks and paper. Therefore, aim for tight, simple compositions and light, snappy prints that won't turn muddy when published on poor-quality paper. Lots of stock-photograph users can't afford quality printing any more than they can afford assignment photographers.

37. Whatever else you shoot, get lots of close-ups of people. These pictures, which don't show clothing or surroundings that may become dated, are major stock sellers for many needs, especially to portray different ages or emotions.

38. Shoot lots of black-and-white pictures. In editorial use they outsell color fifteen-to-one, and you can shoot under a much wider range of conditions than with color. Black and white won't make every sale, but it will make more sales than color in the editorial-textbook stock-photograph market; and playing the averages is an essential facet of successful stock photography.

39. Shoot a ratio of at least ten-to-one for quality stock photographs—more if you're a beginner. (In Hollywood, the ratio of film shot to film used in a final production is at least twenty-to-one!)

40. Always carry more film than you think you'll need—a lot more.

41. If you do much color shooting, check into contrast-control slide duplicators—for example, the Matrix Reprobox from Leedal, Inc. (1918 South Prairie Avenue, Chicago, IL 60616), and the Bowens Illumitran from the Bogen Photo Corporation (100 South Van Brunt Street, Englewood, NJ 07631). These devices allow low-contrast duplication of your slides onto Kodachrome. If properly done, the dupes will look like originals on Kodachrome, everyone's favorite color film. And check out new duplicating films for use with less expensive duplicating devices.

42. Remember that stock photography constitutes a legitimate business activity and thus entitles you to tax deductions. Check with the Internal Revenue Service for guidelines about establishing it as a second business. This will add up to a tax refund and is completely legal. Just be sure that you follow the rules.

43. Don't give stock photographs away to anyone. Many nonprofit organizations would like to have free use of pictures, but it's almost always a bad idea to accede to such requests. When you give something away, you may in the long run feel cheated. You invested money to take your pictures, and someone else should pay money to use them. There are lots of buyers out there with money in their pockets. Do business with them.

44. Do your composing with your eyes rather than squinting through the viewfinder on the camera. That is a very conspicuous action. The more obvious you are about taking pictures, the less natural people will look in them. Use a minimum of equipment, learn all its capabilities, and don't put that camera to your eye until you're ready to take a picture.

45. Time you spend adjusting your camera is time taken away from shooting pictures. Make using your camera automatic. How? *Practice!*

46. Lots of good stock photographs are close-ups. Practice fast, careful focusing to get them sharp, for when you're working in close, you're that much more noticeable and focusing is that much more critical.

47. Do *not* announce yourself as a professional when you're shooting stock photographs. Coming on like an enthusiastic amateur is not only a good idea for quality pictures, but also it puts your subjects at ease.

48. Don't have your subjects look into the camera. They'll almost always look self-conscious, and such photographs are poor sellers.

49. Direct-flash-on-camera shots are almost unsaleable for stock uses. If you must shoot stock photographs with flash, use bounce or bare-tube light with an automatic-exposure unit.

50. Don't judge camera bags by the way they look in a store. The best bag is the smallest, least conspicuous one you can find. Try an army surplus gas-mask bag; they're cheap, small, and don't look like camera bags. Keep your loose

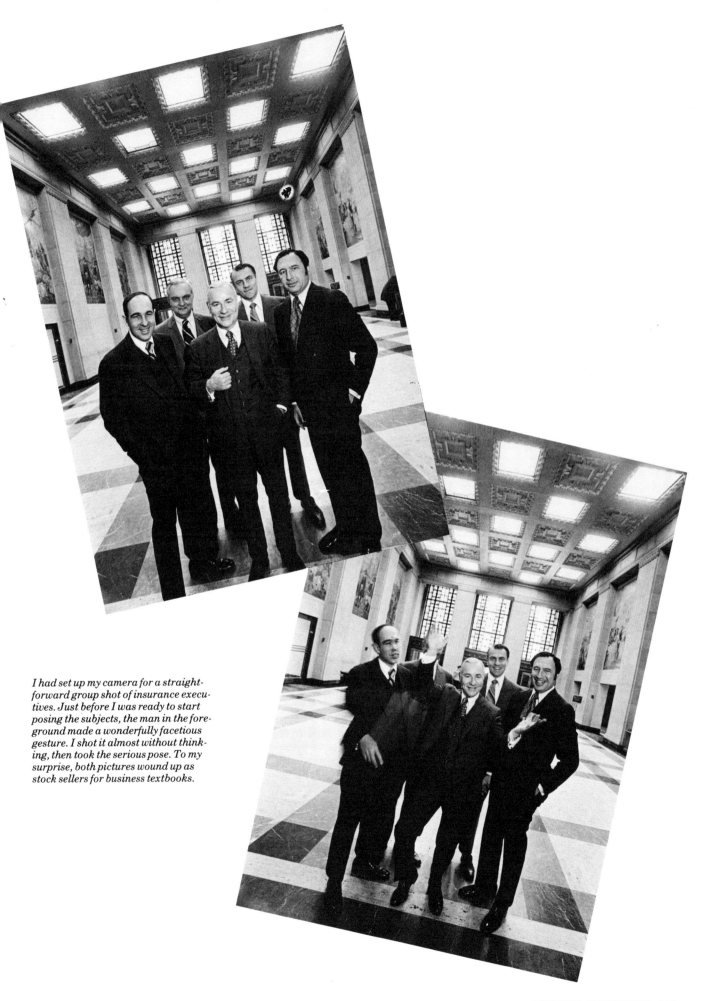

*I had set up my camera for a straight-
forward group shot of insurance execu-
tives. Just before I was ready to start
posing the subjects, the man in the fore-
ground made a wonderfully facetious
gesture. I shot it almost without think-
ing, then took the serious pose. To my
surprise, both pictures wound up as
stock sellers for business textbooks.*

lenses in pouches like the zip-top "Cam-Accessory" ones from J. B. Perrin & Co., Inc. (7777 Cortland Avenue, Detroit, MI 48204).

51. Photographs incorporating arty darkroom tricks like high contrast and solarization have a certain market among poster makers and darkroom magazines. The market is relatively small, but it does exist for those who want to take advantage of it.

52. Be particularly thorough about your research before you travel to a foreign country with which you're unfamiliar. It's all too easy to look upon the natives as cute or exotic, and the resulting pictures will have a patronizing quality with poor stock possibilities. Stock photographs are descriptive, and the greater your understanding of a country and its people the more effective your stock photographs will be.

53. In foreign travel, you will find you have less hesitation about taking pictures of the people if you can speak the language. Both you and your subjects will be more at ease.

54. When traveling overseas, be sure to declare your equipment with the U.S. Customs Service before you leave or you'll have a hard time bringing it back into the country. Type a list of your equipment, complete with serial numbers and your name and address. Take two extra copies and your equipment to the customs office in your town, if there is one, or at your point of departure. The officials will spot-check your equipment against the list and issue a statement that the equipment has been declared. That way, there will be no chance that you will wind up on your re-entry having to pay duty on equipment you already own.

Of itself, this is a nice picture of a zebra at the Smithsonian zoo in Washington. By printing it on a contrasty No. 5 paper, however, I created an abstract effect that might appeal to buyers of stock photographs for poster or other graphic-arts uses.

Special Interests of Some Stock Photo Agencies

Specialty

Agency Name	Black-&-white	Color–35mm	Color–Large format	Accepts assignments	General stock	Features	News	Celebrities	Movie stills	Historical	Natural history	Fine arts	Industrial	Agriculture	Food	Sports	Glamour	Human interest	Scientific	Geographic	Still life
After-Image, Los Angeles		X		X	X	X	X	X	X	X			X	X	X	X	X	X	X	X	X
Animals Animals, New York	X	X	X	X							X										
Peter Arnold, Inc., N.Y.	X	X	X	X	X	X					X		X	X	X				X	X	X
Black Star, N.Y.	X	X		X	X	X	X	X			X		X	X	X				X	X	X
Camerique, Bluebell, Pa.	X	X	X	X	X				X	X			X	X	X		X				X
Woodfin Camp & Associates, N.Y. and Washington	X	X	X	X	X	X		X		X	X	X	X	X	X				X	X	
Bruce Coleman, Inc., N.Y.		X	X	X	X	X					X		X	X	X				X	X	X
Dewys, Inc., N.Y.	X	X	X		X								X	X	X	X			X	X	X
Earth Scenes, N.Y.	X	X		X							X		X	X						X	X
Editorial Photocolor Archives (E.P.A.), N.Y.	X	X	X	X	X			X			X	X	X	X	X	X			X	X	
F.P.G., New York	X		X	X	X					X	X		X	X		X	X	X		X	X
Globe Photos, N.Y.	X	X	X	X	X	X	X	X	X	X	X	X	X	X	X	X	X	X	X	X	X
Grant Heilman, Lititz, Pa.	X	X	X		X									X					X	X	
Image Bank, N.Y.		X	X	X	X						X	X	X	X	X	X	X				X
Frederic Lewis, Inc., N.Y.	X	X	X		X			X	X	X	X		X	X	X	X	X	X	X	X	X
Liaison Agency, N.Y.	X	X		X	X	X	X	X	X				X	X	X			X	X	X	X
Life Picture Service, N.Y.	X	X	X		X	X	X	X	X	X	X	X	X	X	X	X	X	X	X	X	X
The Phelps Agency, Atlanta, Ga.		X	X	X	X						X	X	X	X	X				X	X	X
Photography for Industry (P.F.I.), N.Y.	X	X	X	X	X			X			X	X	X	X	X				X	X	X
Photo Media, Ltd., N.Y.		X	X	X	X	X						X	X		X		X	X	X		
Photo Researchers, N.Y.	X	X	X	X	X			X			X		X	X	X			X	X	X	X
Picture Group, Providence, R.I.	X	X		X	X	X	X	X			X		X	X		X			X	X	X
Plessner International, N.Y.		X										X									
R.D.R. Productions, N.Y.	X	X		X				X	X		X					X	X	X	X		
H. Armstrong Roberts, Philadelphia	X	X	X		X					X	X		X	X	X	X	X	X		X	X
Shostal Associates, N.Y.		X	X	X	X						X	X	X	X	X	X	X	X	X	X	X
Sports Illustrated, N.Y.		X		X		X	X									X	X	X			
Tom Stack & Assoc., Colorado Springs	X	X	X	X	X					X	X					X			X	X	X
Stock Boston, Inc., Boston	X	X	X		X			X			X		X	X	X	X			X	X	X
Transworld Features Syndicate, N.Y.	X	X	X	X	X	X	X	X	X		X	X				X	X	X	X	X	X

MARKETING DIRECTORIES AND SOURCES

Left:

This dizzying chart gives some idea of the subject specialties and photographic preferences of stock-photo houses. These happen to be members of the Picture Agency Council of America. Whatever you do, don't start firing off big submissions—most of these agencies have more than enough material already. All the chart shows is that some houses do specialize. Besides the PACA members listed here, there are a hundred or more stock houses in North America. It's a good idea to see if any of your particular interests or capabilities match any of theirs. One way to find out, and to find agencies near you, is to check for listings in several directories in the list that follows. Another is to query the American Society of Picture Professionals, a nationwide organization of picture makers and picture users (Box 5283, Grand Central Station, New York, NY 10163)—better yet, join up! In any case, follow the guidelines in Chapter 8 to see if you and the agency could do business. The growth of the stock-photography industry means that many new agencies are starting up. Some may not yet be on any of the lists. Such upward strivers are looking for new talent, and newcomers can expect more appreciative welcomes than they could from the big companies.

Here are the directories and information sources referred to in Chapter 2 and Chapter 7. They will guide you to many markets for your existing pictures and can give you ideas of subjects to add to your stock files, too. You will discover others as you dig into your research. Some of the reference books are very expensive, but some are not. Besides, many are available in local public and college libraries, or your librarian can borrow them through the Inter Library Loan System. As you use these resources, you will probably find two or three that are especially useful, and you will want to own them. If your local bookstores do not stock them, write to the addresses given here. (If any are annual directories, be sure to ask for the most recent or the *next* edition. If they are newsletters, ask to see a sample before you subscribe.)

American Auto Racing Writers
and Broadcasters Association
Directory of Members
911 North Pass Avenue
Burbank, CA 91505

American Society of Picture Professionals
Directory of Members
Box 5283, Grand Central Station
New York, NY 10163

Association for Educational
Communication and Technology
Directory of Members
1126 16th Street N.W.
Washington, DC 20036

Ayer Directory of Publications
Ayer Press
1 Bala Avenue
Bala Cynwyd, PA

R.R. Bowker Company
publishers of
Associations Publications in Print
Literary Market Place
Magazine Industry Market Place
Ulrich's International Periodicals
1180 Avenue of the Americas
New York, NY 10036

Camera Buffs' Newsletter
Don Langer, Editor
Camera Cruises, Inc.
Box 387,
Larchmont, NY 10538

Canadian Almanac and Directory
Richard De Boo, Ltd.
70 Richmond Street East
Toronto, Ontario M5G 2M8

Creative Directory of the Sun Belt
Ampersand Inc.
1103 Shepherd Drive
Houston, TX 77019

Directory of Members
and *Dial-a-Writer* Service
American Society of Journalists
and Authors
1501 Broadway, Suite 1907
New York, NY 10036

Directory of Small Press and
Magazine Editors and Publishers
Dustbooks
P.O. Box 1056
Paradise, CA 95969

Education Directory:
Colleges and Universities
National Center
for Education Statistics
Statistical Information Office
400 Maryland Avenue, S.W.
Washington, DC 20402

Educational Marketer Yellow Pages
Knowledge Industry Publications
2 Corporate Park Drive
White Plains, NY 10604

Free Stock Photo Directory
Info Source Business Publications
1600 Lehigh Parkway East
Allentown, PA 18103

Freelancer's Newsletter
Circle Publications, Inc.
Dept. L-1
307 Westlake Drive
Austin, TX 78746

Gebbie House Magazine Directory
424 North Third Street
Burlington, IA 52601

Graphic Artists Guild
30 East 20th Street
New York, NY 10003

Guide to the Health Care Field
American Hospital Association
840 North Lake Shore Drive
Chicago, IL 60611

Madison Avenue Handbook
Peter Glenn Publications
17 East 48th Street
New York, NY 10017

Media Alliance
Building 314, Forth Mason
San Francisco, CA 94123

O'Dwyer's Directories of
Corporate Communications
Public Relations Firms
Public Relations Executives
and *Jack O'Dwyer's Newsletter*
271 Madison Avenue
New York, NY 10016

Outdoor Writers Association
of America, Inc.
Directory of Members
4141 West Bradley Road
Milwaukee, WI 53209

Oxbridge Communications, Inc.
Publishers of
Directory of Newsletters
Standard Periodical Directory
183 Madison Avenue (Suite 1108)
New York, NY 10016

Photo Market Survey
1500 Cardinal Drive
Little Falls, NJ 07424

The Photoletter
Dept. 60
Osceola, WI 54020

Photographically Speaking
Uniphoto
1071 Wisconsin Avenue, N.W.
Washington, DC 20007

The PRSA Directory
Public Relations Society of America
845 Third Avenue
New York, NY 10017

Society of American Travel Writers
Directory of Members
1120 Connecticut Avenue, N.W. (Suite 940)
Washington, DC 20036

Standard Rate and Data Service, Inc.
Publishers of
Community Publication Rates and Data
Consumer Magazine/
Farm Publication Rates and Data
Newspaper Circulation Analysis
5201 Old Orchard Road
Skokie, IL 60077

The Thomas Register
1 Penn Plaza
New York, NY 10001

Underwater Photographic Society
Box 15921
Los Angeles, CA 90015

Wide Angles
International Photography Society
8 E Street, S.E.
Washington, DC 20003

Working Press of the Nation:
Vol. 1—Newspapers
Vol. 2—Magazines
Vol. 5—Internal Publications Directory
National Research Bureau
A subsidiary of Automated
Marketing Systems, Inc.
310 South Michigan Avenue
Chicago, IL 60604

Writer's and Photographer's Guide
Clarence House Publishers
2115 Van Ness Avenue
San Francisco, CA 94109

Writer's and Photographer's Guide
to Newspaper Markets
Helm Publishing
P.O. Box 512
Costa Mesa, CA 92627

Writer's Digest Books
Publishers of
Photographer's Market
Photographer's Market Newsletter
Writer's Market
9933 Alliance Road
Cincinnati, OH 45242

A Writer's Guide to
Chicago-Area Publishers
Writer's Guide Publications
Gabriel House, Inc.
9329 Crawford Avenue
Evanston, IL 60203

The Yearbook of American
and Canadian Churches
Abdingon Press
201 Eighth Avenue South
Nashville, TN 37202

The Home Front in the North

Diane Smolinski

Series Consultant:
Lieutenant Colonel G.A. LoFaro

Heinemann Library
Chicago, Illinois

© 2001 Reed Educational & Professional Publishing

Published by Heinemann Library,
an imprint of Reed Educational & Professional Publishing,
Chicago, IL

Customer Service 888-454-2279

Visit our website at www.heinemannlibrary.com

Designed by Herman Adler Design
Printed in China by WKT

08
10 9 8 7 6 5

Library of Congress Cataloging-in-Publication Data
Smolinski, Diane, 1950-
 The home front in the North / Diane Smolinski.
 p. cm. -- (Americans at war. Civil War)
 Includes bibliographical references (p.)
 and index.
 ISBN 1-58810-099-5 (lib. bdg.)
 ISBN 1-58810-393-5 (pbk. bdg.)
 ISBN 978-1-58810-099-3 (HC)
 ISBN 978-1-58810-393-2 (pbk)
 1. United States--History-Civil War, 1861-1865-Social
aspects--Juvenile literature. 2. Northeastern States-Social
conditions--19th century--Juvenile literature. 3. Lincoln,
Abraham, 1809-1865--Juvenile literature. [1. United States
-Social conditions--To 1865. 2. United States--History--Civil
War, 1861-1865.]
 I. Title.
E468.9 .S66 2001
973.7'1--dc21

 00-012485

Acknowledgments
The author and publishers are grateful to the following for
permission to reproduce copyright material: p. 3 University
of Washington; p. 4, 11 top, 17, 27, 28 Corbis; p. 6 top, 7,
7 inset, 9, 10–11, 14–15, 15, 16, 17 inset, 20–21, 22, 26 left,
29 Bettmann/Corbis; p. 6 bottom, 19 inset Library of Congress;
p. 12 Chicago Historical Society; p. 13 Museum of the City
of New York/Corbis; p. 18–19 State Historical Society of
Wisconsin; p. 19 inset The Granger Collection, New York;
p. 20 PictureQuest; p. 23, 26 right Culver Pictures/PictureQuest;
p. 24 New York Historical Society; p. 25 top Lowell Georgia/
Corbis; p. 25 bottom Nathanial Currier & James Ives/Wood
River Gallery/PictureQuest.

Cover photograph Courtesy of the Rhode Island Historical
Society, RHi (x3) 1692.

Every effort has been made to contact copyright holders of
any material reproduced in this book. Any omissions will be
rectified in subsequent printings if notice is given to the
publisher.

About the Author
Diane Smolinski is a teacher for the Seminole County School
District in Florida. She earned B.S. of Education degrees
from Duquesne University and Slippery Rock University in
Pennsylvania. For the past fourteen years, Diane has taught
the Civil War curriculum to fourth and fifth graders. She was
also instrumental in writing the pioneer room curriculum,
indicative of the Civil War era, for the school district's
student history museum. Diane lives with her husband,
two daughters, and a cat.

About the Consultant
G.A. LoFaro is a lieutenant colonel in the U.S. Army currently
stationed at Fort McPherson, Georgia. After graduating from
West Point, he was commissioned in the infantry. He has
served in a variety of positions in the 82nd Airborne Division,
the Ranger Training Brigade, and Second Infantry Division
in Korea. He has a Masters Degree in U.S. History from the
University of Michigan and is completing his Ph.D in U.S.
History at the State University of New York at Stony Brook.
He has also served six years on the West Point faculty where
he taught military history to cadets.

Some words are shown in bold, **like this.**
You can find out what they mean by looking in the glossary.

Contents

The Union Is Divided .4

Abraham Lincoln .6

Economy of the North10

Slavery in the North14

Farming in the North18

Small Towns .22

Life on the Frontier23

Cities in the North24

Ideas and Inventions27

Union Victory .29

Glossary .30

Historical Fiction to Read and Civil War Places to Visit31

Index .32

The Union Is Divided

The citizens in the United States of America had been arguing about slavery and states' rights for many years. Leaders in the northern states wanted to stop slavery from spreading. They thought newly admitted states or territories should not permit slavery. Leaders in the southern states believed each state or territory should decide on an individual basis whether or not to allow slavery.

Representatives from both sides tried many solutions.

- According to the Missouri Compromise of 1820, Congress admitted Missouri as a slave state and Maine was admitted as a free state.
- As part of the Compromise of 1850, California became a free state, people in Utah and New Mexico could vote on whether they wanted their states to be free or slave, and a stricter **fugitive** slave law was passed.
- In the Kansas-Nebraska Act of 1854, citizens in those states were allowed to vote to decide whether they wanted their states to be free or slave.

Senator Henry Clay helped write the Missouri Compromise and defended it in the Senate chamber.

4

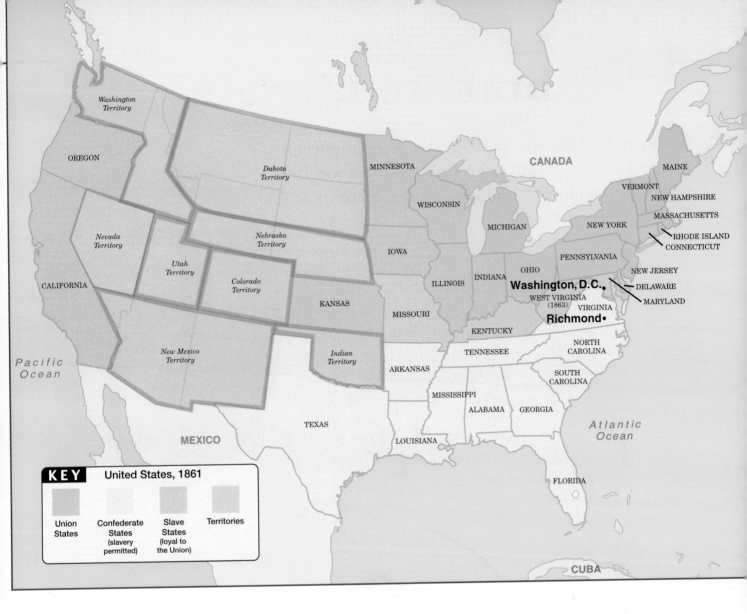

Washington
Territory

OREGON

Dakota
Territory

MINNESOTA

CANADA

MAINE

VERMONT

NEW HAMPSHIRE

WISCONSIN

MICHIGAN

NEW YORK

MASSACHUSETTS

RHODE ISLAND

CONNECTICUT

Nevada
Territory

Nebraska
Territory

IOWA

PENNSYLVANIA

NEW JERSEY

Utah
Territory

OHIO

INDIANA

Washington, D.C.

DELAWARE

CALIFORNIA

Colorado
Territory

WEST VIRGINIA
(1863)

MARYLAND

KANSAS

ILLINOIS

VIRGINIA

MISSOURI

Richmond•

KENTUCKY

Pacific
Ocean

New Mexico
Territory

Indian
Territory

TENNESSEE

NORTH
CAROLINA

ARKANSAS

SOUTH
CAROLINA

MISSISSIPPI

MEXICO

TEXAS

ALABAMA

GEORGIA

Atlantic
Ocean

LOUISIANA

FLORIDA

KEY United States, 1861

Union
States

Confederate
States
(slavery
permitted)

Slave
States
(loyal to
the Union)

Territories

CUBA

No More Compromises

It seemed that nothing could satisfy all the states. In 1860, no more
compromises could be reached. South Carolina thought northern congressmen
would ruin their social structure and economy with these compromises. South
Carolina wanted to make its own decisions.

On December 20, 1860, South Carolina seceded from, or left, the United States of
America. Leaders of the United States government in Washington said that no
state had the right to separate from the Union. On May 20, 1861, North Carolina
was the eleventh state to secede. These eleven states formed a new country called
the Confederate States of America. The division of the United States into North
and South was now complete.

Union leaders were willing to go to war to keep these southern states from
leaving the nation. These leaders had no way of knowing that this war would
last four long years.

Abraham Lincoln
(1809–1865)

Abraham Lincoln was perhaps the most important leader during the American Civil War. He was the leader of the citizens on the northern home front, as well as the leader of Union soldiers and sailors on the battlefields and seas.

Abraham Lincoln was **inaugurated** president of the United States on March 4, 1861, taking office just one month before the Civil War began. Even though he did not have military experience, Lincoln's previous work in public office helped him guide the nation throughout the Civil War.

This portrait of Lincoln was taken February 9, 1861, just before his inauguration.

Lincoln often visited the battlefields. Here he stands with Allan Pinkerton, a civilian, and Major General John A. McClermand.

6

Childhood and Education

Living on the **frontier** made it difficult for Lincoln to attend school regularly. However, he wanted to succeed and taught himself to do many things.

As a young boy, Lincoln would read by firelight in this one-room log cabin.

Military Career

Living on the **frontier,** Lincoln was more focused on farming than on the military. However, after moving to New Salem, Illinois, he enlisted in the Illinois state **militia** to fight in the **Black Hawk War.** He served in a rifle company, or unit, for three months in 1832, but never fought in a battle.

Political Career

Lincoln was well-liked in the New Salem area. He was friendly, intelligent, honest, and a good storyteller. These qualities helped him win a seat in the Illinois **General Assembly.** Beginning in 1834, Lincoln served four two-year **terms.** In 1836, after studying law books on his own, Lincoln earned his law license. Lincoln's ambitions continued to grow. He tried twice to win a seat in the **U.S. House of Representatives.** Finally, in 1847, his hard work paid off, and he took a seat in the U.S. House of Representatives for two years.

Lincoln's background as a lawyer and politician helped him speak effectively. This ability gained him national attention in the Illinois Senate election in 1858. Lincoln's opponent was Stephen Douglas. Although Lincoln lost the election, his arguments during the **Lincoln-Douglas debates** made him famous throughout the country. This popularity helped him two years later. In November of 1860, Abraham Lincoln was elected the sixteenth president of the United States of America.

Lincoln During the Civil War Years

Lincoln used his presidential powers to try to end the war as quickly as possible, often acting without the permission of Congress. Lincoln thought it necessary to do everything within his power to keep the United States together. He believed that the fate of world democracy was the most important issue of the Civil War.

Lincoln Civil War Facts

- Originally, like most northerners, Lincoln was interested merely in keeping slavery from spreading. Some citizens, called **abolitionists,** wanted to stop all slavery immediately.

- As the war continued, Lincoln's view changed. On January 1, 1863 he issued the **Emancipation Proclamation.**

- Abraham Lincoln made one of the most famous speeches in history on November 19, 1863, dedicating a cemetery at the site of the Battle of Gettysburg. The Gettysburg Address honored soldiers who died on this battlefield.

- John Wilkes Booth shot and killed Lincoln on April 14, 1865, while Lincoln was watching a play in Washington, D.C.

Lincoln Timeline

1810	1820	1830
2/12/09 born		1832 enlisted to fight in **Black Hawk War**
		1834–1842 Illinois State Legislator
		1836 passed the bar exam to receive his law license

Lincoln and Douglas debated seven times throughout Illinois during the U.S. Senate campaign of 1858. Lincoln argued that all new states to the Union should outlaw slavery, but slavery would remain where it was already legal. Douglas thought that citizens of each state should have the right to decide whether to allow slavery. Douglas called this idea "popular sovereignty."

1840	1850	1860
1847–1849 served in the U.S. House of Representatives	**1858 Lincoln-Douglas debates**	**11/6/60 elected President of the U.S.** **3/4/61 inaugurated President of the U.S.** **1/1/63 issued Emancipation Proclamation** **11/19/63 delivered Gettysburg Address** **4/14/65 assassinated**

Economy of the North

Northern industries relied on the South to supply them with cotton for manufacturing clothing, sugar and rice for food, and tobacco for tobacco products. Once the war began, the North lost this most important trading partner.

Midwestern and western states could grow some of these products once supplied by the South. An efficient railroad system moved these materials from the West to northern factories. However, since northern factories now received less of these materials, they produced fewer finished products. Even though fewer products were made, the demand for these products remained high. These items became very expensive. The northern economy was in trouble.

Bank notes worth $500 were printed by the Boylston Bank in 1862.

Money

The Civil War caused major changes in the handling and distribution of money in the North. In 1862, the U.S. Congress passed the first Legal Tender Act. This allowed the U.S. Treasury to print a common **national currency.** The U.S. government would guarantee the full value of each bill. The bills were all of one design and were accepted everywhere in the United States.

Money Facts

Before the War

- Debts were paid with gold or silver coins.

During the Civil War

- Citizens had to cash each individual bill at the place it was printed, or they may not receive full value for that bill.

- Paper bills were printed again.

- Banks and businesses began printing their own designs of paper money.

Rising Costs—Inflation

Costs were rising quickly for several reasons. States and businesses in the North could not collect money that southern businesses owed them. Also, the U.S. government could no longer collect taxes from the eleven seceded Confederate states. This created a shortage of money that the government needed to pay for much needed war equipment.

Therefore, the government printed more money to pay for war materials. Too much of anything can make it less valuable. Business leaders were concerned about this, so they continued to raise prices to insure profits. The government printed more money. This cycle caused prices to continue to inflate, or rise above their original value, in a short time. Prices also were inflated when available products were limited, but demand for these products was high.

Benefits for Some Citizens

During the war years, factories grew quickly because of the need to produce large quantities of uniforms, boots, rifles, and tools. When men left their factory jobs to fight as soldiers, women took their places in the factories. This opened the doors for women to enter the work force. New machines and technology were developed for war products. Food processing, industry, and farming equipment benefited greatly from this improved technology. Many factory owners became rich during the war. When the war ended, war factory equipment was changed to make products for everyday use.

Women did much of the factory work because so many men were fighting as soldiers. These women are filling cartridge shells in a factory in Massachusetts.

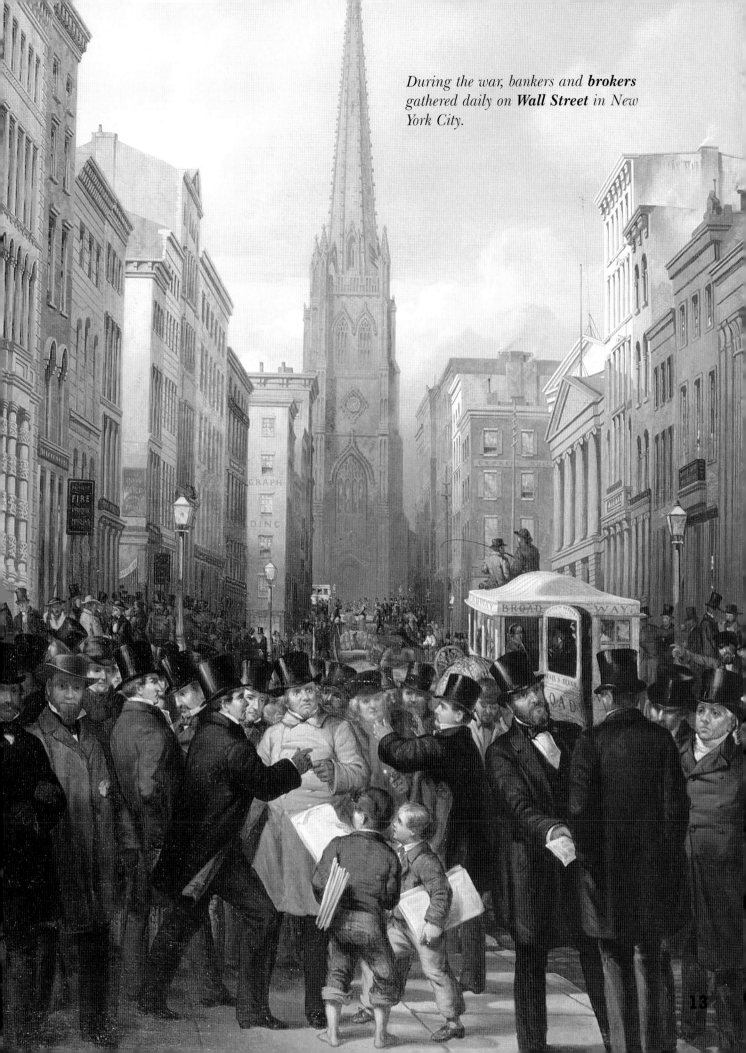

*During the war, bankers and **brokers** gathered daily on **Wall Street** in New York City.*

13

Slavery in the North

Slavery existed in northern colonies for several hundred years before the Civil War began. Although the writers of the Declaration of Independence and the U.S. Constitution believed in the idea that all people were created equal, they did not try to end slavery. Each state was allowed to decide whether slavery could stay in that state.

Throughout the 1800s, northern politicians did not support slavery, but they hesitated to make it illegal. The main concern was to keep states united and keep the government working smoothly.

Unlike the cotton plantations in the South, the types of crops grown in the North required fewer workers to get the products to market. Also, in 1860, most northern farms were small. Slave labor was not as necessary. However, slavery was an issue that was causing much disagreement in the government.

Union soldiers remove chains from a slave woman.

Abolitionists

In the 1600s, the **Quakers** had been one of the first large groups to speak out against slavery in the northern colonies. Then, in the mid-1800s, as the possibility of a war grew, more people spoke out against slavery. People in the North called **abolitionists** believed that slaves should be freed immediately.

Some of the abolitionists in the 1800s no longer pushed for immediate freedom for slaves, but they tried to force government leaders to pass laws to end slavery. Once such person was Frederick Douglass. Douglass was a slave who escaped to Europe, earned enough money to buy his freedom, then returned to the United States. He tried to win freedom for slaves by convincing political leaders in the North to pass laws against slavery.

Frederick Douglass

Free African Americans

Although free, African Americans in the North did not have the same rights as white citizens, even after the war. **Federal laws** enacted in 1866 and 1875 gave African Americans some rights. Not until the 1965 Civil Rights Act was signed into law—100 years after the Civil War ended—were African Americans ensured equal rights.

As shown in this engraving, schools in the North were open to freed slaves during the Civil War.

African American Facts: Before 1865

- Free African Americans could not vote.

- Free African Americans could not join state **militias.** This changed later in the war.

- Free African Americans could not eat or sleep in the same places as white citizens.

- Free African Americans could not sit in church with white citizens.

- Free African Americans could not serve on juries.

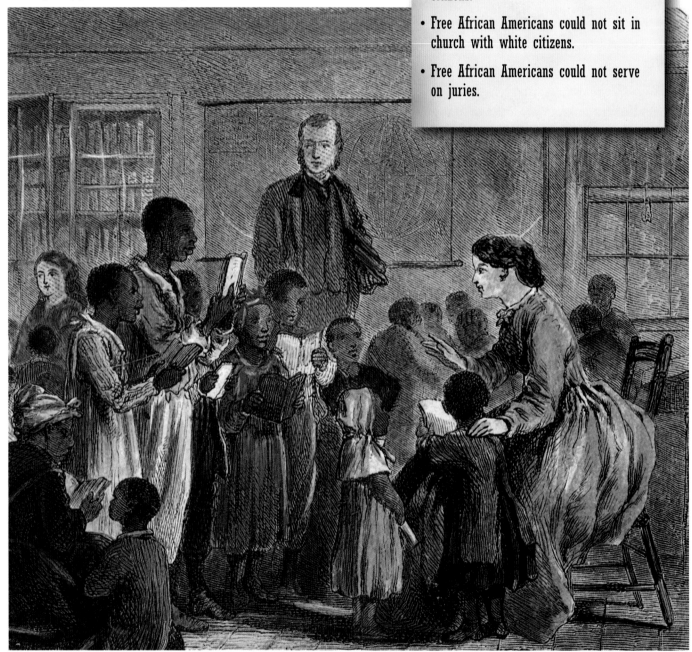

The Underground Railroad

Even though slavery did not directly affect many citizens in the North in the 1860s, most people did not think that one human had the right to own another. Some northerners helped runaway slaves escape by offering their homes and properties as resting places or by providing supplies. Railroad terms were used as code words, because everything had to be kept very secret. Harriet Tubman was one of the most famous slaves who helped others escape using the Underground Railroad.

Underground Railroad Facts

- A "conductor" was the person who led a group of slaves to freedom.

- "Freight" was the group of slaves trying to escape.

- Places where slaves could rest and get supplies were called "stations."

- A "line" was the path or route the slaves followed to freedom.

Harriet Tubman (at left) escaped from slavery and went to Philadelphia in the North. She then returned to the South 19 times and led about 300 other slaves to freedom.

Slave owners considered slaves to be their property. They hired people to track down runaways. Escaping slaves usually traveled at night to make it difficult for slave hunters to find them.

Farming in the North

Most of the northern population during the Civil War lived or worked on farms. Farms were all sizes, from a few acres to more than 500 acres. Ideal weather, soil, and landscape conditions made it possible for farmers in northern states to grow many different types of crops and raise a variety of livestock.

Most northern farmers grew grain as a cash crop. Many farmers also grew apples, potatoes, or corn, raised cattle, pigs, or sheep, or produced lumber. The length of the growing season allowed crops to be planted and harvested one time each year. Some of the wealthier farmers hired helpers during the harvest season. All family members worked to keep a small farm running.

By the 1860s, farmers in the North were relying more and more on machinery to help with farm work.

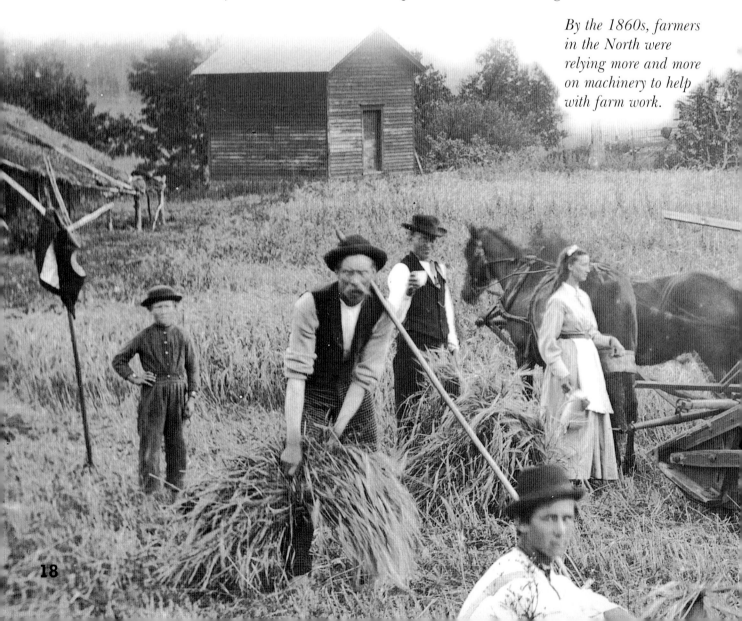

18

Men

Men usually did the outdoor work, which included taking care of crops and livestock. The seasons determined the type of work that was possible. During the war, farmers grew extra crops to sell to the government to feed the soldiers.

Farm Responsibilities

- Chores, such as milking cows, cleaning barns, and feeding animals, had to be done daily.

- During the summer months, farmers cleared land, prepared soil, planted seeds, and harvested crops.

- Winter months were spent cutting firewood, **threshing** grain, slaughtering farm animals, and repairing fences and buildings as necessary.

- Farming machinery was beginning to perform tasks that traditionally had been done by hand.

- Farmers within a community would usually help one another build barns and harvest crops.

Women

Women usually did all of the household chores. These chores included cooking, baking, laundry, cleaning the house, and sewing. Women also did some lighter outdoor work, such as gardening. When the men left the farm to fight in the war, women and children and older family members did all of the farm work.

Children

Farm children were expected to do their share of the work at a very early age. Children usually had daily chores. They chopped wood for cooking and heating, cleaned barns, fed animals, gathered eggs, and milked cows. After early morning chores, many northern children went to school. Some had to walk long distances to get there. When they came home from school, children had afternoon or evening chores to do as well as school lessons to study.

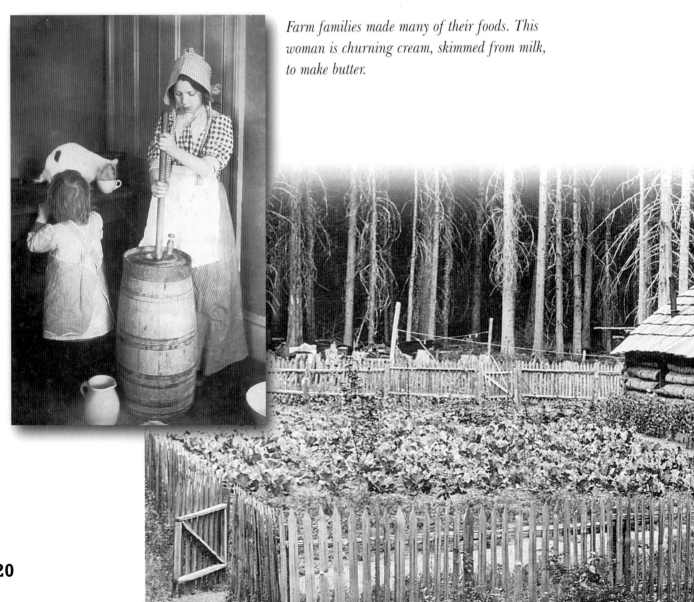

Farm families made many of their foods. This woman is churning cream, skimmed from milk, to make butter.

Farmhouses

Large families usually lived in big farmhouses. Many farmhouses in the Northeast and Midwest were two-story, wood-framed buildings. **Frontier** homes were one-story houses made of **sod** or logs, depending on available materials. The houses had no electricity or running water. In cold weather, wood stoves heated the homes.

Effects of War

Most battles were not fought on northern soil, so farming continued as usual. Food was plentiful, leaving extra food to sell to the government to feed its soldiers.

Crops that normally came from the South, such as tobacco, coffee, and cotton became expensive—if they were available at all. Some northerners began raising sheep because wool could be used to make clothing. As the war progressed, better machinery for farming was developed. This allowed farmers to produce more food with less physical labor.

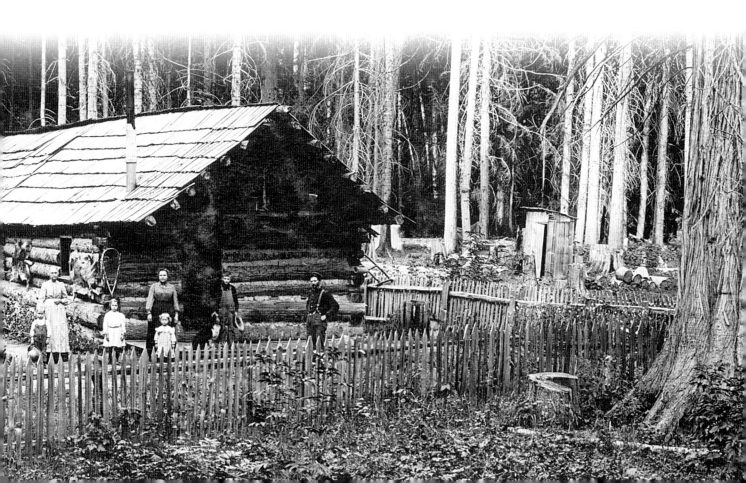

Small Towns

Small towns provided farm communities with goods and services. These towns were places where citizens went to socialize, attend church, buy supplies, send and receive mail, and get medical treatment. The size of the town depended on the population of the surrounding area.

General stores sold groceries, clothing, and hardware items. In many towns, the post office was part of the store. The general store was a place to buy and sell supplies, chat with other townspeople, and catch up on local news.

Another important business was the blacksmith shop. A blacksmith made hand tools and decorative iron, put on and fixed horse shoes, and repaired wagons and buggies.

The unpaved streets of Helena, Montana, like those of many small towns in 1865, were filled with covered wagons.

Life on the Frontier

Most Civil War fighting was far from western frontier communities. During and after the war, populations grew rapidly in these states and territories.

In 1862, Congress passed the Homestead Act. Selected government land was given to people who were willing to live on it for at least five years. These settlers had to build a home and farm and improve the land. Most often, the **pioneers** built log cabins or **sod** homes. These homes were usually small, contained one room, and had dirt floors. As frontier communities grew, railroads were built to connect these farmlands to the industrial northeast.

Neighbors often worked together to build a new settler's home. Trees were cut down and the branches and bark were removed to make logs. The ends of the logs were then notched, and the logs were stacked on top of each other to build the walls of the home. Cracks between the stacked logs were packed with mud and clay.

Cities in the North

According to the U.S. Census Bureau, in 1860, New York City was the largest city in the North with more than 800,000 people. Approximately 150,000 people lived in the Philadelphia, Pennsylvania, and the Boston, Massachusetts, areas. **Immigrants** from Europe and people from farming areas crowded into northern cities looking for work in factories or shipyards.

Cities were usually built near factories, rivers, or seaports. Factories and shipyards in these cities needed workers. Docks in seaports and river cities were crowded with products from all over the world.

Wealthy business owners built large mansions on tree lined streets. **Row houses** and crowded **tenements** housed middle class and poorer citizens. Banks and businesses lined the streets in the center of large cities.

City streets were bustling with shoppers and workers going about their daily lives, such as on Hudson Street in New York City in 1865.

Cities Prospered

Life in a large city during the 1860s was much different from life in smaller communities or on the **frontier.** New ideas and inventions usually reached the cities first. A.T. Stewart's, the first department store, opened in 1862 in New York City. This building covered an entire city block. It stood five stories tall and had elevators.

Plays and musical entertainment were popular during the Civil War years. Citizens also gathered in city parks for recreation. Amateur baseball teams provided additional sports entertainment.

Supported by taxes, cities were able to offer services, such as uniformed police and fire departments. In 1865, postal carriers began delivering mail door to door.

The Opera House in Central City, Colorado, built in the 1800s, brought stars to the small, mining town.

As early as the 1700s, larger cities had fire departments. These were necessary since wooden buildings burned easily. Fire could spread quickly because these buildings were so close together.

City Problems

As more poor people moved into cities, problems arose. There were many jobs, but not all citizens were able to earn enough money to make a comfortable living. Even though public education was available at no cost, many poorer children did not attend school. They often worked full-time jobs to help earn money for their families.

Immigrants arrived from Europe in great numbers. Many were poor, uneducated, spoke little English, and had few work skills. Affordable housing was often crowded and run down. These apartment buildings were called **tenements.**

Street cleaning and garbage collection were not free services, and dirty living conditions allowed illnesses to spread easily. Crowded conditions often brought increased crime, as desperate people looked for quick solutions to their problems.

Low wages forced many immigrants to share a living space. These overcrowded places had few comforts and little privacy for the tenants.

Ideas and Inventions

Many weapons invented before the Civil War were improved during the four-year struggle. Some of these ideas came late in the war and were more useful in later conflicts.

Watching Enemy Troops

Thaddeus Lowe convinced the Union Army leaders that hot air balloons could be useful in battle. Hot air balloons were used for a short time near the beginning of the war. Balloons with an attached basket held Union spies. During the First Battle of Bull Run, or Manassas, men in a balloon telegraphed Washington when Confederate troops stopped following the retreating Union troops.

Balloons in Action

- Telegraphs sent messages between the balloon and the ground using a thin wire to connect the two.

- Telescopes spotted enemy troops, soldiers, and equipment.

- The floors of some balloons were lined with iron.

- Balloons could be placed on **barges** and moved along waterways.

Northern Navy

The Union Navy had more ships than the newly formed Confederate Navy. However, the Confederate Navy's development of armor-plated ships forced Union shipbuilders to design their own ironclad warships. The USS *Monitor* was developed by John Ericsson. Thick plates of steel covered the top, which had a revolving gun.

The revolving turret, or structure that housed the cannons, on the USS Monitor *allowed these guns to be fired without having to turn the entire ship. The round shape of the turret also made it more difficult for enemy fire to damage it.*

Weapons for the Army

The smooth bore musket, which used round musket balls, was the standard weapon at the beginning of the war. Guns with rifled barrels using bullets called minié balls greatly improved a shooter's accuracy and range. Dr. Richard Gatling invented a rapid firing gun that was tried out near the end of the war. Another improvement made during the war was to place heavy **mortars** on railroad cars, making them easier to move.

Union Victory

After the Civil War, the United States was again one nation under one government. Slavery in the South ended, and many soldiers returned home to their families. According to official war records, 646,392 Union soldiers were killed or wounded in the conflict.

Rebuilding the Union

The population of the United States was growing and shifting. Some people moved to cities while others moved west to develop the **frontier.** Some western **territories** applied for statehood. Not long after the end of the Civil War, railroads connected the East to the West.

The eleven southern states that had seceded at the beginning of the Civil War needed to be readmitted. But for the country to be truly reunited, citizens across the nation needed to adopt new attitudes to follow special laws. This was difficult for many people.

New railroads allowed the country to rebuild more quickly after the war ended. The Transcontinental Railroad, completed in 1869, four years after the Civil War ended, was celebrated when railroad officials drove in the final spikes at Promontory, Utah.

Glossary

barge boat without a motor that carries materials by being pushed or pulled

Black Hawk War small war in 1832 between the U.S. government and the Sac (Sauk) and Fox Indian tribes; named after Chief Black Hawk

broker person who buys and sells property, stocks, or materials for other people

Emancipation Proclamation announcement that freed slaves in those states fighting against the Union

Federal law law written by U.S. Congress that must be obeyed throughout the entire country

frontier edge of the settled part of a country

fugitive person who is running away from something

general assembly group of representatives that makes laws for a state

immigrant person who moves from one country to another to live

inaugurated took an oath, usually for a political office

militia small military unit organized by an individual state

mortar cannon designed to lob shells. Mortars were not easily moved and were used primarily to attack fixed structures rather than soldiers on the battlefield.

national currency money that can be used throughout a country

Quakers religious group that believed slavery was wrong

pioneer one of the first people to settle in an area

row house house connected by a common wall to the one next to it

rural area where there are farms

senator elected representative who helps make laws for all United States citizens

sod squares of grass with the soil attached

tenement building divided into separate apartments, generally low-income housing

term agreed upon amount of time for holding a political office

territory land in the United States that was not a state

thresh to separate the grain from the rest of the plant

U.S. Census Bureau government agency responsible for counting the population in the United States

U.S. House of Representatives group of elected leaders that makes laws for all United States citizens; one half of the U.S. Congress

Wall Street street in New York City on which many banks are located

Historical Fiction to Read

Beatty, Patricia. *Jayhawker*. New York: Morrow Jr. Books, 1991.
The story of twelve-year-old Elijah, who becomes a Union spy and is able to join the Confederate Army.

Hamilton, Virginia. *House of Dies Drear*. Old Tappan, N.J.: Macmillan Publishing, Inc., 1984.
A young African American boy and his family move into a house in Ohio that was at one time a station on the Underground Railroad.

Hunt, Irene. *Across Five Aprils*. New York: Silver Burdett, 1993.
Young Jethro Creighton grows from a boy to a man when he is left to take care of the family farm in Illinois during the Civil War.

Nixon, Jean Lowery. *A Dangerous Promise*. Milwaukee: Gareth Stevens, Inc., 1994.
In 1861, while living with his foster parents at Fort Leavenworth, Kansas, twelve-year-old Mike Kelly and his best friend, Todd Blakely, join the Union Army as drummer boys. Their dreams of glory end, however, when they experience the full horrors of war at the Battle of Wilson's Creek in Missouri.

Civil War Places to Visit

Lincoln Home National Historic Site
413 S. Eighth Street
Springfield, Illinois 62701-1905
Telephone: (217) 492-4241
The home and neighborhood where Lincoln and his family lived before moving to the White House has been restored to look just as it did when the Lincolns lived there.

Levi Coffin House State Historic Site
113 U.S. 27 North, P.O. Box 77
Fountain City, Indiana 47341
Telephone: (765) 847-2432
This is the restored home of Levi and Catharine Coffin, who helped more than 2,000 slaves reach safety in the North. Their home was known as the "Grand Central Station" of the Underground Railroad.

Golden Spike National Historic Site
P.O. Box 897, Promontory Summit via Highway 83
Brigham City, Utah 84302
Telephone: (435) 471-2209
This is where two railroads joined to make the first transcontinental railroad. Working replicas of the two engines and a visitor's center are at the site.

Index

abolitionists 8, 15
animals 18, 19, 21

Black Hawk War 8
Booth, John Wilkes 8
Boston, Massachusetts 24

children 20, 26
chores 19, 20
cities in the North 24–26
Civil Rights Act of 1965 16
Compromise of 1850 4
Confederate Army 27
Confederate Navy 28
crime 26
crops 18, 19, 21

Declaration of Independence 14
Douglas, Stephen 8
Douglass, Frederick 15

economy of the North 10–13
education 20, 26
Emancipation Proclamation 8
entertainment 25

factories 10, 11, 12, 24
farms and farming 12, 14, 18–21
free African Americans 16
frontier 7, 8, 23, 25, 29
fugitive slave law 4

Gatling, Dr. Richard 28
general stores 22
Gettysburg, Battle of 8
Gettysburg Address 8

Homestead Act 23
hot air balloons 27

ideas and inventions 27–28
Illinois 7
illnesses 26
immigrants 24, 26
Indiana 7
industry in the North 10, 12
inflation 12

Kansas 4
Kansas-Nebraska Act of 1854 4
Kentucky 7

Legal Tender Act of 1862 11
Lincoln, Abraham 6–9
Lincoln–Douglas debates 8, 9
Lowe, Thaddeus 27

mail 22, 25
McClermand, General John A. 6
men 12, 19
Missouri Compromise of 1820 4
money 11, 12

New Salem, Illinois 8
New York City 24, 25

Philadelphia, Pennsylvania 24
pioneers 23

Quakers 15

railroads 10, 29
religion 22

slavery 4, 8, 14–17, 29
South Carolina 5
South, the 12, 14, 17, 21
state militias 8, 16

technology 12, 19, 21
tenements 24, 26
territories 4, 23
towns in the North 22
Tubman, Harriet 17

Underground Railroad 17
Union Army 11
Union Navy 11, 28
Union soldiers 6, 12, 14, 19, 29
U.S. Census Bureau 24
U.S. Congress 4, 11

Washington, D.C. 27
weapons 28
women 12, 20